On This Day In

HAMPTON
HISTORY

for Margaret

On This Day In

HAMPTON
HISTORY

Wythe Holt

Edward B Hicks

WYTHE HOLT & EDWARD B. HICKS

THE
History
PRESS

Published by The History Press
Charleston, SC
www.historypress.com

Copyright © 2018 by Hampton History Museum
All rights reserved

Cover image of boats at anchor courtesy of the Hampton History Museum.

First published 2018

Manufactured in the United States

ISBN 9781467139748

Library of Congress Control Number: 2017963930

Contents

Acknowledgements

Many people have kindly given us help and encouragement in the task of producing this volume, for which we are very grateful. In particular, Carolyn Hawkins, Tom Sinclair, Gloria Rogers, Jim Tormey, Jim Eagle, and John "Billy" Schwartz aided with certain facts and entries. Mark St. John Erickson shares a passion for Hampton's history with us, and we have gratefully used portions of his extensive research. As usual, Tim Smith has properly reproduced all of the images, going the extra mile. And if it were not for historian Mike Cobb (founding curator of the Hampton History Museum and curator of Fort Wool) and his vast knowledge of Hampton's history, his consistent generosity and good cheer, and his friendship and assistance, our book would be a good deal less thorough and informative. Mike has continued to be, throughout our work, a compass along the path to publication.

Introduction

We have undertaken to write a different kind of history of Hampton. For each of the 366 dates of the full calendar year, we tell, briefly, the historical event or events that pertain to Hampton or Hamptonians on that day. Our entries are terse, often tantalizingly so. For many of the events, we have written much that we knew or could ascertain, while other entries are distillations of occurrences or events too complicated to state in a sentence or two. A very few important happenings spread themselves over several dates. We have chronicled many of the bits and pieces of the everyday life of our city over the past four centuries and more. Some of these occasions were momentous on a regional or even national basis, but most are just interesting.

Our definition of "Hampton" is quite broad and inclusive. The city today encompasses almost all of what was once Elizabeth City County (minus only the slice that has been absorbed into Newport News), thereby including the town of Phoebus, the old town of Kecoughtan, and the unincorporated but quite self-aware communities of Aberdeen Gardens, Bay Shore Beach (during its existence), Buckroe, Fox Hill, Grandview, Hampton University and Wythe, plus the U.S. Army base (now decommissioned) of Fort Monroe at Old Point Comfort, the U.S. Air Force base at Langley, and the research facilities of the National Aeronautics and Space Administration (NASA), also at Langley. We have also included several marine events that happened in the waters of Hampton Roads, the portion of Chesapeake Bay adjacent to Hampton, and even the Atlantic Ocean just outside the

Bay. Since the Virginia Company chanced to have its settlers in the *Susan Constant, Godspeed* and *Discovery* come ashore at the Native American village of Kecoughtan in late April 1607 before they settled thirty miles up the James River at Jamestown in May, we have included a very few dates and events before then.

We are most fortunate in Hampton, as many of its citizens are deeply caught up in its past and enjoy learning more about it. Four superb local museums—the Hampton History Museum, the Casemate Museum at Fort Monroe, the Hampton University Museum, and the Virginia Air and Space Center—retell portions of these tales at greater length and with greater sophistication. Vigorous historical and community associations exist in Aberdeen, Buckroe, Fox Hill, Phoebus and Wythe. History is featured regularly in the local newspaper, the *Newport News Daily Press*. We love our stories.

We have made every effort to be accurate, and we encourage readers to bring any errors or omissions to our attention.

January

JANUARY 1

1781—A letter of this date informs John Adams in Amsterdam that the British had landed troops in Hampton two days previously, during the American Revolution, in an unsuccessful attempt to capture or disable Virginia's navy, headquartered on Cedar Point at the mouth of what is now called Sunset Creek. The invaders, led by American turncoat Brigadier General Benedict Arnold, re-embark, capture Suffolk and Portsmouth, and temporarily occupy Richmond.

1829—E.A. Perry (pseudonym of Edgar Allan Poe) is promoted to sergeant major while stationed at Fort Monroe. Although he comes to hate his military service and importunes his foster father, John Allan, to get him released, Poe publishes his second collection of poems while there (*Al Aaraaf, Tamerlane and Minor Poems*, 1829). Like his first, it receives mixed reviews.

1863—The Emancipation Proclamation is first read to the public in Virginia near Butler School under what would come to be called the "Emancipation Oak," a huge live oak on the grounds of today's Hampton University made memorable by free black Mary Peake's having taught contrabands to read and write under its shelter in September 1861. African Americans greet the news of the Proclamation with great acclaim.

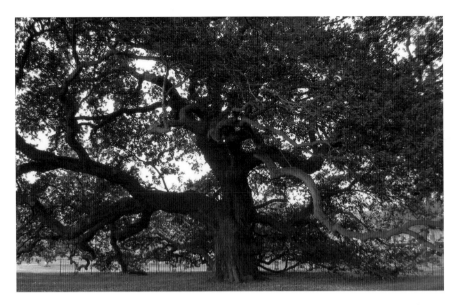

Spanning one hundred feet across, the "Emancipation Oak" has been designated one of the ten great trees in the world by the National Geographic Society. *Wikimedia Commons.*

("Contrabands" were enslaved persons who claimed their freedom during the Civil War and prior to the Emancipation Proclamation by seeking refuge at a U.S. Army base or position.)

1927—After a decade-long existence as a separate incorporated town, Kecoughtan, bordering on Salter's Creek and Pear Avenue and located within Elizabeth City County, successfully petitions to be annexed by the City of Newport News and becomes part of its East End. With a population of 1,500, Kecoughtan had its own mayor, council, city sergeant, fire department, and tax collector. Its county school, Woodrow Wilson, becomes the property of Newport News upon annexation. The Elizabeth Buxton Hospital and its nurses' training program also become part of Newport News.

1942—The U.S. Navy, after acquiring the financially unsound resort hotel at Old Point Comfort, commissions it as "USS *Hotel Chamberlin*" and uses it to house transient naval officers. One of the notables who stays there is Lieutenant Douglas Fairbanks Jr., a leading movie star in civilian life.

1950—Fort Monroe is designated a National Historic Landmark.

JANUARY 2

1923—Old Point National Bank opens, at first located behind the counter of Cooper's Confectionary Store in Phoebus. Eventually, it grows a great deal and moves to its present locations. It becomes the largest trust company headquartered in the Hampton Roads area.

JANUARY 3

1624—William Tucker is born in Elizabeth City (now Hampton), becoming the first African American child recorded in the New World. A monument in the Tucker Family Cemetery near the Aberdeen Gardens community memorializes this event.

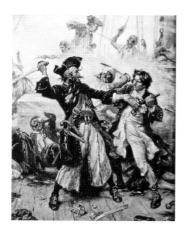

The attack on Blackbeard is depicted in this 1920 painting by Jean Gerome Ferris. *Wikimedia Commons.*

1719—British Lieutenant Robert Maynard returns to Hampton with Blackbeard's head hanging from his sloop's bowsprit. The notorious pirate, whose civilian name is thought to be Edward Thatch (or Teach), had been killed during a spirited battle near the coast of North Carolina. According to tradition, the head is placed on a pike at the site now known as Blackbeard's Point at the entrance to Hampton Creek (now Hampton River), supposedly to warn off other pirates.

1781—British forces, numbering about one hundred marines and sailors, commence a foraging expedition that penetrates into the heart of Elizabeth City County during the American Revolution. The arrogant intrusion lasts for several days, as the Redcoats seize provisions from "the peasants" in both Elizabeth City and Warwick Counties. The local militias are called out.

1888—The Hampton Town Council elects Jacob Heffelfinger fire marshal and names H.F. Phillips first fire warden, J.W. Boyenton second fire warden,

and W.T. Daugherty chief engineer. Hampton's first fire department had been organized after the disastrous downtown fire of 1884.

JANUARY 4

1808—A general court-martial of Hampton's Commodore James Barron, to hear charges brought against him for his conduct in the "*Chesapeake-Leopard* Affair," is convened on board the United States frigate *Chesapeake* sitting at its berth at Norfolk. The naval engagement, fought the previous year, had resulted in the defeat and capture of Barron's ship, the controversy over which helped to instigate the War of 1812. Barron would be convicted of not properly preparing his ship for the action and would be suspended for five years without pay but would return to the U.S. naval service thereafter.

The crew of the ill-prepared *Chesapeake* fired only one shot at the *Leopard* before Commander James Barron surrendered his vessel to the British. *Wikimedia Commons.*

1896—The first edition of the *Newport News Daily Press* appears, a four-page effort distributed by Charles E. Thacker from a small print shop in the basement of Newport News' First National Bank. The paper would maintain a Hampton office for many years and is still considered its local newspaper. Published successively by the Schmelz, Van Buren, and Rouse Bottom families, it would be purchased by the Tribune Company in 1986.

1921—Public schools in Hampton first authorize the use of standardized tests.

JANUARY 5

1781—In an action damaging to British pride, Captain Edward Mallory and thirty militiamen from Elizabeth City County rout a much larger British foraging party near the James River during the American Revolution, killing nine and capturing eleven, with the loss of only one life.

JANUARY 6

1609—Having been blown ashore during a storm, Captain John Smith and several companions end a weeklong stay with the Kecoughtan Indians. Smith would write that "extreame winde, rayne, frost and snow caused us to keep Christmas among the Salvages, where we were never more merry, nor fed on more plentie of good Oysters, Fish, Flesh, Wild-foule, and good bread; nor never had better fires in England, than in the dry smoky houses of Kecoughtan." At that time, the English celebrated Christmas from December 25 through January 5.

1921—The Hampton city police move to their new quarters on Court Street (now Queen's Court). After the town's 1887 incorporation, the force had consisted of a sergeant and two to six constables. When a mayor-council form of government was adopted in 1920, the sergeant's position was terminated in favor of a chief of police.

JANUARY 7

1846—Hampton's court orders a family to be quarantined at Little England Plantation, near downtown, because of smallpox. The notion of contagious disease had been discussed since the Renaissance, but it was not until the middle of the nineteenth century that Louis Pasteur and others demonstrated conclusively that some communicable diseases are caused by microorganisms.

1865—Major General Benjamin F. Butler not only has recently failed to capture the Confederate stronghold of Petersburg, but he has also suffered

his entire army to be bottled up on Bermuda Hundred, a peninsula jutting into the James River above its confluence with the Appomattox River. Joined with Butler's failure in December 1864 to capture Fort Fisher at Cape Fear, North Carolina, guarding the entrance to Wilmington (the last port remaining in Confederate hands on the East Coast, whence a direct rail line enabled supplies to be sent to Petersburg for General Robert E. Lee's beleaguered army), Lieutenant General U.S. Grant relieves him of his command of the Department of Virginia and North Carolina and of Fort Monroe. Major General E.O.C. Ord would assume these commands the next day.

JANUARY 8

1862—Union Brigadier General Ambrose Burnside debarks from Fort Monroe with ten regiments to attack and capture Roanoke Island, New Bern, Beaufort, and Fort Macon in coastal North Carolina—enlarging the enclave Major General Benjamin F. Butler had captured around Hatteras Inlet in late August 1861. Burnside returns, successful in his endeavor, on July 7.

1977—Hampton's recently constructed city hall is dedicated. Its architecture is modern, strikingly different from earlier classical-style buildings.

JANUARY 9

1921—Mrs. Henry L. Schmelz heads up a campaign to feed "the starving Armenians" that raises $3,000. Spurred by reports of genocide among the Christian Armenian minority in eastern Turkey, public outrage in the United States leads to unprecedented church-organized efforts to send food to the survivors. Even in later years, American children would be admonished to eat their vegetables since "the starving Armenian" children don't have any.

1921—Approval is obtained for Dr. Max Munk's design for a variable density wind tunnel at the NACA (the National Advisory Committee on Aeronautics, now NASA) facility at Langley Field. The design allows for

the scaling of the air stream to the size of the model being tested so that conditions more closely resemble actual flight. Newport News Shipbuilding and Dry Dock Company builds the tunnel, delivering it in February 1922.

JANUARY 10

1976—The First Tactical Fighter Wing at Langley Air Force Base begins to fly its first F-15 "Eagle" fighter jet, which had arrived the previous day. During the arrival ceremony, the airplane is christened the *Peninsula Patriot*, a designation chosen from names submitted by local schoolchildren in a contest.

JANUARY 11

1985—The Booker T. Washington Bridge across Hampton River is opened. Leading from downtown Hampton toward Hampton University, the bridge honors the most famous student and alumnus of that institution. Born into slavery, as a young man Washington walked from West Virginia to Hampton to gain an education at what was founded as Hampton Normal and Agricultural Institute, where his poverty forced him to earn his degree through hard manual labor.

JANUARY 12

1805—Hampton Academy, a free school, is established on Cary Street by the merger of the Syms Free School and the Eaton Charity School, as mandated by the Virginia General Assembly after much protest from farming families in Elizabeth City and York Counties served by the two schools in their rural locations near Back River. It would be the only public school in Hampton and Elizabeth City County for many years. The wooden school building would perish in the great fire of August 1861, but after the Civil War, a brick Hampton Academy would be constructed at the same site. Its first high school graduates, in 1896, will be Blanche Bullifant and Bessie Birdsall.

The brick building would also perish in another fire in 1900. A new West End Academy, enrolling students from first grade through high school (as did Hampton Academy), had been opened in 1899, and students from both schools will attend it until 1902, when a new Syms-Eaton Academy is opened, serving grades first through seventh. Syms-Eaton Academy will close its doors in 1940. The trust funds derived from the seventeenth-century legacies of Benjamin Syms and Thomas Eaton are still utilized to support public education in the city.

1922—$100,000 is authorized for the construction of a new Queen Street Bridge over the Hampton River.

JANUARY 13

1914—The Newport News and Hampton Railway, Gas and Electric Company is formed, merging several local utilities together. The new company will provide gas and electricity services and trolley transportation. Bus service would come a decade later.

1948—Langley Field is transferred to the newly created Department of the Air Force, and its name is officially changed to Langley Air Force Base.

JANUARY 14

1946—The last straw being a derailment in front of Hampton's Dixie Hospital the previous day, trolley service in Hampton is discontinued. Bus service, already in operation since the mid-1920s, supersedes it.

2007—The city of Hampton holds a public Day of Appreciation for native Mary T. Christian. Having graduated with a BS in education from Hampton Institute (now Hampton University) in 1955, Christian earned her PhD in elementary education in 1967 from Michigan State University. She became the first African American to serve on the Hampton School Board and taught at her alma mater until retirement in 1987, serving as Dean of Education in 1980–87. The first African American since Reconstruction to

be elected from Hampton to the Virginia House of Delegates, she enjoyed seven terms from 1986 through 2004.

2012—Because of the deep recession, owner Donald Gear decides to close Mugler's, a men's clothing shop founded in 1898 by C.C. Mugler on Mellen Street in Phoebus. Bought in 1970 from the Mugler family by Gear's father, Thomas, a NASA retiree who wanted a small business of his own, the store was eventually relocated to Armistead Avenue in Hampton.

JANUARY 15

1898—Hampton's citizens request a $100,000 bond issue from the Virginia General Assembly for street paving and sewer construction. The Progressive era in American history, from the 1890s until the U.S. entry into World War I in 1917, was marked by widespread efforts to modify cities in ways that made them more healthful, efficient, and orderly, as well as to upgrade roads. Hampton proves to be typical in this respect.

JANUARY 16

1898—Fire destroys the eighty-year-old Sewall mansion in Phoebus. Many of the exemplary homes in the vicinity of Phoebus around the turn of the twentieth century were built in the Italianate, Victorian, and Colonial Revival styles, reflecting the varying tastes of Americans' architectural design and independence of thought and taste. Sewall Avenue in Phoebus would later honor this family's name.

1925—The Phoebus Chamber of Commerce proposes a ferry service to Willoughby Spit. Before the days of bridge tunnels, ferries provided transportation for the public across Hampton Roads. Regular runs were already made to Norfolk from Newport News and to Willoughby Spit from the end of Manteo Street in Hampton. In response to the Phoebus proposal, the latter ferries also begin to stop at Old Point Comfort.

JANUARY 17

1820—Colonel Walter K. Armistead, superintending army engineer at Fort Monroe, and Marshall Parks, design engineer for the Dismal Swamp Canal, receive approval to build the Hygeia Hotel at Old Point Comfort, adjacent to the site where the fort is being built. Originally intended to be used by men working on the fort's construction, the hostelry soon becomes a fancy resort. In an era of formal dress and manners, where bathing occurs indoors, summer vacations were enjoyed at hotels such as the Hygeia. Grand dining, ballroom dances, horseback rides, and walks in the sea breeze on the beach were typical, rather than informal swimming (then called "bathing") or beach games.

1873—Captain P.T. Woodfin assumes charge of Hampton's branch of the National Soldiers' Home. Founded as one of a series of apartment-like lodgings built to house disabled Union Civil War veterans, the Hampton or Southern Branch is the fourth to be built—and the first such home in the South. Initially only places to live, the homes eventually offer recreational activities, libraries, theaters, and billiard halls.

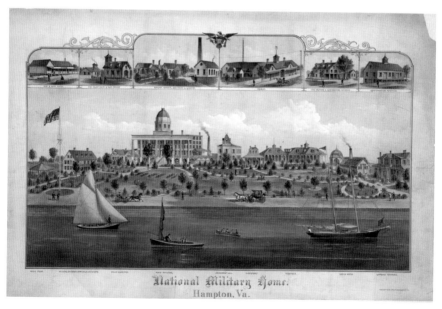

The National Soldiers' Home was originally established using the domed dormitory of the former Chesapeake Female College overlooking Hampton Roads. *Library of Congress.*

1881—A state charter is issued to the Bank of Hampton. Judge George Meredith Peek is the first cashier, while Henry Clay Whiting is the first president. The bank is at first located in the store of H.L. Schmelz & Company, but in 1885, it will be moved to its own building. In 1902, the bank will construct a large and impressive structure at the corner of King and Queen Streets, and in 1903, the Schmelz Brothers Bank will be consolidated into it. By 1909, Henry L. Schmelz is the president, and Nelson S. Groome is the cashier. Forced to close its doors during the "bank holiday" called in 1933 by President Franklin D. Roosevelt because of the Great Depression, it reopens quickly, merging with the First National Bank to become Citizens National Bank.

1950—The nation's only battleship in commission at the time, the USS *Missouri*, runs aground a mile and a half from Thimble Shoal Light, just off Old Point Comfort. It sticks hard and fast in the sand, and many locals make special trips to view the sight. A combination of tugboats, pontoons, and an incoming tide finally manage to free it on February 1.

1991—Having deployed to support the multinational response to Iraqi president Saddam Hussein's invasion of Kuwait, Langley's Twenty-Seventh and Seventy-First Tactical Fighter Squadrons enter combat from their base in Dhahran, Saudi Arabia.

JANUARY 18

1922—Watermen in Hampton oppose a ban on crab dredging in wintertime. There is a constant tension between the needs of watermen to make a living and the amount of stock necessary to reproduce the species sufficient to allow worthwhile future harvesting. Bans such as these are enacted to attempt to maintain a balance.

JANUARY 19

1942—The U.S. Navy continues laying its own mine field in the Chesapeake Bay near Fort Monroe and adjacent to an already existing army mine field. Despite an ability to make the mines "safe" when friendly ships are nearby,

and despite the existence of a narrow mine-free safe channel, several friendly ships will veer off course and strike the mines. A new field of controlled, reliable mines will be laid in February 1943.

JANUARY 20

1955—The 405th Fighter-Bomber Group from Langley Air Force Base deploys aircraft to take part in simulated atomic weapons delivery tests at a Nevada test site.

JANUARY 21

1780—In the grip of a cold winter, temperatures begin to plummet in the evening. The next day, six loaded wagons are able to cross the frozen James River, the first of three times that history has recorded Hampton Roads' harbor and the lower James River as being covered by solid ice. Heavy snows will accompany the freeze of January 1857, when Hampton postmaster Samuel Cumming would reportedly ice-skate to Norfolk to collect the mail. During the extreme cold spell of January 1918, a person will attempt to drive an automobile from Newport News to Norfolk across the icy expanse but will make it only about halfway before the car falls through. The driver reportedly saves himself.

JANUARY 22

1922—Hampton police announce that they have made sixty-three arrests in a crackdown on the illegal sale of alcohol during Prohibition. The Commonwealth of Virginia undertook to ban the sale of spirituous liquors in 1916. In 1900, the vacation resort towns of Hampton and Phoebus had twenty-three and fifty-two saloons, respectively, so alcohol sales were a big business. Even repeated actions, such as this mass arrest, rarely provide effective enforcement of Prohibition, and almost everyone breathes a sigh of relief when it is repealed in 1933.

2006—The sign for Sam's Seafood Restaurant of Phoebus is taken down. Samuel F. Haywood started the waterfront eatery in 1963, and although he passed away in December 1993, the popular restaurant continued in operation until severely damaged by Hurricane Isabel in September 2003. A subsequent fire completed the destruction.

JANUARY 23

1861—Having received orders the previous day, Captain Israel Vogdes and Company A, First U.S. Artillery, leave Fort Monroe with six field howitzers to reinforce the beleaguered Fort Sumter in Charleston Harbor, South Carolina. It will not be until April 20 that several companies from the Third and Fourth Massachusetts militia regiments arrive at Monroe with hundreds of reinforcements.

JANUARY 24

1828—The Hampton and Mill Creek Toll Bridge Company is granted permission to build toll bridges on routes served by ferries. On November 15, 1838, a deed from the company would convey its toll bridge across Mill Creek to Old Point Comfort, together with the right-of-way (or road) between that structure and the span across Hampton Creek, to the U.S. Army at Fort Monroe.

1925—U.S. Army Air Corps photographers based at Langley Field photograph a solar eclipse from the air.

1972—Continuing his comeback after an absence from boxing of four years because of a conviction for refusing to be inducted into the military, conscientious objector and former heavyweight champion Muhammad Ali toys with four different opponents before a crowd of 3,700 at the Hampton Coliseum. Ali would regain his heavyweight championship by knocking out George Foreman in Kinshasa, Zaire, on October 30, 1974, in the widely publicized "Rumble in the Jungle."

JANUARY 25

1780—A regimental hospital for United States armed forces engaged in the Revolutionary War is established at Hampton.

1893—The Phoebus Hook and Ladder Company No. 1 is organized. A fire station built the same year at a cost of $694 and named Fireman's Hall will stand for forty-five years on land donated by the Lancer family of Phoebus. The original building would be added onto several times, including a bell tower, horse stables, and hay lofts for the faithful animals used to pull the steamer engines then in use. In 1938, a new building will be constructed containing both the Phoebus town hall and the Phoebus Fire Department. In 1952, the name will be changed to the Phoebus Volunteer Fire Company.

1921—A thief steals the money box holding contributions made by Hampton schoolchildren for "starving Armenian children" from the lobby of the Bank of Hampton.

JANUARY 26

1982—The First Tactical Fighter Wing at Langley makes the first U.S. Air Force intercept by an F-15 "Eagle" of a Soviet TU-95 "Bear" aircraft flying off the East Coast of the United States.

JANUARY 27

1925—Hampton oystermen angrily claim that a nationwide scare about contaminated oysters is merely "yellow journalism"—that is, sensationalist lies.

JANUARY 28

1719—According to the log of the British Royal Navy vessel HMS *Pearl*, and consistent with archaeological evidence drawn from a waterside burial

excavated in Hampton in 1989, two captured members of Blackbeard's crew are convicted of piracy and hanged at Hampton this day. A plasticized replica of the bones found in the burial will be put on display at the Hampton History Museum. Sixteen more crew members are tried in March 1720 in Williamsburg for piracy on the high seas. Fourteen are convicted and hanged.

1942—Not long after Pearl Harbor and the entrance of the United States into World War II, the Langley Sub Depot at the airfield is activated to allow civilians to perform aircraft maintenance and parts manufacture, freeing military personnel for field duties. Originally comprising fifty-six men, the unit is soon forced by the exigencies of warfare to bring about the training of female mechanics.

JANUARY 29

1944—The U.S. government purchases the Hampton–Langley Field Railway, which was built in 1917 by a group of private individuals in Hampton led by Frank Darling and Harry H. Holt to connect the Langley Field air base to the Chesapeake and Ohio Railroad. Operating with two locomotives, the rail line hauls baggage, freight, and passengers between the base and Hampton. It will cease service in August 1961, its tracks later removed.

2015—The Pamunkey Indians, whose forefathers were the Powhatans who met the first English settlers when they arrived in 1607, are approved by the national Bureau of Indian Affairs to be the first federally recognized Indian tribe in Virginia. Long since moved away from Hampton (at first called Kecoughtan), many Pamunkeys live on a state-granted reservation on the Pamunkey River in King William County, Virginia.

JANUARY 30

1677—Governor William Berkeley travels from Jamestown to Hampton to discuss his actions in putting down Bacon's Rebellion with three commissioners sent from England by King Charles II "to enquire into

the present troubles." Berkeley gives them a list of those he has hanged, including twenty-three men executed after Bacon had died in October 1676 and the rebellion had clearly begun to wane. The commissioners demand his resignation. Berkeley refuses but soon capitulates, resigns, and journeys to England to explain himself. Death overtakes him before he can see the king.

1897—The grand opening of the Hampton Roads Golf and Country Club is held on its ten-acre site within the quadrangle formed by East Avenue, Kecoughtan Road, what is now Hampton Roads Avenue, and Chesapeake Avenue (the Boulevard), overlooking Hampton Roads. The nine-hole course hosts its first tournament six days later. Among its crack early golfers are James and John McMenamin, sons of Hampton's famous crabmeat entrepreneur. The course would close in 1920, as the owners of the land, who had been renting it to the golf club, wish to develop the area for housing. The Golf and Country Club board would purchase from the Chamberlin Hotel its eighteen-hole links, which is now the city of Hampton's Woodlands Golf Course.

1924—A delegation from Hampton urges the Virginia General Assembly not to regulate the rates charged by harbor pilots. The bars and shoals of Hampton Roads and the lower Chesapeake Bay are shifting and treacherous, so a great deal of knowledge and skill is required to bring a ship of any size into or out of port. Shippers are at the mercy of pilots, and regulation of pilotage fees is often a matter of political contention.

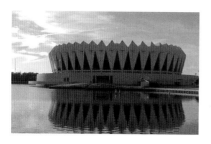

With a venue capacity configurable from 9,800 to 13,800 seats, the Hampton Coliseum was the first multipurpose arena in the Hampton Roads region. *City of Hampton.*

JANUARY 31

1970—The Hampton Coliseum opens with a performance by entertainer Jack Benny. Built on farmland by the city at a final cost of more than $8.5 million, the Coliseum is considered an architectural gem anchoring a large shopping area called Coliseum Central and hosts a variety of entertainment forms each year.

February

FEBRUARY 1

1832—The U.S. Army installation at Old Point Comfort receives its official name, "to be called Fort Monroe, and not Fortress Monroe." The official name is always Fort Monroe, but many people, because of the large size of the base and the wet moat, continue to refer to it as "Fortress Monroe."

1913—The Chesapeake Ferry Company, operating between Pine Beach in Norfolk and a pier at the end of what is now Manteo Avenue in Hampton, launches its newest ferry, the *Warwick*. It can carry autos and trucks as well as horse-drawn vehicles and makes fourteen fifteen-minute trips per day (with returns a half hour later) between six o'clock in the morning and ten o'clock at night.

1955—Fort Monroe is named the headquarters for the Continental Army Command (CONARC). With the reorganization of the army accomplished on July 1, 1973, the Training and Doctrine Command (TRADOC) will remain at Fort Monroe, while the Forces Command (FORSCOM) will be headquartered at Fort Belvoir, Virginia, near Washington. When Fort Monroe is slated for closure as an army base under the Base Realignment and Closure Commission (BRAC) in 2005, TRADOC will be shifted to nearby Fort Eustis, Virginia. The base at Fort Monroe will finally close in 2011.

FEBRUARY 2

1909—Hampton City Council adopts a resolution approving the construction of an automobile bridge from Queen Street to "Little Scotland," an area of the town that is rapidly undergoing development. "Little Scotland" was originally a plantation on Hampton Creek but became the site of Hampton Institute (now Hampton University) after the Civil War. The plantation's mansion would become the home of Hampton University's president. The bridge was rebuilt in 2017.

1917—The Aviation Experimental Station and Proving Grounds (later NACA, now NASA) establishes its first base of operations in a downtown office on the third floor of the Bank of Hampton. Only later will it move to an area on the west side of Langley Field, where it will design and test aircraft components and aircraft.

1943—The construction of Military Highway (now Mercury Boulevard) from Fort Monroe to the James River Bridge is completed by the U.S. Army as an escape route for military personnel. The route uses the railroad right-of-way over Mill Creek from Phoebus to Old Point, abandoned after the trestle suffered grave damage in the 1933 hurricane, and the remains of the trestle are used as the initial fill for a new bridge. Built against a good deal of local opposition, Mercury Boulevard will become the "main street" of Hampton.

FEBRUARY 3

1865—During what would prove to be the final months of the Civil War, a peace conference meets on the *River Queen* in the Chesapeake waters near Fort Monroe, its location and timing a poorly kept secret. President Abraham Lincoln and Secretary of State William H. Seward represent the Union, while Vice President Alexander H. Stephens, Judge John A. Campbell and Senator Robert M.T. Hunter represent the Confederacy. The conference fails, as Southerners demand independence.

FEBRUARY 4

1813—When the news of a British invasion fleet coming into the Chesapeake reaches Hampton Roads during the War of 1812, the pride of the American fleet, the frigate USS *Constellation*, lies grounded off Willoughby Spit opposite Old Point Comfort. Its men struggle desperately to free it, finally using a flooding tide to quit the exposed position. *Constellation* races into the Elizabeth River to safety, just ahead of the two seventy-four-gun ships of the line and three frigates in the British squadron. Gunboats from the Portsmouth Navy Yard close off the mouth of the river. The British ships take up their station at Lynnhaven Bay to form a blockade, although at times they reappear inside Hampton Roads. For two years, no tobacco, wheat, or cotton would move through Hampton Roads.

1933—The Women's Club of Phoebus continues its drive for public contributions to partially alleviate the burdens of widespread unemployment at the height of the Great Depression. As in most other American communities, the Great Depression is devastating for the lower Peninsula. Banks go under, jobs and cash are scarce, hobos proliferate, and the people hunker down. Only with the coming of World War II, and the economic boost the region's many military-related activities brought, did the Great Depression recede on the Peninsula.

FEBRUARY 5

1624—A current census shows that 349 English people reside in Elizabeth City County. It is becoming one of the most populous parts of the English settlement.

FEBRUARY 6

1935—The first Hampton One Design, a sailboat designed and made in Hampton by Vincent J. Serio, is purchased by Sydney Vincent, a naval architect who works at the Newport News Shipbuilding and Dry Dock Company. Vincent pilots his *Jasyto* to the national Hampton One

championship in 1936, while his sons, Syd Jr. and Jack, sail *Jasyto II* to similar championships each of the following three years.

FEBRUARY 7

1891—Answering the need for better firefighting equipment, and funded by the contributions of citizens who raise money at events such as local fairs, a horse-drawn steamer fire engine is shipped from the LaFrance Engine Company. Given the name "Volunteer," it is for several years the pride of Hampton's fire department.

FEBRUARY 8

1949—The Old Bay Line becomes the last steamship line docking at Fort Monroe. Having commenced in 1840 as the Baltimore Steam Packet Company, Bay Line visits to Hampton terminate late in 1961, and the wharf is demolished. The Old Bay Line will go out of business in 1962, having provided the last overnight steamship service in the United States.

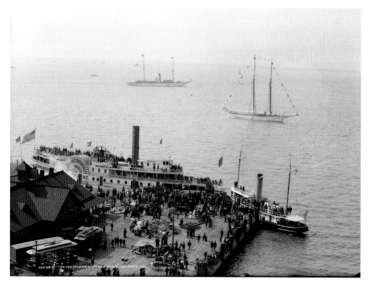

The Old Bay Line provided freight and passenger transport to Old Point, gaining acclaim for its genteel service and fine dining featuring Chesapeake Bay specialties. *Library of Congress.*

FEBRUARY 9

1918—A submarine chaser built at the Newcomb Lifeboat Company on Sunset Creek is commissioned by the U.S. Navy. The small boatyard is one of many that sprang up in the United States because of the great World War I need to combat the infamous and effective German submarines, the U-boats. Hampton, home to the Virginia Navy during the Revolution and having had an important ship construction industry in colonial times, also wishes to compete with the large successful shipyard in Newport News. The vision is that large dry docks can be built on the shallows of Hampton Bar, in Hampton Roads off the mouth of Hampton Creek (now River), but the dream remains a fantasy, never materializing. Five wooden-hulled sub-chasers are constructed in Hampton, but they prove vulnerable to fire, and the "splinter fleet" is disbanded late in 1918. Newcomb quickly goes out of business, being sold at auction in 1921. Only the street name Newcomb Avenue remains to memorialize this endeavor.

1921—Three officers and five enlisted men from Langley Field sail for Italy aboard the transport ship USS *Somme*. They will inspect, test-fly, and disassemble the Italian airship *Roma*, recently purchased by the U.S. Army and berthed in a huge, specially constructed hangar at the airfield. It will be the first large lighter-than-air ship to be flown by any members of the U.S. armed forces.

FEBRUARY 10

1936—Langley Field squadron commander Major Barney Giles, on maneuvers at Concord, New Hampshire, searches through the night for seven Civilian Conservation Corps workers stranded on an ice floe in the Atlantic. Finally sighting them, he alerts the Coast Guard, and the youths are rescued.

FEBRUARY 11

1929—After informally welcoming guests the previous year, the Chamberlin-Vanderbilt Hotel (built on the site of its fire-destroyed predecessor) has a spectacular grand opening at Old Point Comfort. A civic effort had been led by Frank W. Darling, John B. Kimberly, and Harry H. Holt to establish a successor for the huge, grand hotels that had made Hampton a tourist mecca in the 1880s and later. The three-hundred-room fireproof structure features many opulent comforts: indoor and outdoor swimming, tennis, golf, boating, fishing, horseback riding, seasonal waterfowl shooting via expeditions to the Eastern Shore, and therapeutic treatments. The menus focus on traditional Chesapeake Bay cuisine, including seafood, Smithfield ham, wild duck, and other local favorites. Its name is changed to the Chamberlin in 1930. The hotel welcomes its first corporate client, the Edison Illuminating Company, for its annual meeting, and each stockholder receives a souvenir paperweight fashioned from metal recovered from the wreckage of the Civil War ironclad CSS *Virginia* (*Merrimack*). However, with the Great Depression commencing in the fall of 1929 and the general decline of grand resort visitation, tourism at the posh hotel never fully covers expenses.

1960—A group of Hampton Institute (now Hampton University) students stage the first civil rights lunch counter sit-in in Virginia at Hampton's F.W. Woolworth department store on Queen Street. The demonstrations continue through the week, and sit-ins occur at several other Hampton stores, none of which would serve African Americans.

FEBRUARY 12

1634—Benjamin Syms's will leaves two hundred acres and the increase from eight cows to pay "an honest Learned Man" to hold "a free school" on the site for the children of the parishes of Elizabeth City and Poquoson River (in southern York County). Part of the increase in cattle is to be sold to erect and maintain a schoolhouse. It would become the first free school in English North America.

1721—Henry Irwin, customs collector at Hampton, is held accountable to the British Crown for "misplaced" pirate booty.

1910—The Riverview Volunteer Fire Department is organized in the populous Riverview neighborhood north of Kecoughtan Road, stretching from Shell Road to Bay Avenue. Mr. and Mrs. W.G. Fraley donate a lot for its use. Members and friends of the Fire Department give their time and resources to build a one-story frame structure. By 1915, the Department would own one of the first motorized pieces of fire equipment in Virginia. Early in 1923, it will be merged with the Wythe Fire Department to become the Wythe District Fire Department, using the Kecoughtan Road station of the Wythe Fire Department and the large fire trucks of Riverview.

1916—With his new bride, Edith Bolling Wilson, President Woodrow Wilson makes one of several visits to Fort Monroe this year. The marital couple strolls around the post unescorted for two hours, at Wilson's request. The stress of the presidential office was greatly increased by the First World War, then raging in Europe, and by the demands of various nations and various interest groups in the United States to join one or the other side or to maintain neutrality. While he showed "much interest in the big defense guns" (as the *Newport News Daily Press* reported), the president delights in the peacefulness and the views offered by the historic walled fort.

FEBRUARY 13

1662—The death of Elizabeth, Queen of Bohemia, Electress of the Palatinate and daughter of James I of England and his wife, Anne of Denmark, becomes known. When the English settled Jamestown in 1607 and seized Kecoughtan (later Hampton) in 1609, she was a young English princess; Elizabeth City County was named for her (as was the Elizabeth River in Norfolk). Capes Henry and Charles, as well as Forts Henry and Charles, built in 1609 to guard the settlement at Kecoughtan, and Henrico County and Charles City County, were named for her brothers.

1902—A half-day holiday marks the opening of Hampton's new public school, the Syms-Eaton Academy, named for the two seventeenth-century benefactors who left property to support public education in Elizabeth City County. Howard Bonneville is the first principal, and thousands of people come to inspect the building and, later, to attend a large parade.

2013—The death of William T. "Sonny" Randall, aged ninety-seven, who was born in Phoebus, is reported. He played professional baseball for the Homestead Grays of Washington, D.C., in the Negro National League during the segregation era, when African Americans were not allowed in the white professional leagues.

FEBRUARY 14

1938—The Hampton Institute men's chorus, "The Crusaders," has its second rehearsal. The school's singing groups gained renown when, in the 1870s, they helped to persuade Northerners to fund the college. Robert N. Dett joined the faculty in 1913, and under his direction, several of its singing ensembles were featured in concerts and tours that attracted national and international attention. Notable were a 1926 concert in the chamber auditorium of the Library of Congress and a European tour of 1930 that visited seven countries. Although Dett retired in 1931, "The Crusaders" and other choral groups kept up his standards, and Hampton University is still proud of its talented choruses.

FEBRUARY 15

1827—Three laundresses, wives of or residing with soldiers at Fort Monroe, are convicted of secreting eight gallons of liquor in the woods nearby in order to sell it to soldiers "clandestinely." They are sentenced to have their heads shaved and are excluded permanently from the post.

1869—By the federal prosecutor's dismissal of the charge of treason against former Confederate President Jefferson Davis, the general amnesty proclaimed by President Andrew Johnson on December 25, 1868, is held to cover him. This ends the years of uncertainty Davis had to endure. His two years of imprisonment at Fort Monroe had been terminated when northerners (including abolitionists) posted $100,000 in bail on May 13, 1867, but the treason indictment still hangs over his head. The Fourteenth Amendment on July 9, 1868, deprived Davis of U.S. citizenship, but it will be restored posthumously by vote of Congress in 1978.

1934—J. Thomas Cain of Fox Hill, said to be the last native-born survivor of the Confederate army in Elizabeth City County, celebrates his ninety-fourth birthday. He served for the entire war with the Old Dominion Dragoons, a cavalry unit raised in the county. After the war, he was a farmer and a fisherman and was, at times, overseer of roads in one of the county's two districts.

1938—Lieutenant Colonel Robert Olds commands a flight of six B-17s taking off from Langley Field on a goodwill flight to Buenos Aires, Argentina, for the inauguration of President-elect Roberto M. Ortiz. Returning twelve days later via Santiago, Chile, Lima, Peru, and Panama City, Panama, they are greeted by Langley personnel and saluted by the band from Fort Monroe.

FEBRUARY 16

1942—During World War II, the privately owned, American-flagged tanker *E.H. Blum* is accidentally sunk by a minefield laid near the entrance to the Chesapeake Bay opposite Fort Monroe. The mines were to deter invasion by enemy shipping.

FEBRUARY 17

1958—Auto ferry service across the Chesapeake Bay is underway, using the *M.V. Old Point Comfort* on a route between Kiptopeke on Virginia's Eastern Shore and Old Point Comfort. The 305-foot vessel began life as an LST ("Landing Ship Tank") in 1945 during wartime before being converted to civilian vehicle transport at the Newport News Shipyard in 1957. Ferry travelers pay $3.00 per vehicle and $0.85 per passenger and enjoy a full restaurant on board. The service would end in 1960 due to poor traffic volume.

FEBRUARY 18

1921—The first of two seaplane hangars designed by Albert Kahn, the foremost industrial architect of the day, is completed at Langley Field. The second is never erected. Smaller in scale and less ornate than Kahn's design specified, the hangar marks the termination of the rich architectural heritage embodied in Langley's original building program.

FEBRUARY 19

1957—Ground is broken for the construction of a new Dixie Hospital (later called Hampton General Hospital) on Victoria Boulevard.

FEBRUARY 20

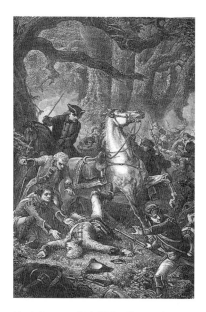

Mortally wounded, Major General Braddock dies during the British retreat after specifically requesting George Washington to oversee his burial. *Wikimedia Commons.*

1755—British Major General Edward Braddock and many of his troops arrive at the busy port of Hampton, en route to disembarking at Alexandria, Virginia, and marching overland to fight the French near present-day Pittsburgh during the French and Indian War. Braddock is fatally wounded in the battle on July 9 and is carried off the field by his aide-de-camp, a young George Washington. Braddock gives Washington his ornate sash, which the American always treasures.

1822—William H. Hawkins, first manager of the Hygeia Hotel at Old Point Comfort, welcomes its first notable guest, Kentuckian and Speaker of the House of Representatives Henry Clay, en route with others to Baltimore on the

steamer *Norfolk*. They had been forced to land due to a snowstorm. It is said that Clay and his companions were not worried about the storm but they did not want to interrupt their card game.

1962—John Glenn, one of the original seven Mercury astronauts who trained at NASA in Hampton, is the first American to achieve earth orbit, circling the earth three times aboard *Friendship* 7 in a flight of four hours, fifty-five minutes and twenty-three seconds following his launch by an Atlas rocket. The popular and accomplished Glenn is eventually elected U.S. senator from Ohio.

FEBRUARY 21

1922—On a cold and overcast day, the airship *Roma*, acquired by the U.S. Army from Italy after World War I, flies over Hampton, Willoughby Spit, and the Norfolk Naval Air Station but crashes in Norfolk when jammed controls force its descent; just before hitting the ground, its hydrogen gas is ignited by striking a high-tension electric wire. The ship explodes and burns, with thirty-four of its forty-five crew members killed. It is the worst U.S. air disaster up to that time.

Following the crash of the *Roma*, hydrogen-filled airships were no longer used by the military, as subsequent ships were inflated with helium. *Wikimedia Commons.*

FEBRUARY 22

1909—President Theodore Roosevelt reviews the return to Hampton Roads of the sixteen battleships, various escort ships, and their fourteen thousand sailors comprising the Great White Fleet, after its fourteen-month 'round-the-globe voyage covering forty-three thousand miles and making twenty port calls on six continents.

FEBRUARY 23

1728—The Virginia House of Burgesses decides to investigate the condition of the fortifications at Old Point Comfort. A committee reports that there is much deterioration of the old Fort Algernourne and recommends the construction of a new battery of "twelve of the best guns." The House votes aye, and soon Fort George will appear, with two brick walls twenty-seven and sixteen inches thick, respectively, and having the sixteen-foot space between the barriers filled with sand. The new construction would be destroyed by a hurricane in 1749, and Fort George in its turn would be replaced seven decades later by the massive Fort Monroe.

1973—Hampton City Schools are noted to be in compliance with the Civil Rights Act of 1964. Unlike many communities that desegregated only under court order, Hampton achieved compliance grudgingly but voluntarily.

FEBRUARY 24

1634—Leonard Calvert, the first governor of the new English colony of Maryland, and his ships *Ark* and *Dove*, with three hundred settlers, arrive off Point Comfort after a voyage from England of three months' duration. They rest ashore and explore the area for a month before sailing up the Chesapeake and into the Potomac River. They begin establishing a settlement on March 27 at what is now St. Mary's City, just north of the Potomac.

1888—J.S. Darling organizes the Hampton and Old Point Railway Company, a trolley line. Other lines are built on the lower Peninsula, largely

as a means of transporting Hampton-dwelling workers to their jobs at the Newport News Shipbuilding and Dry Dock Company. Eventually, after a complicated series of mergers, a single trolley company will emerge. New neighborhoods will grow up along the streetcar tracks.

1905—The "Frogs" social club celebrates its first anniversary with a dance at the Pythian Castle. The Progressive era, lasting roughly from the 1890s until U.S. entry into World War I in 1917, is a time of increased civic responsibility and interest. Many types of social organizations spring up, such as collegiate fraternities and sororities, civic groups (such as the Knights of Pythias), and fraternal/sororal social clubs (such as the "Frogs"). The Pythian Castle, built four stories tall in 1889 and fronting on Queen Street, and the Masonic Temple, three stories high and erected farther along Queen Street in 1888, are typical structures for such groups. The Castle has a large third-floor auditorium that served many Hamptonians as a meeting hall and was the locale for the first movies shown in town. Urban renewal will force the Castle's demolition in the 1970s, while the Masonic Temple building still stands.

FEBRUARY 25

1886—Entrepreneur Harrison Phoebus, the proprietor of the famous Old Point Comfort resort Hotel Hygeia, dies unexpectedly at age forty-five of heart disease. Phoebus had been instrumental in obtaining an extension of the Chesapeake and Ohio railroad tracks to Chesapeake City (later renamed Phoebus in his honor) in 1882, as well as to Old Point Comfort, completed in 1890 after his death.

1909—Sightseers fill special trolleys and special trains bring gawkers from Richmond to see the large whale caught in Taylor Dixon's offshore fishing nets at Buckroe Beach. The dead animal is eventually hauled on shore by ropes attached to a streetcar. Sailors from the battleship USS *Ohio* say that their vessel had struck the whale as it entered Hampton Roads. Dixon soon sells the whale meat and blubber.

1946—As the U.S. government no longer needs the space for wartime billets, Newport News businessman Lloyd U. Nolan purchases the Chamberlin

Hotel and reopens it. He sells it to Richmond Hotels on December 31, 1947. Becoming economically unviable after the attack on September 11, 2001, the once-grand resort hotel will close soon after. It later is renovated and revived as a retirement home.

1994—Police officer Kenneth Wallace is shot and killed while sitting in his patrol car near the Wythe Shopping Center when four men mistake him for another officer. One of the assailants is executed for the murder, while the others are given long prison terms.

FEBRUARY 26

1759—St. Tammany Lodge No. 5 of the Masons is organized in Hampton, becoming the fifth-oldest masonic lodge in Virginia. Masonry in Hampton can trace its roots back to Scottish records, as in 1756 the Grand Lodge of Scotland issued a warrant for a writ in Hampton in the colony of Virginia. The lodge still possesses the Bible given by a Captain Rogers in 1787 along with a complete set of solid silver jewels thought to have been used at the foundation of the lodge.

FEBRUARY 27

1941—To accommodate increases in weight and landing speed of aircraft, Langley Field engineers complete a runway network expansion including taxiways, parking areas, and drainage facilities. The runways and approach surfaces are paved with six inches of concrete.

FEBRUARY 28

1920—The Air Service Field Officers' School operates at Langley Field as the War Department's official training course. Later moved to Montgomery, Alabama, it would evolve into the U.S. Air University by 1946.

FEBRUARY 29

1916—James C. Wallace served as the first postmaster of the Rip Raps Post Office in Fox Hill, appointed in 1892. The office closes on this date. The name reflects an older appellation for Fox Hill.

March

MARCH 1

1935—Langley Field becomes the center of all combat aviation for the U.S. Army with the Department of War's creation of General Headquarters Air Force, bringing together all army air combat units under the single command of Brigadier General Frank M. Andrews, who would introduce sweeping changes in the organization, training, deployment, and equipping of flying squadrons. It proves to be the first step toward the creation of an autonomous air arm within the U.S. Army, the Army Air Corps. Andrews, by this time a lieutenant general commanding all U.S. forces in the European Theater during World War II, would perish in the crash of a B-24 in Iceland on May 3, 1943. Joint Base Andrews in Washington, D.C., is named for him.

Clark Gable and Myrna Loy are shown with a Langley aircraft in the 1938 Oscar-nominated movie *Test Pilot*. Filming took place at the airfield. *Hampton History Museum.*

1937—With the advent of long-range aircraft, Brigadier General Frank M. Andrews brings the first B-17 bomber to Langley from Seattle. It is assigned to the

Second Bombardment Group, the initial tactical unit to possess the "Flying Fortress." The bomber proves to be very useful in Allied attacks in World War II, both in Europe and in the Pacific.

1942—To prevent German U-boat attacks during World War II, an anti-motor torpedo net is installed, stretching from Fort Monroe on the north to Willoughby Spit on the south, with a gate for the main channel entrance to Hampton Roads. Specially built vessels with cranes are used to position the net.

MARCH 2

1646—Still angry over the 1644 Indian attempt to wipe out the colony, Virginia's General Assembly authorizes a force of sixty militia to track down the great Indian adversary Opechancanough, organizer of the attack and leader of the powerful Algonquin group named the Powhatans after his deceased brother. The militia is given orders either to kill him or to force him to terms. The expedition gathers at Elizabeth City (now Hampton), sails up the York River, and enters the forest. The Pamunkey Indians flee, carrying Opechancanough on a litter, but the very elderly leader is soon captured without a fight. Two weeks after he is brought to Jamestown, he is murdered by a shot through his back made by a soldier angered at Opechancanough's success in killing Englishmen and at keeping the colony in mortal terror. In October, as a result, the Powhatan Indian confederation and their associated tribes surrender and sign a treaty that breaks up the alliance, makes the Powhatans subjects and allies of the English Crown, and cedes the Peninsula (containing Jamestown and Elizabeth City) and the south side of the James River to England.

1755—Two ships carrying two hundred British troops make port in Hampton, delayed by weather in their Atlantic passage. They soon join Major General Edward Braddock, who had arrived two weeks earlier, for his expedition against the French coming down from Canada to do battle in what is now Western Pennsylvania. Five British deserters are caught and whipped in view of the townspeople. The ships then embark to meet Braddock at Alexandria, Virginia.

MARCH 3

1865—The U.S. War Department establishes a "Freedmen's Bureau," with a regional headquarters office at Fort Monroe headed by Brigadier General Samuel Chapman Armstrong. The bureau is to provide food, shelter, medical care, and education to the large population of contrabands, other former slaves, and members of free black communities near the fort. More than ten thousand blacks escaped slavery and settled within Elizabeth City, Warwick, and York Counties, as well as others nearby.

1887—John Chamberlin, a restaurateur who is running a dining establishment at the House of Representatives in Washington, receives authorization to build a resort hotel at Old Point Comfort. Architect John Smith Meyer, who had designed the Library of Congress, is hired to draw up the plans. Construction breaks ground in 1890, and the first Chamberlin Hotel is completed in 1896, after several funding-related work delays.

1891—Federal permission is granted to extend the trolley tracks of the Hampton and Old Point Railway Company onto the base at Fort Monroe. This would provide greater ease of transporting goods and people to Old Point over a broad water gap.

1895—Matthew B. Ridgway is born at Fort Monroe, the son of Ruth and Colonel Thomas Ridgway. A graduate of West Point, Ridgway will rise in rank until he becomes major general in August 1942. Important in the planning of the Allied invasions of Italy and Normandy in World War II, Lieutenant General Ridgway and his aggressive tactics would later turn around a deteriorating situation in the Korean War and lead to Allied victory. Winning his fourth star when President Truman relieves General Douglas MacArthur of command in 1951, Ridgway will command all Allied forces in Korea until he becomes Supreme Allied Commander in Europe in 1952,

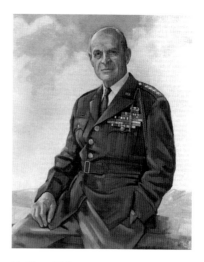

Matthew Ridgway would be awarded the Presidential Medal of Freedom in 1986 by President Ronald Reagan. *Library of Congress.*

succeeding General Dwight D. Eisenhower. He will serve as chief of staff for the U.S. Army during 1953–55, until he retires following disputes with President Eisenhower. Hampton's Ridgway Park honors him.

MARCH 4

1889—Hampton's black community leaders—including A.W.E. Bassette, Isaac Johnson, and Reverend Richard Spiller, pastor of the First Baptist Church—found the People's Building and Loan Association, located at the corner of North King Street and Lincoln Street. As the era of segregation renders it very difficult for black citizens to obtain loans from white-run banks, this black-run lending institution makes it possible for hundreds of African Americans to realize the American dream of owning their own piece of land. Many homes and businesses receive financing over the years, and it becomes for a time the largest savings and loan in Virginia before it declines, enters receivership, and is merged into Consolidated Bank and Trust Company in 1990. Later it is called Premier Bank.

1892—The Virginia General Assembly grants a charter for the Hampton Training School for Nurses at Hampton Institute (now Hampton University), one of the first American training schools for black nurses. Eventually, it becomes Hampton General Hospital.

MARCH 5

1623—The General Assembly orders that court be held each month in Kecoughtan (now Hampton). Much of the law for colonial Virginia is written in England, thousands of miles away. People in America have to interpret and apply laws to match local conditions. Initially weak, by the mid-eighteenth century local justice of the peace courts are seen as irreplaceable parts of their communities and have become quite powerful.

MARCH 6

1632—Virginia settlers inform the Virginia Company in London that the project of constructing "the fort at Old Point Comfort" is complete. The project consumed 80 percent of the colony's military budget for the year. The installation mounted fourteen small guns. The cost of maintaining a garrison of seven men there is very high, and by 1640 so many repairs are needed that a tax is enacted to construct yet another fort and garrison house. It, too, soon falls into ruin.

1830—The reconstructed and repaired St. John's Church in Hampton is consecrated by Right Reverend Richard Channing Moore, Episcopal bishop of Virginia. Bishop Moore was greatly significant in reviving his denomination in the Commonwealth, as there were only nineteen Episcopal churches that had settled ministers in all of Virginia at the time Moore became bishop in 1814. He traveled throughout the huge state to bless new churches, ordain ministers, and confirm new communicants, including twenty-two in Hampton in 1827. The parish minister at the time of consecration was Reverend Mark L. Chevers, who also became chaplain at Fort Monroe and would oversee the building of the Chapel of the Centurion there in 1858.

1956—Paul and Edith Smith open Smitty's Better Burger on North King Street in Hampton. It is an old-fashioned drive-in where a carhop takes your order and can make change on the spot when she brings the food to your car. The popular eatery would be owned and run by the Smith family for decades to come.

1962—The "Ash Wednesday Storm" begins with high winds and flooding. The three-day nor'easter produces water levels up to 8.5 feet above normal in parts of Hampton. An estimated $4 million in wind and flood damage occurs in the city.

1985—Ground is broken for construction of the new main branch of the Hampton Public Library on Victoria Boulevard.

MARCH 7

1920—A devastating fire caused by defective wiring breaks out on the third floor of the first Hotel Chamberlin. The building is not fireproof, and the blaze quickly grows out of control, its leaping flames visible for miles. The structure burns to the ground, resulting in $4 million in damages, while an estimated crowd of 20,000 watches. Fortunately, no lives are lost, but Adams Express, John Kimberley's general store, and two Fort Monroe military classrooms are also destroyed. Many of the hotel's 1,400 guests are taken in temporarily by nearby army families.

MARCH 8

1781—A British foraging party of three to four hundred troops under Colonel Thomas Dundas, part of the American turncoat Benedict Arnold's invading force, engages Colonel Francis Mallory and Colonel William Roscoe Wilson Curle, commanding forty militia, in the last skirmish to occur near Hampton during the American Revolution. Perhaps in revenge for his brother Edward's victory over another foraging party in January, the Americans are completely routed and Mallory is killed, along with his nephew Henry King. Both are buried in the same grave, close by the home of George Wythe. Sixteen other militiamen also perish, while Curle is among the eleven captured. One British officer is slain, with several soldiers being wounded.

1862—The Confederate ironclad CSS *Virginia* (*Merrimack*) emerges from the Elizabeth River into Hampton Roads and, under heavy fire that causes no damage whatsoever, proceeds to sink the USS *Congress* and the USS *Cumberland* in extremely short order, forcing other Union ships to run aground or find shelter near Fort Monroe. *Virginia* suffers neither casualties nor harm, and Union officials are in despair, as *Virginia* is clearly superior to any wooden-hulled vessel. As *Virginia* retires back to the Elizabeth River that evening, a Union ironclad, USS *Monitor*, arrives at Fort Monroe.

MARCH 9

1862—When the CSS *Virginia* (*Merrimack*) reenters Hampton Roads for a second day of conflict, it is immediately engaged in battle by the USS *Monitor*. While the furious four-hour clash is inconclusive, with neither ironclad warship suffering any real damage, the event marked the end of wooden fighting ships, changing naval warfare forever. The *Monitor* plus the Union guns at Forts Monroe and Wool bottle the *Virginia* up inside Hampton Roads, keeping it from destroying more Union shipping in the Chesapeake.

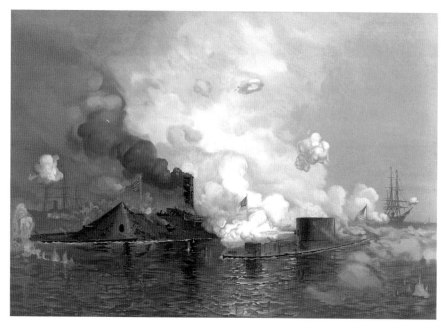

The first fight between ironclad warships is represented in this chromolithograph by Louis Prang & Company, Boston. *Library of Congress.*

MARCH 10

1606—The charter, or royal grant, from the king for the Virginia Company is signed by King James I, permitting it to establish a settlement in a portion of the New World anywhere from Cape Fear to Long Island Sound. It is not until May 14, 1607, that Jamestown is located on the James River. The second settlement is at Hampton, formerly the Indian town of Kecoughtan, from which the natives are driven in July 1610 in order for English colonists

to have the place. The king revokes the company's charter in 1624 and reestablishes Virginia as a royal colony.

1840—The Baltimore Steam Packet Company initiates steamship service to Old Point Comfort. Over the years, other lines—many of them serving cities such as Norfolk, Washington, Philadelphia, and New York—add Old Point in Hampton as a port of call.

1913—Harriet Tubman, American abolitionist and humanitarian known as the "Black Moses," dies of pneumonia. Famous for escaping from slavery, for risking her life and freedom by traveling back to the South to aid the escapes of more than three hundred slaves, and for leading Federal troops in South Carolina on an armed raid on June 2, 1863, that freed seven hundred slaves, Tubman from March through July 1865 was the matron or chief nurse for African American troops in the Union army's giant hospitals near Fort Monroe and Hampton. Afterward, on her train ride home to Auburn, New York, she refused the conductor's order to move into the smoking car with other "Negros" and had her arm broken in the ensuing melee. Upon her death, Tubman would be buried with military honors at Auburn's Fort Hill Cemetery.

1915—The Imperial German warship *Prinz Eitel Friedrich*, a recently converted passenger liner, passes Old Point Comfort into Hampton Roads early in World War I, before the United States had become a combatant. The British are very angry and threaten to invade the supposedly neutral waters of Chesapeake Bay in pursuit. In an eventual compromise, on April 7, the *Prinz Eitel* is "interned," or passed into U.S. custody. Seized when the United States entered the war in April 1917 and converted into a troopship, the proud *Prinz Eitel* would never fight again and ends service as a passenger liner in 1927.

MARCH 11

1911—Units from Fort Monroe are among the troops President William Howard Taft sends to Texas to defend the United States border with Mexico during the widespread unrest marking the beginnings of the Mexican Revolution.

1917—Hampton's Battery D returns from service in the Mexican Punitive Expedition, where it had been under the command of Major General John J. Pershing. The United States is retaliating against the populist bandit Pancho Villa's raid on Columbus, New Mexico, when several soldiers and civilians were killed and the town burned on March 9, 1916. While Villa's forces are effectively destabilized during the expedition's eleven-month stay in Northern Mexico, Pershing's troops never capture him. Most of the U.S. National Guard troops are stationed along the border while army regulars do the fighting.

MARCH 12

1899—Phoebus entrepreneur and newspaperman James M. Cumming, son-in-law of J.S. Darling, publishes the weekly *Phoebus Sentinel*, which sells for three cents per copy, one cent of which goes to the newsboy. Cumming, once apprenticed to a printer in Baltimore, came to Hampton when his health failed in 1888. In 1901, Cumming will move into real estate and insurance, and L.M. Brown will become the *Sentinel's* publisher. A founder of the Bank of Phoebus and a mover of Phoebus's incorporation as a town in 1899, Cumming will sell his insurance business in 1907 just before the panic of that year destroys his other businesses, leaving him in realty alone. He also serves as a member of the Hampton City Council.

MARCH 13

1993—Hampton celebrates its receipt of the City of Vision Award from the International Making Cities Livable Council for its outstanding downtown revitalization efforts led by local media entrepreneur Thomas P. Chisman, who is a member of the Hampton Redevelopment and Housing Authority.

MARCH 14

1944—The Hampton Fire Department is happy that the town council accepted its proposal for a new engine house. At the time, Hampton had only four fire stations: in Phoebus (founded 1893), Fox Hill (1922), downtown Hampton (1884), and Wythe (1909). By 2018, there would be eleven stations throughout the city.

MARCH 15

1895—W.T. Patrick opens a general store near the corner of West Queen Street and Back River Road in Hampton. With several grocery stores nearby, the company soon begins to specialize in hardware and glass. Third-generation Cary Patrick II would run W.T. Patrick & Sons for decades in the same location. Two fourth-generation Patricks, Ryan and Cary III, have joined him.

1967—First Lieutenant Ruppert L. Sargent, a graduate of Phenix High School who had two years of study at Hampton Institute (now Hampton University), dies in Vietnam when he throws his body over two grenades hurled by a Viet Cong soldier. He saves the lives of two comrades, and in 1968, he is posthumously awarded the Congressional Medal of Honor, the first recipient of the nation's highest military decoration for valor to be born and reared in Hampton. A downtown public office building is named for him.

MARCH 16

1895—Telephone service begins in Hampton. As with automobiles, this modern invention is initially quite costly, and its use spreads slowly. Numbers with more than four digits arrive only after World War II, and the widespread use of joint or "party" lines is discontinued only thereafter.

MARCH 17

1962—In a show of local pride and enthusiasm for the success of NASA's Project Mercury space program, a huge parade is held, and Hampton renames one of its main thoroughfares Mercury Boulevard to honor the original seven U.S. astronauts. Thirty thousand people cheer as the motorcade winds twenty-five miles through the flag-bedecked streets of Hampton from Langley Air Force Base to Darling Memorial Stadium. In September 1961, NASA had announced the relocation of its Space Task Group to Houston, Texas, and the move had been underway for months; it would be completed by the end of June 1962. Aeronautical research continues at Langley's NASA laboratories.

MARCH 18

1910—Jacob Heffelfinger discovers the location of the second site of St. John's Church, near Hampton Institute (now Hampton University). From 1968 to 1973, the site would be excavated by an archaeology team of St. John's parishioners skillfully led by scientist and housewife Eleanor S. Holt. The backfilled area is now surrounded by a brick wall and contains marked graves.

MARCH 19

1862—Many Southern whites begin to protest the previous day's renaming of Fort Calhoun as Fort Wool. Heavily burdened by the Civil War, President Lincoln did not want a Federal fort to honor the name of the famous South Carolinian John C. Calhoun because of his advocacy of secession. Brigadier General John E. Wool is the most senior officer in Federal service except for General-in-Chief Winfield Scott and is commandant at Fort Monroe. He is promoted to Major General on May 17.

MARCH 20

1629—Eight court commissioners are appointed for Elizabeth City (today, Hampton). The commissioners, later known as justices of the peace, meet monthly to issue marriage licenses and tavern and ordinary licenses; they also deal with runaway slaves, land patents, indentured servants, commodity prices, Indian affairs, the militia, and the supply of gunpowder.

1638—Major Richard Moryson is appointed commander of "the fort at Old Point Comfort," which had been constructed in 1632. Since the point commands the entrance into the port and harbor of Hampton Roads at the mouth of the James River, its strategic significance had been recognized by Captain John Smith. The first fortification there, probably a stockade of wood, is Fort Algernourne (1609–12), while later ones include Fort George (built 1728, destroyed by a fierce hurricane in 1749) and Fort Monroe (1822).

1775—The delegates elected from Hampton and Elizabeth City County to Virginia's second revolutionary convention are Worlich Westwood and Henry King. Patrick Henry delivers his "Give Me Liberty, or Give Me Death" oration, and a Committee of Defense is named. The same men are also elected to attend the third convention, commencing on July 17, 1775. It is the state's governing body because the last British governor, Lord Dunmore, took refuge aboard a British warship on June 8, and it elects a statewide Committee of Safety to run governmental affairs on a day-to-day basis. Westwood and King also attend the fourth convention, which meets on December 1, 1775, in Williamsburg, unlike the previous conventions, which had met in Richmond.

1862—The Commission of Investigation established at Fort Monroe to inquire into alleged ill treatment of contrabands (refugees from slavery) finds in favor of the contrabands. Wage payments by the quartermaster are $10,000 in arrears, food and clothing rations are inadequate, and the quartermaster is found to have taken and sold much of the clothing and rations for his own profit.

MARCH 21

1781—Governor Thomas Jefferson receives word from Commodore James Barron of the Virginia Navy that a British frigate, a part of the fleet sent from New York City under Vice-Admiral Mariot Arbuthnot to aid the invading army of the American turncoat Benedict Arnold, has joined the several vessels of Arnold already stationed in Hampton Roads. The remainder of Arbuthnot's ships are at Lynnhaven Bay.

1849—Seventeen-year-old Alexander Breckinridge Heiskell is aboard the *Marianna*, anchored off Fort Monroe, awaiting passage into the Atlantic. From Augusta County, he is one of 117 men, mostly Virginians, who pay $300 each to join a joint stock company whose purpose is to sail to San Francisco and engage in gold prospecting—the great '49 Gold Rush is on. The money is used to purchase the vessel and two years' provisions, and they embark from Richmond. Heiskell keeps a diary of the rough, stormy, often provision-deprived six months' voyage around Cape Horn, the ship landing at only three harbors en route before reaching its destination. Heiskell contracts a fever on board and dies shortly after San Francisco is reached.

MARCH 22

1622—Opechancanough, a brother and successor to Powhatan, and his Indian forces make the first organized and widespread massacre of the English in Virginia. During a series of well-coordinated attacks along both shores of the James River extending from Newport News Point, near the mouth of the river, up to what is now the city of Richmond, near the head of navigation, approximately one-third of the settlers are killed. Hampton (then called Kecoughtan) is not assaulted, and the village becomes a place of refuge for many English

Opechancanough was paramount chief of the Powhatan Confederacy. His name meant "He Whose Soul Is White" in the Algonquian Powhatan language. *Library of Congress.*

settlers, probably a significant spur to its future development after the uprising is extinguished. By 1625, the town is the most densely populated portion of Virginia.

MARCH 23

1788—John Dunlap asks the government of Virginia to be repaid for printing presses he bought in 1780 at the request of Virginia's delegates in Congress that were captured by the British at Hampton when they were on their way up the James River to Richmond.

MARCH 24

1861—The fifteen-inch "Lincoln Gun" is mounted on Fort Monroe's ramparts. Firing 437-pound projectiles or 330-pound explosive ones, the largest artillery weapon in the world at the time has a range of up to four miles. It is fifteen feet, ten inches long and four feet in diameter. More than five hundred test rounds are fired on this day, the longest traveling an estimated three miles.

1979—Dr. William R. Harvey is inaugurated as Hampton University's twelfth president. His tenure marks a golden age in the school's history, and Harvey becomes one of Hampton's leading citizens.

MARCH 25

1952—Two F-84G "Thunderjets" from the Twentieth Fighter-Bomber Wing make a nonstop, 4,775-mile flight from Langley Air Force Base to Edwards Air Force Base, California, and back. Flying at high altitude and at speeds up to Mach 1 (the speed of sound), they are refueled in midair by tanker planes for the eleven-hour, seventeen-minute round trip.

MARCH 26

1781—After the inconclusive Battle of Cape Henry on March 16 between French ships under the command of Admiral Charles Sochet, Chevalier Destouches, and a British fleet commanded by Vice-Admiral Mariot Arbuthnot, Arbuthnot's ships ride at anchor in Hampton Roads. They unload two thousand men to reinforce the American turncoat Benedict Arnold, now a general in the British army occupying Portsmouth. Arnold's forces had recently devastated Richmond and rampaged through Virginia. Arbuthnot soon returns to station at New York City.

MARCH 27

1733—Thomas Jones serves as the appointed constable for Fox Hill and Harris Creek. A constable was appointed by the county court for each precinct. He would perform some executive functions, such as implementing court orders and legislative decrees, watching over taverns and restaurants, ensuring the sufficient planting of corn, and arresting those he thought guilty of riotous or disorderly conduct. A constable could lead the "hue and cry" to find escaped slaves and absconded accused felons or murderers.

1821—The will of Hampton's Samuel Parsons has awarded half of his estate to his daughter Mary (child of his slave Phyllis), whose freedom he requests of his legatee, Henry Tabb, to petition the Virginia General Assembly.

MARCH 28

1908—Hampton reaches a population of more than five thousand and will be designated as a "City of the Second Class." Virginia has three classes of incorporated cities, based on the population. Cities of the first class must have more than ten thousand people. Cities of each class are, uniquely in the nation, functionally and governmentally separate from the counties that contain them.

MARCH 29

1881—Former President Ulysses S. Grant is enjoying a vacation at the Hygeia Hotel. The popular Grant had spent two and a half years on an around-the-world tour when he left office in 1877, and upon his return, he finds a huge groundswell supporting his candidacy for a third term. When after thirty-six ballots he cannot increase his vote count among delegates, the Republican convention quickly settles on compromise candidate James A. Garfield. Grant decompresses during his vacation at Virginia's seashore and would weep bitterly upon Garfield's assassination six months into his presidency.

MARCH 30

1629—The Virginia General Assembly passes a resolution to erect a new fort at Point Comfort. Fort Algernoune has disappeared, as troops have not been quartered there since 1612, but piracy and the threat of Spanish and Dutch incursions demand some sort of defense for the entry into Hampton Roads. The new fort would be finished in 1632, but its name is unknown.

1899—Famous British Open golf champion Harry Vardon plays a much anticipated exhibition match against 1894 U.S. Open champion Willie Dunn at the Hampton Roads Golf and Country Club, located along Hampton Roads between East and Hampton Roads Avenues—now a residential area. A special train brings onlookers from Richmond, while ferries transport other avid golf fans from Norfolk. Vardon wins the match, establishing new club records for the longest drive and the lowest nine-hole score.

1934—The Department of War purchases the Shellbank tract from Hampton Institute (now Hampton University), using the 46.66 acres, formerly a dairy farm, to build a highway along the southwest boundary of Langley Field.

1942—The Department of War purchases an additional 582 acres on the northwest side of Langley Field, with a portion being transferred to the National Advisory Committee on Aeronautics (NACA, now NASA). An enlarged Langley Field at the time comprises 3,016 acres, almost double its size when purchases of land began in December 1916.

MARCH 31

1824—Brevet Brigadier General Abraham Eustis is assigned to Fort Monroe to take charge of the Artillery School. He soon finds himself in command of one of the largest and most important posts in the United States. His nearly six-hundred-man garrison represents almost one-third of all U.S. Army artillery forces. Eustis retains command until November 1828. Much later, Fort Eustis (from 1918 to 1923 called Camp Eustis), in what was then Warwick County, will be named for him.

April

APRIL 1

1864—Newly promoted Lieutenant General Ulysses S. Grant, now the commander of all Union armies, spends three days conferring with Major General Benjamin F. Butler at Fort Monroe, coordinating the latter's assault toward Richmond up the James River with his own attack from the north. Grant would accompany Major General George Meade and the Army of the Potomac, venturing down through the Virginia Piedmont region. To prevent the Confederates from shifting troops from farther south, Major General William T. Sherman would attack Atlanta.

1868—Brigadier General Samuel Chapman Armstrong opens the Hampton Normal and Agricultural Institute (now Hampton University) as its first principal. It was illegal to teach African Americans to read and write under the Confederacy, so a major task following their emancipation from slavery is to provide a means of education, and several colleges spring up throughout the South, many under the aegis of the American Missionary Association. Chapman, born of missionary parents in Hawaii and commander of the Union army's Eighth U.S. Colored Troop Regiment, desires in paternalistic fashion to uplift an "inferior race" through education. While his curriculum emphasizes artisanal skills for young black people (and soon for equally "inferior" Native Americans), the goal is to produce educators, and 84

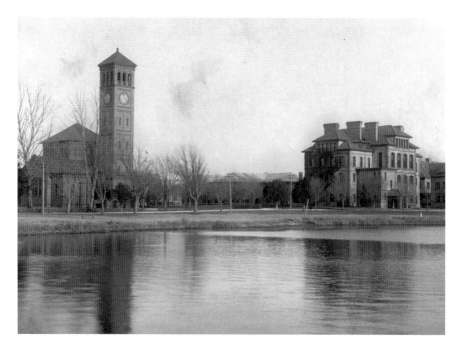

By 1893, Hampton Institute was serving 636 students, 188 Indians, and 300 primary students, and graduates had taught more than 129,400 children throughout the South. *Library of Congress.*

percent of the graduates of Hampton's first twenty graduating classes become teachers. Chapman would die in Hampton on May 11, 1893, following a stroke.

1900—Phoebus, formerly Chesapeake City, incorporates as a town and is named in honor of Harrison Phoebus, an enterprising local entrepreneur who greatly enlarged the second Hygeia Hotel at Old Point Comfort and managed it so well that it became one of the best-known resorts in the nation, visited by many noted southerners and by several of the foremost northern figures in politics, finance, and industry. The occasion of the town of Phoebus's incorporation is celebrated with impressive ceremonies, a parade, and a banquet, attended by the governor of Virginia, J. Hoge Tyler. John A. White becomes Phoebus's first mayor.

1931—Langley Field's first aircraft fighter unit, the Eighth Pursuit Group, is activated. They fly P-40s and B-10s. The Eighth would move to Mitchell Field, New York, in 1940.

1978—NASA Langley Research Center completes oversight of the Viking Project. There are two unmanned Viking spaceships, each consisting of an orbiter and a lander. After appropriate orbital reconnaissance, each lander arrives safely on the surface of Mars in the mid-1970s and sends a wealth of information back to Earth. The orbiters obtain the first complete set of photographs of the surface of the Red Planet. As of 2018, plans have not been finalized for manned flight to Mars.

APRIL 2

1862—To test its gun carriage, the mighty fifteen-inch, 49,099-pound "Lincoln Gun" fires ten shots from the shore near the lighthouse at Old Point Comfort, whence it had been moved from Fort Monroe's ramparts. The second of these shells skips three times across the surface of Hampton Roads before plunging into the water short of the Confederate works at Sewell's Point.

1862—Major General George McClellan arrives at Fort Monroe, preparing to commence what would come to be known as the Peninsula Campaign. The Federal government commits enormous resources to an attempt to move up the Virginia Peninsula to capture the Confederate capital at Richmond, ninety miles from Hampton—113 steamers, 118 schooners, and 88 barges transport 121,500 men, 1,150 wagons, 44 artillery batteries, 74 ambulances, and large numbers of horses and mules, along with assorted pontoon bridges and materials for telegraph lines, are also brought. The materiel and troops are landed at a series of holding areas on the Virginia Peninsula, preparatory to engaging in the assault.

1917—As President Woodrow Wilson asks Congress for a declaration of war against Germany, the U.S. Navy's fleet, normally stationed off Fort Monroe, begins moving to a safer location in the lower York River, attempting to evade Germany's unrestricted submarine warfare. The fleet had also anchored there in 1898 before sailing for Cuba in the Spanish-American War. While no information is released by the navy, observers on shore count from fourteen to eighteen dreadnoughts, or battleships, with several cruisers and destroyers also present.

1917—As America enters into World War I, Hampton's Battery D, the local militia unit, is mobilized and assigned to defend the area's harbor and the Newport News Shipbuilding and Dry Dock Company.

APRIL 3

1889—The first "lamp boys" are appointed to be members of the Hampton Fire Department. They are James V. Bickford (who would later become mayor of Hampton), John Weymouth, Patrick Daugherty, Emmet Connor, Ross Lawson, James Gammel, and Walter Johnstone. The position is a sort of apprenticeship, as the "boys" carry lanterns to illuminate the way for the horse-drawn fire engines at night to fires and other potential rescue situations.

1900—The first editions of the morning *Herald* and the afternoon *Times* newspapers are published in Newport News. On December 26, 1901, the papers merge and are published as the *Times-Herald*, which becomes Hampton's regular afternoon news sheet and is eventually printed by the same company that owns the morning *Daily Press*. The evening paper would cease publication on August 30, 1991.

1994—Nelson T. Fuller, third-generation proprietor of Fuller's Restaurant in Phoebus, passes away. Philip A. Fuller opened the eatery in 1901 and coined the famous slogan "Eat Dirt Cheap at Fuller's." The restaurant closed in 1989.

APRIL 4

1864—Dr. David Warman of New Jersey is assigned as contract surgeon to the Chesapeake Hospital for Union officers near Fort Monroe. The former Chesapeake Female College and surrounding outbuildings accommodate 500 patients, served by five doctors. Across Jones Creek, a much larger set of wooden structures in a rough triangle forms the Hampton General Military Hospital for Union enlisted men. The two together have 3,500 beds, with tents swelling their capacity to more than 5,000 patients. They

The hastily built Hampton General Military Hospital's expanse of tents and soldier wards transformed the complex into the second largest in the Federal hospital system. *Hampton History Museum.*

are connected with Old Point Comfort by a narrow-gauge railway. The facilities occupy what are today the sites of Hampton University and the Hampton Veterans' Administration. Through April 25, 1864, Hampton General received and treated 6,540 patients, of whom 4,491 recovered and returned to duty, 1,049 were transferred to the Veterans Reserve Corps, 784 remained at the hospital, and 216 died.

1896—The first Hotel Chamberlin opens at Old Point Comfort after being under construction for several years and in and out of bankruptcy. It was designed by Paul J. Pelz, chief architect of the Library of Congress. A grand opening is held for notables from New York, Philadelphia, Washington, Baltimore, and Richmond, with visitors arriving on a special Chesapeake and Ohio excursion train. Virginia Governor Charles T. O'Ferrall, U.S. Postmaster General William Wilson, Secretary of the Navy Hilary Abner Herbert, and the commanding general of the U.S. Army, Major General Nelson A. Miles, join congressmen and senators in attendance.

APRIL 5

1614—Pocahontas, daughter of Powhatan and half-sister of Pochins, the last werowance (king) of Kecoughtan, marries John Rolfe, the English planter who introduced and profited from a strain of Caribbean tobacco that Europeans found pleasant. It is the only recorded legally allowed racial intermarriage in Virginia before the Civil War. Their son, Thomas, would be born on January 30, 1615. Having been converted to Christianity under the name Rebecca during her English captivity from 1613 to 1614, she would die in England in March 1617.

1824—The Adjutant General of the U.S. Army orders the establishment and organization of the Artillery Corps of Instruction, a school for artillery officers alone, at Fort Monroe. Ten companies of artillery are directed to form the instruction contingent of the school.

Booker T. Washington became the first African American person invited by a president (Theodore Roosevelt) to a White House dinner, as well as the first to appear on an American postage stamp. *Library of Congress.*

1856—Booker T. Washington is born in Hales Ford, Virginia, to Jane, an enslaved woman, and an unknown white father. In his late teens, he would walk from West Virginia (whence his mother had moved) to Hampton to enroll in Hampton Institute, one of the first institutions established to provide an education for former slaves, and eventually he would become a faculty member. On July 4, 1881, he will become the first principal (president) of a new college in Alabama for African Americans, Tuskegee Institute. Developing and expanding his school, Washington also would become for the last quarter century of his life the leading spokesperson for African Americans and an American icon.

1992—The Virginia Air and Space Center opens in downtown Hampton. With a spectacular modern design, including a three-story glass atrium, it features the first institutional digital IMAX theater in the world. The building also serves as the visitors' center for both NASA's Langley Research Center and Langley Air Force Base.

APRIL 6

1879—The First Presbyterian Church in Hampton is founded. Presbyterians met at the home of Samuel G. Cumming on March 18, leading to the establishment of the church in less than a month, with twelve charter members. Cumming is the first Elder.

1917—The Elizabeth City County Chapter of the American Red Cross is founded. Only about one hundred chapters of the national organization existed in 1914. Its initial goals are to befriend American soldiers and their families, although today it has become an angel of mercy for all victims of warfare and catastrophe. The new chapter is inspired by President Wilson's naming the Peninsula as a major port of embarkation for American troops traveling to Europe in the First World War. On the succeeding July 1, a chapter would be formed in Warwick County, and the two will give much aid to soldiers arriving at hastily constructed camps along the Chesapeake and Ohio Railroad tracks. The two will merge to become the Hampton Roads Chapter in 1966.

1972—The First National Bank in downtown Hampton is demolished during urban renewal. It had been established in 1903 in the Schmelz Bank building at the corner of King and Queen Streets, vacated when George and Henry Schmelz merged their banking operation into the Bank of Hampton (across the street).

APRIL 7

1915—With four British cruisers steaming just off the entrance to the Chesapeake Bay anxious to wage battle, Korvettenkapitan Max Thierichens of the large German sea raider *Prinz Eitel Friedrich* reluctantly decides to intern himself and his ship in the Norfolk Navy Yard after four tense weeks of high drama. The *Prinz Eitel* had run through the Capes and into Hampton Roads the previous March 10, having made no port calls for seven months while destroying British shipping in the South Pacific and the South Atlantic during the First World War. Thierichens meets with representatives of the then-neutral U.S. government, which agrees to allow him to put his vessel into Dry Dock no. 3 at the Newport News Shipbuilding and Dry Dock

Company, guarded by marines from the Norfolk Navy Yard. The British make dire threats of warlike acts against the German ship and reportedly send a warship into the Chesapeake, which puts the large coastal guns at Fort Monroe into high battle alert. Six companies of American artillerymen are called into action, and the local population is quite alarmed, thinking themselves perilously close to war. Hordes of sightseers, apparently unafraid of the pending battle, swarm into Newport News and crowd the Hotel Chamberlin and the Hygeia Hotel at Fort Monroe to catch a glimpse of the German ship. Thierichens's decision to surrender the ship to internment seems to ease all the tensions.

1934—The inaugural performance by the Coast Artillery Band is given at the just-completed Fort Monroe Bandstand, built by Works Progress Administration labor and located at the center of Continental Park. The Bandstand has been a focus of entertainment and social gatherings for more than eighty years. It replaced the original band pavilion, destroyed in the "Great Storm of 1933."

APRIL 8

1924—After training at Langley Field in global navigation, survival, and engineering maintenance, four aircraft, each manned by a pilot and a mechanic, leave Seattle, Washington, to complete a circumnavigation of the entire globe. They follow a route to Alaska, Japan, Saigon (in what was then French Indochina), India, Iraq, Vienna, Paris, London, and over the North Atlantic toward home.

APRIL 9

1798—Secretary of War James McHenry requests $30,000 to erect new fortifications at Old Point Comfort and at Fort Nelson on the Elizabeth River at Portsmouth, opposite Fort Norfolk. Newly elected President Thomas Jefferson would declare in December 1801 that these and other fortifications would be too expensive to construct and too labor-intensive to maintain, resulting in no appropriations being made in the following six years.

1884—A devastating fire breaks out along Queen Street in downtown Hampton, destroying more than a quarter of the town, including many homes and thirty-three businesses. With no town fire department, firefighters from Hampton Institute (now Hampton University), the National Soldiers' Home, and Fort Monroe combine to extinguish the flames. One hero is firefighter Richard A. Roth. The direct result is the formation of Hampton's first volunteer fire department and the purchase of its first fire engine later in 1884.

1959—NASA introduces the first astronaut class, the "Mercury Seven," who will receive their original spaceflight training at facilities built at Langley Field. The men are Virgil "Gus" Grissom, Scott Carpenter, Donald "Deke" Slayton, Gordon Cooper, Alan Shepard, Walter Schirra, and John Glenn. All but Glenn move their families to the Hampton Roads area; Glenn commutes weekly from Arlington, Virginia. Hampton would later name seven bridges and two roads, Mercury Boulevard and Shepard Boulevard, after the project and its astronauts.

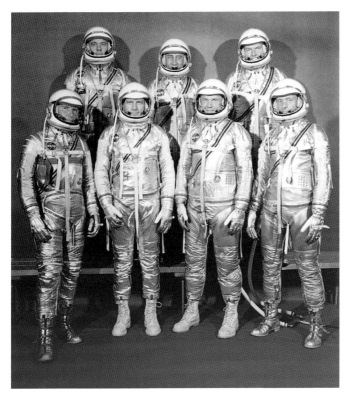

While Mercury astronauts underwent training, NASA's wind tunnels were used for aerodynamic studies and spacecraft recovery was practiced in Langley's pools. *Wikimedia Commons.*

APRIL 10

1922—Having steamed past Old Point Comfort, the captured German luxury liner *Vaterland*—renamed *Leviathan* by President Woodrow Wilson upon its seizure in 1917—arrives from Hoboken, New Jersey, at the Newport News Shipbuilding and Dry Dock Company. Under a contractual price of $8 million, it would be completely refitted, its hulls strengthened and its engines converted from coal to oil, emerging in May 1923 to become one of the two fastest liners in the competitive transatlantic steamship service. *Leviathan* would serve as the flagship of the United States Lines until 1934.

1985—Roseland, an elegant twenty-room brick mansion located near the site of the Kecoughtan Indian village on the shore of Hampton Roads and an official Virginia State Landmark listed in the National Register of Historic Places, is gutted by a fire visible throughout Hampton Roads. The mansion was built by Harrison Phoebus, the developer of Old Point Comfort's grand resort hotel, the Hygeia. Joseph T. Segar, later a Unionist congressman, had purchased Roseland Farm in 1856. He subdivided its eastern portion into lots in 1871, which became Chesapeake City (later renamed in honor of Phoebus), and sold the western portion of forty-five acres to the hotelier in 1873. The seventeenth-century farmhouse was redesigned in 1886–87 by architects Arthur Crooks of New York City and C. Taylor Holtzclaw of Hampton, becoming a three-story Queen Anne manor house with large parlors and a grand staircase, rivaling the sumptuous homes of Newport, Rhode Island. Following Phoebus's sudden death in 1886, his widow, Annie, and their large family lived there until her demise in 1907.

APRIL 11

1942—First Lady Eleanor Roosevelt makes her third trip to Hampton, motoring down from Washington the night before in order to attend the annual meeting of the Rosenwald Fund Trustees at Hampton Institute (now University). After lunch, she visits Langley Field, where rainy weather mars her tour, prevents a stop in Williamsburg, and forces her to drive to Richmond and take the train rather than flying, as planned, to New York City, where she has an engagement on April 12. Mrs. Roosevelt's first local

trip had been in 1936, accompanied by a granddaughter, to tour Hampton Institute and the National Soldiers' Home. The second was in April 1938.

1943—Lieutenant Isabel Becker and sixty enlisted women of the Eighty-Eighth Women's Auxiliary Army Corps (later Women's Army Corps, or WAC) are the first WAACs serving at Langley Field. Due to the pressing need to place men in combat assignments, and consistent with dominant views at the time, WAACs served in such varied capacities as bakers, weather observers, truck drivers, and mechanics, as well as cooks and secretaries.

APRIL 12

1861—The Chesapeake Female College, incorporated in 1854 and opened in 1857 as one of the few institutions of higher learning for women in the South, ceases all school activities following the attack on Fort Sumter in South Carolina. The tallest building in Hampton at four stories, its structure is

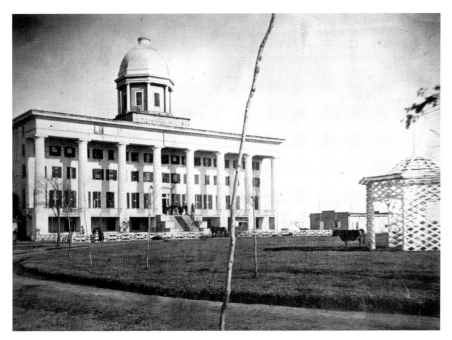

Incorporated in 1854, the Chesapeake Female College, with its ornate main building, operated on a forty-acre campus along the Hampton waterfront with accommodations for four hundred. *Library of Congress.*

briefly occupied by Confederates, who use it as an observation platform, but Union forces seize the building on May 26; after temporary use as quarters for escaping slaves, it is converted into a hospital for Union officers. The building has long since been demolished, and the site now contains the Hampton Branch of the Veteran Administration's National Soldiers' Home.

1915—Raising local and international tensions to great heights, the giant German sea raider *Kronprinz Wilhelm* evades four British cruisers at the mouth of the Chesapeake Bay and seeks haven in Hampton Roads, passing the Hotel Chamberlin to anchor off Newport News Point. A major disaster had been averted days earlier when the smaller and slower *Prinz Eitel Friedrich* had ended four weeks of desperation and high drama by moving from the Newport News Shipbuilding and Dry Dock Company into internship at the Norfolk Navy Yard. The upset British threaten warlike acts once more. With beriberi rampant among its crew, the crippled *Kronprinz* spends two tense and fruitless weeks in Dry Dock no. 2 of the shipyard and then joins its sister ship, *Prinz Eitel Friedrich*, in surrendering to internship at the Norfolk Navy Yard on April 26. The two ships and their crews remain local curiosities until they are moved to Philadelphia in September 1917, long after the United States enters World War I and the vessels have become enemy ships.

APRIL 13

1863—Three months after issuing the Emancipation Proclamation, President Abraham Lincoln signs a contract to transport 500 contrabands (slaves who escaped and claimed sanctuary with the Union army) to the Ile a Vache in Haiti. They depart from Fort Monroe on the USS *Ocean Ranger*. They suffer brutal exploitation in Haiti under Bernard Koch, an American planter profiting from cotton and timber by using cheap contraband labor. Miserable conditions force the Lincoln administration to send a rescue ship in March 1864. Only 365 survivors return from the failed experiment.

1878—The first Native Americans enroll at Hampton Institute (now Hampton University). By 1900, more than one hundred Indians have graduated from the Institute's Indian School, and Native Americans would continue to attend Hampton through 1923. A dormitory there is still called "The Wigwam."

2002—The death of Donald Rosenbaum of Hampton is reported. Having in 1966 converted his tinsmith grandfather Adolph's hardware store, founded in 1885, into a business selling fences, this pleasant community-oriented businessman was quietly friendly to all people. For example, Rosenbaum Fence is the first in Virginia to hire a woman fence installer.

APRIL 14

1909—Civil War veteran William Morris Smith commences a casket and cabinetmaking business in Phoebus, while his son, R. Hayden Smith, starts a funeral home. The founder's granddaughter, Mattie Hayden Smith, in 1926 becomes one of the first female licensed funeral directors in Virginia. The funeral business eventually passes into the hands of a sixth-generation descendant, Timothy B. Smith, having moved from Phoebus to Hampton in 1932.

1942—The destroyer USS *Roper* sinks the German submarine *U-85* off the coast of North Carolina, becoming the first U.S. Navy warship to torpedo a U-boat during World War II. The bodies of twenty-nine enemy sailors are recovered and buried nocturnally with military honors at Hampton National Cemetery. Americans had been surprised and dismayed by the bold German strategy of using U-boats to attack merchant and naval shipping along the East Coast of the United States in January and February 1942, bringing the war home to complacent U.S. citizens. The German submarine crews, in turn, are amazed to discover U.S. cities still fully lit at night, allowing target ships to be silhouetted against city lights. The entrance into the Chesapeake had not yet been thwarted with defenses, and many of the sinkings occur in the waters off Virginia and North Carolina, while one U-boat lays fifteen mines between Cape Henry and Cape Charles, to the devastation of U.S. trade. The U-boats are refueled and restocked with food at sea by "Milk Cows," large slow tanker submarines. "Operation Drumbeat" is hugely successful, sinking 397 vessels totaling more than 2 million tons. Development by the United States of the convoy system, escorting grouped merchant ships with sub-hunting destroyers, immediately results in kills of U-boats and forces the Germans to redeploy their submarine fleet.

APRIL 15

1623—In the early days of English settlement, with neither precious metals nor a passage to China discovered, the search is on for industries that might provide an economic basis to support the Virginia colony. White mulberry trees are brought from Languedoc in France by James and Anthony Bonnall to found a silk industry in what is now Buckroe. Silkworms are introduced, and other silk growers include Elias LaGuard, David Poole, and Peter Arundel, who reports back to England on this date, "Our Wormes are well hatched & very hopefull." The climate is hostile for the Asian-originated tree, however, and the project fails. Another variety of mulberry, the red, is widespread in the area and noted by the Powhatan Indians for its tasty fruit, but it cannot support silkworms.

1862—As an additional measure of defense after the surprising success of the Confederate ironclad CSS *Virginia* (*Merrimack*) three weeks earlier, on this and the succeeding day the fifteen-inch "Lincoln Gun" at Fort Monroe roars into action, firing several projectiles accurately into the Rebel base at Sewell's Point about three miles away. The twelve-inch "Union Gun" joins in the barrage.

1907—The U.S. Atlantic Fleet steams into Hampton Roads, taking up anchorage off Old Point Comfort, preparatory to the opening of the Jamestown Exhibition at Sewell's Point in Norfolk. The fleet joins seventy-five warships from other nations, including Great Britain, France, Germany, Italy, and Chile, as part of a second "Great Naval Rendezvous." The exhibition commemorates the 300th anniversary of the founding of Jamestown, and many of its buildings can still be seen on the Norfolk Naval Base.

Jamestown Exposition exhibits showcased American history and industry, a Panama Canal scale model, a Wild West show, and a re-creation of the then-recent San Francisco earthquake. *Library of Congress.*

APRIL 16

1862—The last significant military engagement of the Civil War on the lower Peninsula, part of Major General George McClellan's massive Peninsula Campaign, takes place near Lee's Mill on the Warwick River. Union Brigadier General W.T.H. Brook's Vermont Brigade, based at Camp Hamilton (now Phoebus), crosses that river under heavy Confederate fire—20 Confederates are killed, while the retreating Federals lose 35 dead, 121 wounded, and 9 unaccounted for. The numbers dwarf the total casualties incurred at the Battle of Big Bethel ten months earlier.

1973—Hampton is named an "All-America City" for the year 1972 by the National Civic League. Founded in 1949 by its predecessor, the National Municipal League, the annual award honors ten of the best-governed American cities, neighborhoods, counties, or metropolitan regions for their innovative achievements in such categories as job creation, neighborhood revitalization, crime reduction, new housing for low-income people, improvements in education, and engaging the civic interest of young people. The city would receive two more such awards, for the years 2002 and 2014, a source of great pride.

APRIL 17

1818—Work on Fort Monroe commences when James Maurice—agent of fortification for Norfolk, Hampton Roads and the Lower Chesapeake Bay—is directed by the U.S. Army's chief engineer to "employ a good wharf builder to extend and complete the wharf at Old Point Comfort, sufficiently large and substantial to allow three vessels to…unload at the same time."

1861—Virginia's Convention had defeated a vote to secede from the Union on April 4, but when President Abraham Lincoln calls on all states to provide men in arms in response to South Carolina's capture of Fort Sumter, the Convention votes to secede this day and join the recently formed Confederate States of America. A statewide public referendum, to affirm or deny secession, is set for May 23. Despite its lack of fresh water, Fort Monroe's massive walls and heavy ordnance, combined with the U.S. Navy's ability to resupply the base at will, make it impossible for the Confederates to

seize Old Point Comfort. General-in-Chief Winfield Scott sends thousands of Northern troops to the Peninsula to hold Fort Monroe and threaten the Confederate and Virginia capitals at Richmond.

1865—Samuel Arnold, one of the original conspirators involved in the failed attempt to kidnap President Lincoln in March, is arrested at Old Point on this date while working for Fort Monroe's sutler, three days after Lincoln's assassination. He is tried and convicted, but since he was not connected with Lincoln's death, he is not executed. Sentenced to imprisonment at lonely Fort Jefferson in the Dry Tortugas islands off the Florida Keys, Arnold is pardoned in 1869.

1879—The Bethel African Methodist Episcopal Church, founded at Camp Hamilton (now Phoebus) in 1864 with the aid of contrabands (escaped slaves), hosts the thirteenth annual state AME Conference.

APRIL 18

1846—In the early morning, fire races through the quarters at Fort Calhoun (now Fort Wool) used for presidential retreats. Awakened by a fire alarm, Colonel Rene DeRussy at Fort Monroe and his men demolish wooden gangways connecting the structures at Calhoun to prevent the blaze's spreading. The building, used by Presidents Jackson and Tyler, burns to the ground.

1917—The first contingent of army troops, an engineer company previously stationed at Fort Wood, New York, arrives at Langley to guard supplies being stockpiled for the construction of the new airfield. Since barracks do not yet exist, the soldiers are billeted at Fort Monroe.

APRIL 19

1949—Hampton's largest drive-in cinema, the Sydney Lust Theater on Pembroke Avenue, opens. It is built at a cost of $175,000 and "seats" 716 automobiles. It becomes the Hampton Drive-In in 1969 but closes for good

in 1980, largely thanks to competition from television. Down the road is the Green Acres Drive-In, with a 500-car capacity, located almost in Newport News and which operates between 1946 and 1982. With Peninsula War Memorial Stadium, Shoney's, and the Stadium restaurants, as well as other hangouts nearby, Pembroke Avenue would be the epicenter of local teen activity in the 1950s and 1960s.

APRIL 20

1901—Hampton seafood entrepreneur James McMenamin dies. The Massachusetts native won international acclaim at the Berlin Exposition, the London Exposition, and the Paris World's Fair for his 1879 invention of a process for canning crabmeat that allows long-distance shipment of the delicate steamed seafood. He builds the world's largest crab-processing factory in Hampton, in which spotlessly dressed African American women pick many pounds of crabmeat daily. He is credited with putting the crab in Hampton's nickname, "Crabtown."

APRIL 21

1817—The U.S. Army orders Colonel Walter K. Armistead to Old Point Comfort to begin collecting materials for the construction of Fort Monroe.

1827—The Elizabeth City County Episcopal Parish names its church St. John's. Previously, like Bruton Parish Church in Williamsburg, it was known as Elizabeth City Parish Church.

1905—The Hampton pest house, a refuge for people with smallpox and other "noxious" communicable diseases, burns to the ground. Two quarantined occupants escape injury.

1938—First Lady Eleanor Roosevelt dedicates Aberdeen Gardens, the second federally funded housing project for African Americans. Designed by Hilyard R. Robertson and constructed under the management of Charles Duke, both black architects, and built by black contractors and black laborers,

the development contains 158 brick houses on large garden plots, a school, a store, and a surrounding greenbelt and is funded by President Franklin D. Roosevelt's Subsistence Homestead Project. At first used primarily by workers at the Newport News Shipbuilding and Dry Dock Company, many of Aberdeen's homes are inhabited to this day by the proud descendants of those first owners.

APRIL 22

1829—Edgar Allan Poe leaves Fort Monroe to enter the United States Military Academy at West Point, where he will serve until his dismissal on March 6, 1831.

1898—Anti-submarine mines are planted in the lower Chesapeake Bay at the outbreak of the Spanish-American War. Carelessness causes damage to commercial shipping. The minefield is raised in August.

APRIL 23

1958—Hampton firefighters join the efforts of firemen from all cities in the area, plus those from the navy, to respond to a raging blaze at the Esso storage facility near the coal yards in downtown Newport News. Thanks to their good work, the fire is limited to seven of the twenty-two giant storage tanks (although seven more are damaged). Triggered by an explosion in a steam-generating plant that spewed debris over a mile-wide area and tumbled citizens in nearby Stuart Gardens out of bed, the fire is out of control for twenty-four hours and rages for nearly forty hours, consuming 2 million gallons of various fuels. The total loss is estimated at more than $1 million, but there are no deaths or serious injuries. The flames and oily black smoke could be seen for miles around. The facility is repaired within a few months.

APRIL 24

1893—The first grand naval rendezvous, a weeklong event participated in by thirty-eight warships from ten nations, comes to a close as the ships, in two long lines, majestically sail out of Hampton Roads for a "review" near New York City. Although it is peacetime, showmanship and international competition in maritime might are rampant: when Russia announces it will send five vessels, Great Britain ups its contingent by one ship to have five representatives (in the event, three Russian vessels are prevented from attending by ice). Hampton is among the municipalities each contributing $2,500 or more to cover the fireworks, the small boat races among crews, the band concerts, and the various military and naval drills that are featured events. The large resort hotel at Old Point, the Hygeia, turns down two times its capacity of curious visitors. Thirteen vessels represent the U.S. Navy.

1933—At Fort Monroe, fire erupts in the Chapel of the Centurion during the funeral of much-respected First Sergeant Thomas E. Austin of Battery F, Fifty-Second Coast Artillery. Considerable structural damage ensues, but there are no deaths or injuries, and no stained-glass windows are lost.

APRIL 25

1854—George Washington Fields is born into slavery in Hanover County. Carrying his three-year-old sister Catherine, nine-year-old Fields would escape with his indomitable mother Martha Ann Fields and four other siblings in 1863, walking to the York River and riding to freedom at Fort Monroe on a passing vessel. Settling in Hampton, the Fields family, remarkably, would be reunited, as the escaping father, three siblings who had been sold, and a runaway brother manage to join them. Fields will graduate from Hampton Institute in 1878 and work as a manservant for prominent Northern families, including that of the governor of New York, before reading law with a local attorney and obtaining his degree from Cornell University School of Law in 1890. He would return to Hampton to practice. Fields will lose his eyesight in 1896 but continue his practice. He will also serve on the board of the Weaver Orphan Home, as a trustee of the Third Baptist Church, and as superintendent of its Sunday school. He will pass away on August 19, 1932.

1907—Mark Twain (Samuel L. Clemens in real life), having arrived from New York City on the magnificent yacht *Kanawha* belonging to Standard Oil chief executive Henry Huttleston Rogers, checks into the Hotel Chamberlin for what proves to be almost a week's stay. Twain attends the opening of the Jamestown Exhibition (the celebration of the 300th anniversary of the founding of English settlement in North America) at Sewell's Point in Norfolk the next day, although *Kanawha* barely avoids a collision with the steamer *John Sylvester*. Fog off the Capes in the Atlantic Ocean prevents the yacht from sailing for the next three days, and then Twain's aversion to rail travel keeps him and the yacht in Hampton Roads until May 1. Twain would return for a speech at the Exposition on September 23, celebrating the 100th anniversary of Robert Fulton's steamboat.

1917—Ella Fitzgerald, the fabled "First Lady of Song," is born in Newport News, although she will be reared in New York. Appearing at Hampton's Bay Shore Beach in the 1930s, she would also perform in the 1940s at the Grandview Dance Pavilion, as would several big bands and other nationally known artists. The Pavilion was originally adjacent to the Grandview Hotel, a small resort inn constructed in 1890 at Grandview Beach on the Chesapeake Bay near Fox Hill. Both pavilion and hotel would be destroyed in the "Great Storm of 1933." The pavilion will be rebuilt nearby but again be destroyed, this time by Hurricane Hazel in 1954. The locations of the hotel and both pavilions are today mostly under water, as water levels have risen, and the beach has totally eroded in the Grandview area.

APRIL 26

1849—Both in their early twenties, James Barron Hope and John Pembroke Jones fight a duel at Buckroe Beach. The affair attracts much attention throughout Tidewater, and both men are severely injured. However, the two later become staunch friends. Hope emerges as a major poet, while Jones becomes a distinguished officer in the United States and then the Confederate navies.

1872—Hampton Public Schools are established by court order. The Virginia Constitution of 1870 was the first to require free public schooling

for all children, including black children. It had been illegal during slavery to educate black people, so this was a momentous step forward.

1907—To commemorate the 300th anniversary of the founding of a successful English colony in the New World, the Jamestown Exposition opens at Sewell's Point in Norfolk. Hampton's Chamberlin is the primary hotel for Exposition attendees, and two ferries provide passenger service between Norfolk and either Old Point Comfort or a wharf at the end of Manteo Avenue in Hampton. President Theodore Roosevelt presides over the opening-day ceremonies.

APRIL 27

1781—In a surprise attack, turncoat British Brigadier General Benedict Arnold destroys most of the drastically undermanned Virginia Navy, under the command of Commodore James Barron of Hampton, at the small town of Osborne's Wharf on the James River, south of Richmond, during the American Revolution. Arnold sinks or burns nine vessels and captures twelve others, laden with two thousand hogsheads of valuable tobacco.

1959—The first seven astronauts begin their training in the Mercury program at NASA Langley. The Russians had shocked the world by sending up the first orbital spaceship, Sputnik, in 1957, and an embarrassed United States wanted to be first in placing a human in orbit around Earth and return him safely. Although John Glenn became the first human to orbit earth three times, Russia's Yuri Gagarin was the first to make a single orbit.

1995—It is reported that a total of 26,460 interments have been made in the Hampton National Cemetery, mostly veterans of U.S. military service but also including some Confederate veterans and twenty-nine German servicemen whose remains were recovered from the sunken submarine *U-85* off the East Coast in April 1942, buried under the terms of the Geneva Convention. The cemetery has filled up, having been closed to new interments as of February 1993.

APRIL 28

1607—Having made landfall two days earlier at the entrance to what will come to be known as the Chesapeake Bay after a voyage of five months' duration from England, the Virginia Company of London's expedition of English settlers, tasked to found a colony in Virginia, dispatches a shallop with a small party. They slowly explore the southern shores of the Bay. Toward the end of the day, they row across to a point of land that gives them such "good comfort" that they call it Cape Comfort. It is now known as Old Point Comfort. In the evening, they return to their ships, anchored near what is now Lynnhaven Bay.

1861—Colonel Justin Dimick, the Union commander at Fort Monroe, reports that the Third and Fourth Massachusetts regiments have arrived, along with 200,000 rations and ammunition. These first units in a belated but massive reinforcement of Federal forces at the vital post by General-in-Chief Winfield Scott help to prevent its capture by Confederate forces.

1864—Military attention in the Civil War refocuses on Fort Monroe when—pursuant to earlier discussions between Major General Benjamin F. Butler and Lieutenant General Ulysses S. Grant—the Union Army of the James is formed, with Butler as commander. It will use Fort Monroe as a launching pad to move toward its twin objectives of Richmond and Petersburg, aiming to avoid the disasters George McClellan incurred during the similar Peninsula Campaign two years earlier. It would prove to be successful in what would become the bloody war's final twelve months.

1899—A banquet is held to welcome home the Peninsula Guards, later designated Battery D, a lower Peninsula militia unit, which is returning from the Spanish-American War. The Guards trained in Georgia but arrived in Cuba too late to participate in any military action. They remained as a part of the occupation forces from December 1898 through February 1899. Several of the men contracted malaria, being hospitalized in Mobile, Alabama.

1900—The death of James Sands Darling is reported. A New Yorker who both farmed and worked in his father's boatbuilding enterprise, and who like many others paid a substitute to fight for him during the Civil War, Darling understood the commercial opportunities existing in a devastated

and poverty-stricken South. Moving to Hampton in October 1866 with a schooner full of lumber, he profited from helping to rebuild the town. Some early ventures failed, but Darling indomitably persisted. By 1879, he had succeeded with a plant at remote Factory Point, where Back River flows into the Chesapeake Bay, producing fertilizer from menhaden fish. J.S. Darling & Son Oyster Packers, begun in 1882, became the largest oyster business in the world, and its huge downtown oyster-shell pile was visible for miles. His streetcar line, built in 1887 to carry shipyard workers from Hampton to Newport News, became the foundation of a network of trolleys on the lower Peninsula, and he sold it at a profit in 1898. He developed the land adjacent to the tracks, realizing great gain. At the trolley line's end in Buckroe, he struck it rich again from the Buckroe Beach Hotel. Darling was Hampton's premier post–Civil War entrepreneur.

1966—A United States appeals court unanimously reverses a lower court decision and awards Mildred Smith, Patricia L. Taylor, and Agnes L. Stokes reinstatement in their jobs as nurses at Hampton's Dixie Hospital, plus full back pay. The three black nurses had decided in August 1963 to eat their lunches in the pleasant whites-only cafeteria of the hospital rather than in the cramped basement room set aside for meals for nonwhites. They were fired on the second day of their sit-in and sued the hospital for racial discrimination. Smith would later say that, like Rosa Parks, she was tired of "taking a back seat" and wanted to mount a stand against segregation among hospital employees.

APRIL 29

1700—Aboard the British man-of-war HMS *Shoreham*, Hampton's Peter Heyman, collector of customs for the lower James River district, is killed during a ten-hour battle while in pursuit of pirate Louis Guittar on the Chesapeake Bay. He is buried at the Elizabeth City County cemetery at Pembroke Farm. The gravestone is still visible.

1705—The prominent Pennsylvania Quaker Thomas Story, famed for his learning and ability as a lawyer, holds a meeting (a worship service) at George Walker's home on the Strawberry Bank, attended by a member of Virginia's provincial council and several commanders of ships in port. Walker's wife,

Ann, is the daughter of the famous missionary preacher George Keith, formerly a Quaker missionary, now a militant Episcopalian, who had recently visited Hampton. In 1708, Ann would win an order from Virginia's Council of State allowing her to rear her children as Episcopalians, against the wishes of her still-Quaker husband. Margaret, one of those children, will become the mother of George Wythe, Hampton's most famous and illustrious citizen.

1965—Trained to operate in remote locations, C-130 air crews from Langley play a significant role in the Dominican Republic crisis of 1965, as the air wing begins airlifting men and supplies from Pope Air Force Base, North Carolina, to San Isidro Airfield in Santo Domingo.

APRIL 30

1607—Moving from their anchorage at Lynnhaven Bay on the southern shore of the Chesapeake, the Virginia Company's expeditionary force of English settlers, under the command of Captain Christopher Newport, arrives off what they call Cape Comfort in the ships *Susan Constant*, *Discovery*, and *Godspeed*. They spend parts of several days with the Kecoughtan Indians at their village on the Strawberry Bank and then reboard their vessels to sail up the James River. As they are instructed, they go thirty miles upriver for defensive purposes, given Spanish claims to the area. They settle on an island on May 4 and proceed to erect a village, which they name Jamestown after their sovereign, James I of England.

1918—The Atlantic, Gulf and Pacific Company concludes the dredging of a channel on Back River, allowing larger boats to dock at Langley Field.

1927—Old Point Comfort Hotel Corporation breaks ground to rebuild the Chamberlin Hotel, destroyed seven years earlier in a fire. Financial difficulties cause the owners to secure backing from the Vanderbilt Hotel Company. The new Chamberlin-Vanderbilt, designed by prominent architects Marcellus Wright and Whitney Warren, is an example of the Beaux-Arts interpretation of the Georgian style, rising nine stories above Hampton Roads.

1976—A "moon tree" (a sycamore) is planted in the inner courtyard at Booker Elementary School in Hampton. It was grown from one of the seeds that traveled into space aboard the Apollo 14 moon mission in 1971. When Booker sixth-grader Marjorie White won a poetry contest, the prize was a "moon seed."

May

MAY 1

1833—Sauk Indian medicine man and leader Black Hawk arrives for his imprisonment at Fort Monroe, along with fellow Sauks Whirling Thunder and the Prophet. Angered at the forced removal of his people from Illinois to Iowa by the U.S. government, Black Hawk had made many raids across the Mississippi River with a band of about 1,500 warriors in what comes to be known as the Black Hawk War. He surrendered after losing a terrible battle at Black Axe River. The Sauks are transported by the U.S. Army through the middle states of the country and are exhibited as captives to ward off other possible native uprisings.

1863—The former owners of the Hygeia, the demolished resort hotel on Old Point Comfort, are given permission by the U.S. Army to build a restaurant near the Point's Baltimore wharf that will be called the Hygeia Room. With federally allowed additions in 1868, 1872, 1875, 1881, and 1884, the last four after its purchase by Harrison Phoebus, it becomes the second Hygeia Hotel and emerges as a nationally known resort.

1916—The Boulevard Development Company begins selling lots in Elizabeth City County's Indian River Park, coincidentally near the spot on the shore of Hampton Roads where British troops landed during the

War of 1812. It becomes one of the earliest planned developments in the United States, with sidewalks, streetlights, and sewer connections built into the original design.

1918—The death of Alice Mabel Bacon is reported. A native of Connecticut, where her father taught at Yale Divinity School, at age twelve the precocious youngster lived for a year with her older sister, Rebecca, professor and assistant principal at Hampton Institute (now University). Returning home, she enjoyed having Yamakama Sutematsu, the daughter of Japanese aristocrats, as a guest in her home for a decade, and she learned Japanese. Without attending college, Bacon passed the Bachelor of Arts examinations at Harvard College in 1881 and commenced a fifteen-year stint teaching economics, government, and theology at Hampton Institute in 1883. On a year's leave, she taught English to elite Japanese women in 1888–89 in Japan. In 1890–91, Bacon was instrumental in founding a hospital and a nurses' training school for people of color on the Hampton grounds. Riding her favorite horse, Dixie, she served as a missionary to the contrabands (former slaves) in Hampton, Phoebus, and Elizabeth City County. Bacon completed a sociological study of Elizabeth City County, culminating in a map that drew considerable interest at the World's Fair in Paris in 1893. She returned to Japan in 1900–1902 to help establish (along with her friend and teaching colleague Tsuda Umeko) the Women's English Preparatory School, the forerunner of Tsuda University.

1922—The Hampton City Council instructs the city manager to purchase a triple-combination Ahrens-Fox Pumping Engine at a cost of $13,000, a modern motorized self-propelled firefighting apparatus.

1957—"Hampton Day" is celebrated, and the Hampton Historical Society unveils the Kecoughtan Monument, located at the probable site of the first 1607 English landing at Strawberry Bank on the grounds of the National Soldiers' Home. A dedicatory address is delivered by Brigadier General E. Sclater Montague, commander of Hampton's Battery D when it was mustered into national service during World War II.

MAY 2

1923—The Citizens Rapid Transit Company is formed to provide bus service to the lower Peninsula. With the demise of the local trolley system in 1946, the CRT becomes the primary method of transportation for those without autos.

Early bus manufacturing grew out of carriage and coachbuilding, as vehicles were merely a bus body fitted to a truck chassis. *Library of Congress.*

1924—After an intensive fundraising effort, the Kecoughtan Literary Society of Hampton presents a portrait of President James Monroe to the Coast Artillery School of Fort Monroe on the occasion of the latter's 100th anniversary. Painted by noted local artist Catherine C. Critcher, the gift is made by Governor E. Lee Trinkle and accepted by Brigadier General William R. Smith, commandant of the school. The participants and guests are feted by Mary Gorton Darling with a grand luncheon at the Darling home, Cedar Hall. Founded in 1892 by Mrs. Darling, a faculty member at Hampton Institute (now University) and the wife of Hampton businessman Frank W. Darling, the Kecoughtan Literary Society still meets monthly.

2000—City Councilperson Mamie Locke becomes the first African American and the second woman to be elected mayor of Hampton. Locke, with a PhD in political science from Atlanta University, also serves as dean of liberal arts and professor of political science at Hampton University. In 2003, she will be elected to the state senate.

MAY 3

1858—Fort Monroe's Chapel of the Centurion is consecrated as an Episcopal church. The funds for its construction were provided by private subscription, the principal contributor being Lieutenant Julian McAllister, who miraculously escaped death in an explosion at the fort on June 22, 1855.

2003—The Hampton History Museum enjoys its grand opening in its new building on Queen's Way. The museum displays artifacts and exhibits that chronicle the city's long and storied past.

MAY 4

1610—Having recovered from illness, Captain George Percy journeys from starving Jamestown downriver to Old Point Comfort, reporting angrily in a letter on this date that he found the English settlers stationed there had "concealed their plenty from us," being so well stocked with food that they had fed "crabb fishes" to their hogs. He notes that the stored food "wo[u]ld have bene a greate relefe unto us and saved many of our Lyves" and threatens to move his entire garrison there.

1864—Union troops leave Williamsburg and Suffolk, marching along both sides of the James River toward Richmond to begin Major General Benjamin F. Butler's advance on the Confederate capital in what would come to be known as the Bermuda Hundred Campaign. On the same date, Butler's giant fleet at Yorktown loads thousands more troops from camps at Yorktown and Gloucester Point, feints up the York and then turns to sail past Fort Monroe and Newport News Point to enter the James as dawn breaks on May 5. The expedition reaches City Point before the Confederates become aware of the danger. However, slowed by the detonation of an underwater mine via an electrical cord from shore that destroys the USS *Commodore Jones*, and thanks to Butler's hesitation and the poor advice of subordinates whom General U.S. Grant insists on assigning to him, the campaign fails at Drewry's Bluff in mid-May. Later, near the village of Bermuda Hundred, Butler's troops, on a peninsula, are effectively cut off and neutralized by the Confederates, to Butler's eternal shame.

1871—Interment of veteran Levi Jones, the first member of Hampton's National Soldiers' Home to be buried at the Hampton National Cemetery. Jones, a white man, fought with the Fifth U.S. Colored Infantry.

1968—The Hampton Redevelopment and Housing Authority is established. It helps in the demolition of much of downtown Hampton and its replacement with new growth.

MAY 5

1956—Jefferson Davis Memorial Park, on a corner of the rampart at Fort Monroe, is dedicated by the United Daughters of the Confederacy. Little if any decoration has been added to the large sign memorializing the Confederate president's imprisonment at the fort.

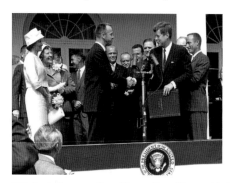

1961—After intensive training at Langley for his Project Mercury mission, NASA's Alan Shepard becomes the first American in space during a sub-orbital flight launched by a Redstone rocket. The flight lasts fifteen minutes, twenty-eight seconds.

Celebrated as a national hero, Alan Shepard is honored with ticker-tape parades and receives the NASA Distinguished Service Medal from President John F. Kennedy. *National Aeronautics and Space Administration.*

MAY 6

1776—The elected delegates from Hampton and Elizabeth City County to Virginia's fifth revolutionary convention, commencing in Williamsburg on this date, are Wilson Miles Cary and Henry King. In the absence of English authority, and with Virginia troops massively supporting a revolution whose leading general is Virginian George Washington, the convention is the state's governing body. On May 15, the convention declares that the former government, under the authority of King George III and Parliament, is "totally dissolved." Crucial resolutions call for a declaration of rights for

Virginia, the establishment of a republican constitution, and the adoption of federal relations with whichever other now-sovereign colonies would have them and alliances with whichever foreign countries would so choose. It also instructs its delegates to the Continental Congress in Philadelphia to declare independence, stating memorably that "these colonies are, and of right ought to be, free and independent states." Richard Henry Lee in Congress moves for independence using those precise words on June 7. The convention adopts George Mason's magnificent Bill of Rights on June 12 and a state constitution on June 29, also selecting Patrick Henry as the state's first governor.

1862—President Abraham Lincoln arrives at Fort Monroe aboard the revenue cutter *Miami*, preparatory to the commander in chief's oversight of a Union assault on Confederate-held Norfolk, which he plans with General John E. Wool and Flag Officer Louis M. Goldsborough.

1905—First Lieutenant Moses Robert Ross of the Coast Artillery Corps leaves the Fort Monroe Officers Club on a bicycle borrowed from a friend and accidently falls into the shallow water of the moat, becoming the only officer known to have drowned in the moat. His younger brother, Rear Admiral Richard Ross of the U.S. Coast Guard, will donate the victim's uniforms and other personal effects to the fort's Casemate Museum.

1966—In ceremonies at Langley Air Force Base, a new $2.8 million hospital with a 128-bed capacity, is dedicated; it will serve personnel at the oldest continually active air force base in the world.

2016—With a talk by Virginia Supreme Court Justice S. Bernard Goodwyn highlighting the occasion, a new $21.5 million Hampton Circuit Court Building is dedicated on North King Street. Three full-sized courtrooms with jury boxes accompany two smaller chambers handling mediations and motion hearings, while 120 closed-circuit cameras provide security.

MAY 7

1735—A petition from masters of British vessels entering Hampton Roads asks that the custom collectors be moved from the small town of Hampton over to Norfolk. The captains state that there is "little or no Business at

Hampton," while most are inclined "to goe to Norfolk, for provisions, Rum, Lumber, &c." They also think that the anchorage at Norfolk is deeper and less dangerous. A similar petition to the same effect had already been submitted from Norfolk merchants on April 2, 1735, which noted the difficulty of navigating from Hampton over to Norfolk, sometimes taking two days because of tides, adverse winds, and heavy streamflow down the James River.

1761—Thirteen-year-old John Paul Jones, an apprentice sailor on his first mercantile voyage from Scotland, arrives in Hampton on board the *Friendship*. He would visit Virginia several times on this ship, usually to see his older brother, William, who had immigrated to Fredericksburg. Jones also immigrates and becomes the first naval hero of the United States, as captain of the *Bon Homme Richard* when it defeats the English ship *Serapis* on September 23, 1779, off the English coast.

1915—The huge British ocean liner *Lusitania* (surreptitiously carrying 4 million rounds of ammunition for use in World War I in addition to passengers) is sunk by a torpedo from a German U-boat. The nearly 1,200 American casualties include the president of the Newport News Shipbuilding and Dry Dock Company, Albert L. Hopkins. Following the christening of the USS *Pennsylvania* on March 16, the commander of the *Prinz Eitel Friedrich*, a German warship visiting Hampton Roads, had been invited to the gala christening party put on by the shipyard at the Hotel Chamberlin, but a scheduled May 12 dinner for the captains of two German sea raiders recently repaired by the shipyard—after they daringly escaped from the pursuing British ships by entering Chesapeake Bay—would be abruptly canceled because of the sinking of the *Lusitania*. The United States was inching closer to participation in the war on the British side.

MAY 8

1862—From newly renamed Fort Wool, President Abraham Lincoln observes the Federal fleet's bombardment of the Confederate base at Sewell's Point (now the site of Norfolk Naval Base). Under Lincoln's gaze, the CSS *Virginia* (*Merrimack*) emerges from the Elizabeth River and drives all Federal ships back to Fort Monroe, but a shot from Fort Wool that passes over the

Virginia eventually sends the formidable Confederate ironclad back to port. The Federal cannonading resumes and continues all night.

MAY 9

1862—Major General John E. Wool leads a Federal amphibious expedition from Fort Monroe across Hampton Roads against Confederate forces on the Southside. Earlier that morning, President Lincoln had personally chosen the spot at Ocean View where the troops would disembark, but he apparently returned to Fort Monroe during the assault. It is nevertheless by far the most danger a president ever placed himself in while acting as commander in chief and the clearest example of a president's assuming direct operational control of a wartime military action. The Federals land safely and advance rapidly to capture Norfolk, Portsmouth, and the large Confederate shipyard at Gosport, the latter of which had been partially burned by retreating Rebels. The Federals also capture much weaponry and ammunition.

MAY 10

1831—Twenty-four-year-old Lieutenant Robert E. Lee of the U.S. Army is serving at Fort Monroe, having reported for duty three days earlier. Lee, an engineer, proves instrumental in helping to forward the construction of this large military base. He works on the wharves, the outer fortifications, and the water battery, while supervising completion of the moat. He contributes to the ongoing work on its companion, the island bastion Fort Calhoun, to be renamed Fort Wool in the spring of 1862. Lee would later describe his three-year assignment as "one of the happiest" of his life.

1862—Learning of the capture of Norfolk, President Abraham Lincoln, staying at Quarters 1, the residence of Fort Monroe's commanding officer, does a happy jig in his nightshirt. Built in 1819, the three-story Federal-style structure is the oldest building at the fort. It hosted the Marquis de Lafayette on his 1824 visit and was the setting for General Benjamin Butler's meeting with three escaping slaves on May 24, 1861, when he termed them "contrabands" and refused to restore them to their "owner."

MAY 11

1849—In a letter of this date written by Helen Hoskins to her mother in Massachusetts, a very recent uprising of slaves in Hampton is mentioned. Slave patrols had been called out nightly, and many whites were highly alarmed. Hoskins writes, "All servants have been compelled to be home at nine o'clock." She is a teacher at the Hampton Female Institute and is certain that "there is [no] negro in Hampton that would harm me." Despite the fact that, as historian Robert Engs noted, life for the Hampton slave "was less harsh than in the rest of the Old Dominion," slaves still wanted their freedom and would take every possible opportunity to achieve it.

1862—The Confederates blow up the CSS *Virginia* (*Merrimack*), as its draft is too deep to steam up the James River toward Richmond, while the guns at Fort Monroe and Fort Wool prevent it from leaving Hampton Roads. The Union's capture of Norfolk and the Elizabeth River deprives it of a safe home port.

1862—President Lincoln ends his stay at Fort Monroe and returns to Washington, having made a short detour to Craney Island to view whatever might have been left of the recently sacrificed CSS *Virginia* before moving back up the Chesapeake. He promotes Fort Monroe commander John E. Wool to major general, afterward noting that Wool's leadership and skill shown in the landing and capture of the cities on Hampton Roads's Southside, forcing Confederate evacuation of the batteries at Sewell's Point and on Craney Island and bringing about the destruction of CSS *Virginia* (*Merrimack*), "are regarded by the President as among the most important successes" so far in the Civil War.

MAY 12

1611—Sir Thomas Dale arrives from England as the new governor of the Virginia colony, stopping briefly at Point Comfort and Kecoughtan and then hurrying upriver to Jamestown. He requires the Jamestown settlers to fell timbers to repair the village's houses and James Fort and to build a wooden stockade around the village. In ten days, he would return to inspect the settlement at Kecoughtan.

1812—Governor James Barbour reports to the Virginia Council of State that he has reviewed militia troops and artillerists at Hampton, finding the men to be excellent shots and Captain Pryor a skillful cannoneer, and asks for two hundred pounds of powder, cannonballs, and lead shot to be supplied to them to deter the British navy from raiding on shore for supplies and sailors.

1938—In one of the most famous exercises involving Langley Field–based aviation units, three B-17s take off from Mitchell Field, New York, to demonstrate the significance of air power's long-range navigation and sea search. With pilot Major Caleb Haynes and navigator First Lieutenant Curtis LeMay in the lead plane, the squadron successfully locates and "intercepts" the Italian liner *Rex*. Passengers on the ship wave to onlookers, and the event is broadcast live on NBC radio. Thanks to the reporters from NBC and major New York newspapers who are onboard the planes, the story appears nationwide the next day.

1991—President George H.W. Bush delivers the commencement address at Hampton University. Many of the students protest his appearance.

2007—The Fox Hill Merchants softball team defeats G.P. Gwaltney of Suffolk in an exhibition double-header, the first contests for the Hillians in seventeen years. From 1946 through 1990, Fox Hill provided the equivalent of a major-league sports attraction with its fast-pitch teams, winning state championships in 1955, 1956, 1959, 1960 and 1962–68 and participating in the fast-pitch World Series in 1965, 1967, 1969 and 1973. As many as 4,500 spectators crowded into the stadium behind Francis Asbury School one Saturday night in 1960, and fans came in droves to see such world-class teams as the Clearwater (FL) Bombers and the Flatiron Athletic Club of Philadelphia. The Hillians never had a losing season but quietly faded out of existence in 1990.

MAY 13

1861—Colonel Justin Dimick, commanding at Fort Monroe, establishes Camp Hamilton across Mill Creek on pastures belonging to Joseph Segar. Much space is needed for the thousands of Northern troops being sent to reinforce Fort Monroe so that the key fortification will stay in Union hands and to be in position to move toward the Confederate capital in Richmond.

After the Civil War, the camp becomes the core of the town of Chesapeake City, which in 1908 is renamed Phoebus.

1867—Former Confederate President Jefferson Davis is released from his confinement at Fort Monroe. His bail of $100,000 is put up by notables such as Horace Greeley, Cornelius Vanderbilt, and Gerrit Smith, the latter a former financial supporter of John Brown. Davis joins his family in Canada, where they will remain until 1868. President Andrew Johnson's amnesty of Christmas Day 1868 relieves him of the indictments pending against him for treason and murder.

MAY 14

1861—A Hampton militia unit, the Old Dominion Dragoons, musters its fifty-one cavalrymen into Confederate service. They will serve at the Battle of Big Bethel in less than a month's time.

1866—The Hampton National Cemetery is established in what would become Phoebus, near the National Soldiers' Home, for the burial of soldiers who served in the Union army. Later, it is opened to the interment of other military personnel, including Confederates. Nine Congressional Medal of Honor recipients rest there.

Hampton National Cemetery, encompassing 27.1 acres with more than thirty thousand interments, is listed in the National Register of Historic Places in 1996. *Library of Congress.*

1952—The still uncompleted *United States*, the largest ocean liner ever built, leaves its berth at the Newport News Shipbuilding and Dry Dock Company and sails majestically past the Chamberlin Hotel, heading into the Atlantic Ocean for two days of time trials, to be measured by Hastings Raydist instruments made in Hampton. A select group of guests, with onboard crew raising the total number to 1,699 people, endure heavy seas and high winds on a short but entertaining luxury cruise. Making thirteen runs over a five-mile course, the *United States* eventually was coaxed up to a speed exceeding thirty-four knots, some said greater than forty (the official number was not released).

MAY 15

1915—En route in a leisurely way from Washington, D.C., to New York City on the presidential yacht USS *Mayflower*, where he would review the Atlantic Fleet, President Woodrow Wilson arrives at Old Point Comfort. A friend drives the president to the Hampton Roads Golf and Country Club, where Wilson plays two rounds, or eighteen holes, that evening. The clubhouse for the course is located at the junction of Kecoughtan Road and Hampton Roads Avenue (named for the golf course), and its nine holes cover 2,660 yards between Hampton Roads Avenue and East Avenue, stretching from Kecoughtan Road to the Boulevard (now Chesapeake

The luxurious steam vessel USS *Mayflower* served as presidential yacht until 1929, providing the setting for much of President Wilson's courtship of Edith Bolling Galt. *Library of Congress.*

Avenue). Wilson would also play there in May and July 1916 and probably on other occasions. Established in 1896, the club and course would close after 1920 for neighborhood development. Before departing, the president visits historic sites in Hampton and stops briefly at Fort Monroe.

1983—The famous African American photographer James Van Der Zee passes away. A skilled pianist and violinist, Van Der Zee also becomes enamored of photography. Upon his marriage in 1907 to Kate Brown, the couple moved to Phoebus to be near her relatives, and while working at the Chamberlin Hotel, Van Der Zee took memorable photographs of African American life, including images of Whittier School and a blacksmith shop, whose capturing of light earned him artistic comparison with the great Italian painter Caravaggio. The Van Der Zees moved in 1908 back to New York, where he achieved some fame. The Metropolitan Museum of Art put on a major photography exhibition in 1969 that featured his work and drew him out of obscurity.

MAY 16

2003—Hampton breaks ground for the Hampton Roads Convention Center, near the Hampton Coliseum. Spanning 344,000 square feet, the versatile state-of-the-art facility includes a conference center, banquet seating for more than two thousand, ballrooms, meeting rooms, and exhibit areas. It can accommodate fourteen thousand people. Its white peak-shaped awnings suspended over the entrance resemble the billowing sails of a large ship racing across the sea.

2013—Hampton holds a citizens' meeting to begin discussion of possible reuses of the George Wythe Elementary School site. The original school with this venerable name opened in 1909, consolidating the Riverview and Merrimac Schools, and was closed in 1950. George Wythe Junior High School, one of the last original examples of early Art Deco architecture in Hampton and built next to the elementary school, was opened in 1937. In 1950, with the opening of a new junior high school, the old one became George Wythe Elementary School, and it is the building for which other community uses are sought. It closes in 2010.

MAY 17

1620—The borough of Kecoughtan is renamed Elizabeth City by order of the Virginia Council to honor "His Majestie's [James I] most virtuous and renowned daughter." The name is perpetuated when, in 1634, Virginia will be divided into eight shires, one of them being called Elizabeth City Shire.

1715—Hampton's court fines Alexander Avery, John Whitfield, Thomas Taylor, and ten other men fifty pounds of tobacco each for failing to attend church services. Until Virginia separates church from state in 1786, the Episcopal Church is the colony's established religion, supported by taxation, and everyone is legally required to attend its services no matter their personal religious beliefs or church affiliations.

MAY 18

1861—Major General Benjamin F. Butler is ordered by General-in-Chief Winfield Scott of the U.S. Army to proceed to Fort Monroe and assume command of that post. It would begin the first of Butler's two tours in command at Fort Monroe.

1985—Fort Wool, which had been closed since 1980, is reopened to visitors by Hampton as a historical park of the city. Due to a quirk of history, the boundaries of Hampton extend across the entrance of Hampton Roads to the mean low-water mark off Willoughby Spit in Norfolk, so the fort, built on an artificial island in shallower water near the Spit, is within the city.

MAY 19

1865—Former Confederate President Jefferson Davis, arrested by the United States as he flees through Georgia and charged with treason and murder, arrives at Old Point Comfort on board the steamship USS *William P. Clyde*, escorted by the warship USS *Tuscarora*. He would spend the next two years as a prisoner at Fort Monroe.

1960—Dr. Jerome Holland is announced as the ninth president of Hampton Institute (now Hampton University). The first African American to play on Cornell University's football team, Holland earns a PhD in sociology from the University of Pennsylvania in 1950 and serves as president of Delaware State College from 1953 to 1960. Following his tenure at Hampton, Holland becomes U.S. ambassador to Sweden (1970–72) and in 1972 becomes the first African American to sit on the board of the New York Stock Exchange.

MAY 20

1695—"A negroe Joan belonging to Eaton's free school," after a lifetime of devoted duty, is ordered "by reason of age" to be "free from Paying Levyes [taxes] and what crops she makes of Corne, Tobacco or Pulse [beans]…she keepe the same to her owne use for her maintenance."

1886—The Marquand Memorial Church is dedicated at Hampton Institute (now Hampton University). A gift from the estate of Hampton Institute Trustee Frederick Marquand and designed in an Italian Romanesque style by J. Cleveland Cady, a distinguished New York architect who also designed the Metropolitan Museum of Art in New York and the Peabody Museum at Yale University, it is perhaps the most striking of the several buildings at the university that have been designed by famous architects. The iconic clock tower of the church would not be completed until 1887.

1898—Three thousand people attend the sendoff ceremony bidding farewell to Hampton's Peninsula Guards, the predecessor of Battery D, as it departs by train for service in the Spanish-American War.

1911—Chesterville, the home built by signer of the Declaration of Independence George Wythe, ignites and burns due to the explosion of a kerosene stove in the kitchen. The ruins, as well as the remains of an earlier home of the Wythe family in which George was probably born, are on the restricted property of NASA at Langley Air Force Base.

1930—President Herbert Hoover visits Fort Monroe and makes a nationwide radio address from the Commandant's House. The president also visited Old Point briefly in 1929 and 1931.

1932—Amelia Earhart begins the first successful solo transatlantic flight by a woman. She would land near Londonderry, Ireland, fifteen hours later. In 1928, while touring the facilities of NACA (now NASA) at Langley, a knee-length raccoon fur coat she was wearing is pulled into the fan of a small high-speed wind tunnel. Earhart is surprised but unhurt. In 1930, while testing her Lockheed Vega 5B (nicknamed the "Little Red Bus") for the cross-ocean adventure, her plane noses over during landing and must be repaired.

MAY 21

1610—With starvation rampant, Captain George Percy plans to move half of his men from Jamestown down to Point Comfort, with the purpose of having them fed on the seafood much more plentiful there. The plan is not effectuated.

1861—Colonel John Bankhead Magruder is appointed to command the Confederate forces on the lower Virginia Peninsula. He places his headquarters near Yorktown, sending several expeditions of soldiers to reconnoiter and harass the Federal positions near Fort Monroe and, eventually, at Newport News Point, all the while fortifying Yorktown and Gloucester Point to attempt to restrain or defeat any Federal attacks either on land up the Peninsula or on water via the York River.

MAY 22

1611—The new English governor at Jamestown, Sir Thomas Dale, sails down the James River to Point Comfort and Kecoughtan, reoccupying and restoring Forts Henry and Charles, which had been built by Sir Thomas Gates in July 1610 and then abandoned in the autumn. The forts are intended both as strongholds against Indian attack and as places of respite for incoming settlers "that the weariness of the sea may be refreshed in this pleasing part of the countree." Dale orders the planting of much corn around the two forts and appoints Captain James Davis to be "taskmaster" (commander) over both. Also repaired and placed under

Davis's command is Fort Algernourne at Point Comfort, which guards against threats from the Spanish.

1865—Escorted by Major General Nelson A. Miles, the newly selected commandant at Fort Monroe, former Confederate President Jefferson Davis begins serving his imprisonment in Casemate no. 2 at Fort Monroe. After two years without trial, he is released on bail of $100,000. The unit he inhabited is now part of the Casemate Museum, and the cell used during his imprisonment has been restored to resemble its Civil War–era furnishings. General Miles would eventually serve as the commanding general of the U.S. Army during the Spanish-American War.

MAY 23

1610—Sir Thomas Gates and Sir George Somers on the Bermuda-built pinnaces *Patience* and *Deliverance* reach Point Comfort. They had sailed from England on June 2, 1609, in *Sea Venture* but had been shipwrecked in Bermuda by a hurricane on July 25. Six other vessels accompanying *Sea Venture* to resupply the Jamestown colony had landed at Point Comfort the previous summer, having braved the giant storm.

1861—Sent from Fort Monroe by recently arrived Federal garrison commander Major General Benjamin F. Butler, Colonel John W. Phelps and the First Vermont Regiment march into Hampton to halt the vote on secession ordered by the Virginia General Assembly. Although previously opposed to leaving the Union, Hampton's citizens are swayed and angered by the firing upon Fort Sumter, and after the First Vermont retires to Fort Monroe, they vote 360 to 6 to secede. The popular vote in the state overwhelmingly ratifies Virginia's secession.

1861—Hearing of the developments in Hampton and greatly fearing that their master, Colonel Charles King Mallory of Hampton, is going to sell them south, away from their families and out of the reach of the Federal army, three young enslaved men—Shepard Mallory, Frank Baker, and James Townsend—seize a boat at night and row from Sewell's Point, where they had been working on Confederate fortifications, across Hampton Roads to Fort Monroe to ask for their freedom. They rest outside the fort's gate overnight.

1934—NACA holds the ninth annual Aircraft Engineering Conference at Langley Field, for executives and engineers in the aircraft industry and government officials. Howard Hughes, Orville Wright, and Charles Lindbergh are among the attendees.

MAY 24

1861—In command at Fort Monroe, Major General Benjamin F. Butler, a lawyer, ingeniously terms three Hampton slaves escaping from their master "contraband of war"—that is, property owned by the enemy that is useful to the enemy's war effort—and allows them and their families to stay. The men are put to work but are paid wages. Word travels fast, and soon dozens and then hundreds of enslaved people escape their farms and journey to Fort Monroe. Many join the Union army, while others perform labor such as farming or janitorial work. The women work too, chiefly as domestic servants for Union officers and as laundresses. By the end of the war, more than ten thousand slaves will seek refuge as contrabands at "Freedom Fort," while tens of thousands more will claim contraband status with other portions of the Union army in York and Gloucester Counties, at New Orleans, in Missouri, and throughout the South.

1924—A centennial celebration is held at Fort Monroe commemorating the opening of the U.S. Artillery School (now called the Coast Artillery School) in 1824. In one of his final appearances in uniform prior to retirement, General of the Armies John J. Pershing reviews the troops, tours the post, and gives an address, as does Virginia's Governor E. Lee Trinkle.

MAY 25

1919—Hampton's Battery D returns home from service in World War I. Boats loaded with happy people meet the troopship in Chesapeake Bay and escort it into the harbor.

MAY 26

1902—In a rebuilding program at Fort Wool, an artillery battery housing two three-inch rapid-fire guns is readied for service amid the scraps and remnants of the old stone fort, its construction and installation having been completed the previous day. A second such battery fronting the Chesapeake Bay would be readied in the fall of 1905.

MAY 27

1861—By order of General-in-Chief Winfield Scott, Major General Benjamin F. Butler assumes command of the Federal Department of Virginia, embracing the area within sixty miles of his departmental headquarters at Fort Monroe. Butler almost immediately seizes farmland across the Peninsula at Newport News Point, at the entrance to the James River, and begins to convert it into a Union army post, called Camp Butler. Two thousand troops and four eight-inch Columbiad cannons are placed there.

1931—The NACA Full-Scale Tunnel is dedicated, allowing for the testing of full-sized aircraft. Subsequently, swept-wing aircraft, the Mercury space capsule, vertical takeoff and landing aircraft, and blended wing–body aircraft are tested here. Ultimately closed on September 4, 2009, the wind tunnel would be demolished in 2010.

1962—Golf legend Sam Snead celebrates his fiftieth birthday by playing an exhibition round at the Hampton Country Club, a course now called the Woodlands. The foursome includes the 1961 U.S. Open champion Gene Littler and two of the best local golfers, Wayne Jackson and Ronnie Gerringer. The course, which overflows with rapt spectators, had opened in 1916 as the new attraction of the Hotel Chamberlin.

MAY 28

1865—Due to popular clamor, as well as pressure by Lieutenant Colonel John Craven, Fort Monroe's chief medical officer, the ankle irons restricting

the movement of Jefferson Davis are ordered to be struck off. They had been attached to Davis's ankles by the fort's blacksmith, Henry Arnold, on May 23, but only after Davis violently resisted being shackled like a slave. It had taken four unarmed soldiers to restrain Davis while Arnold completed his work.

1999—Bill's Barbecue closes its doors. The burger and barbecue emporium had been the hangout place for generations of kids, teens, and young people in Wythe. Those growing up in this part of Hampton for the sixty-seven years since Bill's opened have fond memories of dates, food, truancy from school, lounging around, and the big blue whale sign on the roof.

MAY 29

1946—The Tactical Air Command settles in at Langley Field, having been renamed and moved by the U.S. Army Air Corps from Tampa. Tactical air power developed rapidly during World War II to support movements and combat by ground forces. TAC concentrates on developing combat procedures for fighters and light bombers; it also develops the capability to deploy tactical striking forces anywhere in the world. In 1992, in a major reorganization by the U.S. Air Force after Operation Desert Storm and the collapse of the Soviet Union in 1991, TAC's resources would be merged into the Air Combat Command, also headquartered at Langley.

1951—The airstrip at Fort Monroe is dedicated as Walker Army Airfield. A brass plaque is presented by General Mark Clark, since the honoree, Lieutenant Colonel John Walker, had been Clark's personal pilot in the Mediterranean Theater during World War II. In addition to piloting for other high-ranking men, including Generals George C. Marshall, Hap Arnold, and Dwight D. Eisenhower, Walker flew artillery-spotting and forward liaison planes, winning many decorations including the Silver Star. He was killed in Italy in February 1945, as the transport plane carrying him home for a leave crashed on takeoff.

MAY 30

1849—The cholera epidemic spreading down the Atlantic seaboard reaches Richmond and Norfolk. It breaks out in Hampton and Elizabeth City County a few days later, and according to George Benjamin West, a local resident, a great many people died. In Tennessee, the life of former President James K. Polk is claimed. The episode is a part of the great cholera pandemic (infecting many people all over the globe) of 1829–51, which originated in India. Cholera killed more people more quickly than any other epidemic disease in the nineteenth century. The disease originates in water and food contaminated by feces but spreads easily among humans. Essentially a disease of rapid dehydration, today it is easily treatable if caught early.

1906—After delivering a Memorial Day speech to Union and Confederate veterans in Portsmouth, President Theodore Roosevelt arrives at Old Point Comfort and travels to Hampton Institute (now University), where he privately addresses African American and American Indian students.

1930—The dedication takes place for the opening of Greenbriar School, in Hampton's black neighborhood of Garden City. It is the 5,000th Rosenwald School. Having become aware of the needs of poor African Americans through acquaintance with Booker T. Washington, Julius Rosenwald, part owner of Sears, Roebuck and Company, establishes the Rosenwald Fund in 1917. Although it gives millions to museums, Jewish charities, higher education, and other worthy causes, the primary philanthropy of the fund is to build schools for African Americans, almost all of them in the South. By the time its resources become depleted in 1948, the Rosenwald Fund will have constructed 5,130 schools and 217 teachers' homes in fifteen states from Maryland to Texas. The old Greenbriar School building would later house the Garden City's Boys' and Girls' Club. The Garden City Cultural and Historical Society on Shell Road was established in 1913.

MAY 31

1921—General Billy Mitchell commands the First Provisional Air Brigade of the U.S. Army at Langley Field. With this new assignment, bomber aircraft, fliers, support personnel, and necessary supplies are concentrated in one location.

General of the Armies John J. "Black Jack" Pershing and General Billy Mitchell inspect an aircraft assigned to Mitchell's air brigade at Langley Airfield. *Library of Congress.*

June

JUNE 1

1903—The Merchants National Bank opens its doors in Hampton in a temporary building, with Hampton businessman Hunter R. Booker as its president. By the end of the year, the Darden Store is remodeled as the bank's permanent home. It would become the second bank in the nation to make a Federal Housing Insured Mortgage Loan.

1951—The Casemate Museum at Fort Monroe opens to the public. With the termination of the United States military presence at Old Point Comfort in 2011, the museum would remain open, chronicling the history of the various fortifications that have been erected there.

2012—A tornado forms as a waterspout in Hampton Roads with winds above 95 miles per hour and travels 3.5 miles through the Hampton neighborhoods of Merrimac Shores and Park Place, also striking downtown, causing $4.3 million in damage. The twister hits during Hampton's annual Blackbeard Festival. Three businesses are struck, including L.D. Amory Seafood on the Hampton waterfront. C. Meade Amory, fourth-generation owner of the business founded in 1917, said it took more than three weeks to clean up the debris and repair his business, but it is once again opened.

JUNE 2

1813—In the War of 1812, barges loaded with British troops attempt to enter Harris Creek, off Back River and about three miles north of Hampton, but local citizens repulse the attack. It is the first reported British attempt of the war to land on the north side of Hampton Roads. After weeks of planning, the British will attempt to attack Norfolk on June 22 but will be defeated by Virginia militia at the Battle of Craney Island. Stung deeply by these losses to the "peasants," the British will return to attack Hampton in force.

1862—Major General John E. Wool, following his successful capture of Norfolk and Portsmouth, is transferred from Fort Monroe to other commands. His troops would deal with the Draft Riots in New York City in July 1863, and he would retire from the U.S. Army the following August 1 after fifty-one years of service. Wool at seventy-nine is the oldest general officer to serve on either side in the Civil War.

JUNE 3

1852—By an act of Virginia's General Assembly, the trust funds for public schools in the seventeenth-century estates of Benjamin Syms and Thomas Eaton are transferred into Hampton's public school treasury. They remain as trust funds into the twenty-first century, helping to educate the children of Hampton.

JUNE 4

1766—Daylong celebrations at Hampton's King's Arms and Bunch of Grapes taverns honor both King George III's birthday and the British Parliament's repeal of the Stamp Act. Created to defray the cost of maintaining troops in the American colonies, the act levied the first English tax to be directly applied to people in America, since everyone purchasing or using printed material (including newspapers, legal documents, and playing cards) had to pay for the specially stamped paper. The colonists, previously fractious, became united in opposition to this "taxation without

representation" (colonials had no representatives in Parliament) and engaged in strong colonies-wide protests, some involving violence. Repeal of the act muted the protests.

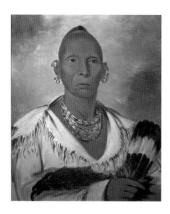

After his release, Black Hawk related his story in the first Native American autobiography published in the United States. It became an immediate bestseller. *Wikimedia Commons.*

1833—Sauk medicine man and leader Black Hawk is released from Fort Monroe after an imprisonment of a few months following his capture in battle by the U.S. Army. The Native American man and his two companions were "beset by visitors who crowded to see them from all quarters." Noted artists Robert M. Sulley and John Wesley Jarvis traveled to Old Point to paint Black Hawk's portrait.

1870—An 1867 bequest of $100,000 by Horatio Ward, who divided his time between New York City and London, is awarded by the U.S. government for construction of what becomes the National Soldiers' Home, Southern Branch, at Hampton.

1914—The Hampton Chapter of the Equal Suffrage League, desiring adoption of the Nineteenth Amendment to grant women the right to vote, is organized. Membership includes white women born in Elizabeth City County before the Civil War, plus some who moved here from the North after the war. By September 1914, the group would have 135 members, and by November 1917, 285 members, including several men, were on its rolls. The group would be greatly gratified by the passage of the amendment in 1920, more than forty years after it was drafted.

1918—A youthful North Carolinian, Thomas Wolfe, signs on as a laborer in the construction of Langley Field. He quits on July 4, beset by bedbugs and mosquitoes. His experiences will later be incorporated into his famous novel *Look Homeward, Angel*, published in 1929, although in the book the character representing Wolfe works in a Norfolk shipyard. Wolfe's first novel is widely considered to be autobiographical.

JUNE 5

1667—Miles Cary of Warwick County is wounded at Old Point Comfort in a battle with the Dutch during the Second Anglo-Dutch War. He perishes from his wound five days later. The Dutch and English are great commercial rivals with large merchant fleets, but the Dutch are wealthier and can afford to build heavier warships. Although they had lost the first war fifteen years before, the Dutch are victorious in the second, fought on a worldwide basis. The victors did not, however, regain their colony of New Netherland (now New York), which had been seized by the English in 1664. The Dutch attack on Virginia came after they defeated the English throughout the Caribbean and seized all English colonies there, but it resulted only in local devastation in Virginia and no land concessions.

1737—A smallpox epidemic is reported at Hampton. This devastating disease has several different varieties, most of them deadly and all resulting in disfiguration after survival. High fevers and delirium are characteristic. Except for a virulent outbreak in 1715, Virginia is hit with smallpox relatively lightly and periodically in the eighteenth century. By the 1720s, the Oriental practice of inoculation, or deliberately infecting a person with a weaker strain of the virus, was beginning to be used in the colonies. Inoculation is often deadly in itself and proves a very controversial issue, causing much fear in the populace. Rioting occurs in 1768–69 when many citizens of Norfolk proclaim their desire to be inoculated. Eventually, inoculation is outlawed. Vaccination with cowpox proves after about 1800 to be a much safer way to protect against smallpox, and its use spreads widely.

1881—President James A. Garfield, a major general in the Union army during the Civil War, visits Hampton and attends religious services at Hampton Institute (today Hampton University) as a demonstration of his support of education for freedmen. During his short tenure in office, Garfield appoints several black citizens to federal office, including Frederick Douglass as recorder of deeds in Washington and John Mercer Langston as ambassador to Haiti. Garfield would be shot by a deranged disappointed office-seeker less than a month after his Hampton visit and would die after lingering for eighty more days.

JUNE 6

1861—Confederate Major E.B. Montague and a small force move down from Yorktown to occupy Big Bethel Church, in York County just over the Elizabeth City County line.

1944—On what would be soon memorialized as D-Day, the 29th Infantry Division of the U.S. Army, led by the 116th Infantry, spearheads the Allied assault against Nazi-occupied France, fighting their way ashore on Omaha Beach in Normandy. The units had trained in England, having arrived there on October 5, 1942. The 111th, containing many troops from Hampton, lands after the beach has been taken.

1948—Delayed by construction overruns and rain, the new Peninsula War Memorial Stadium opens as the Newport News Dodgers play the Norfolk Tars. It realizes the dreams of local entertainment entrepreneur Herbie Morewitz and Brooklyn Dodger baseball executive and visionary Branch Rickey. Over the years and under many major-league affiliations, such future major-leaguers as Johnny Podres, Johnny Bench, and Lou Pinella will appear there. The 1980 Peninsula Pilots, a Philadelphia Phillies farm club, will win one hundred games while losing only forty. Home to the Newport News shipyard's Apprentice School squad and a summer professional development team, the field will also be used by local teenage leagues and women's fast-pitch softball teams.

JUNE 7

1610—The Jamestown colonists, "our miseries now beinge at the hygheste" since their peak population of about five hundred, were "onely lefte about sixty, the reste being either sterved throwe famine," having deserted, or having been killed by Indians; they decide to return to England. On June 9, their four ships are met in Hampton Roads or the lower James River by three vessels under Thomas West, Lord De La Warr, with additional colonists, including a doctor, as well as much food and supplies. All go to Jamestown, and the colony is saved.

1861—Many more Confederates come down from Yorktown to Big Bethel Church. Colonel D.H. Hill and Major George W. Randolph and their men begin building fortifications on both sides of Wythe Creek, the boundary

between Elizabeth City and York Counties. The main defensive work is on the York County side, with a significant redoubt thrown up around a rise on the Elizabeth City side. Both are thoroughly hidden and disguised with cut bushes, small trees, and foliage.

JUNE 8

1806—The greatly venerated elder statesman, jurist, and law teacher George Wythe, seventy-nine, is buried near the door of St. John's Church in Richmond. Wythe, born and reared at Chesterville in Elizabeth City County, had been poisoned with arsenic two weeks earlier by George Wythe Sweeney, his profligate, larcenous, and ungovernable ward and great-nephew, sixteen, in order to obtain an inheritance. Wythe lives long enough to cut Sweeney out of his will. Also poisoned are Michael Brown, a young freed black man Wythe was educating in mathematics, philosophy, languages, and science, and Lydia Brodnax, Wythe's black cook and housekeeper whom he had freed from slavery in 1787. Brown also dies, but Brodnax survives, although her health is greatly impaired. Sweeney is arrested with arsenic in his possession and is tried for murder but is acquitted because the testimony of Brodnax, who had seen him pour a white powder into the stewpot, is inadmissible—Virginia law did not allow a black person to testify in court against a white person.

JUNE 9

1741—The Virginia Council hears a petition from inhabitants of Norfolk and Hampton desiring relief because Spanish privateers are committing depredations near the Capes at the mouth of Chesapeake Bay. The petitioners are ordered to attend the council on the succeeding day to estimate how much it would cost to fit out a proper vessel of war for three months to deal with the issue, to name a person to command it, and to provide men for the expedition.

1861—One contingent of Union troops, marching in the middle of the night from its camp at Newport News Point toward a Confederate entrenchment

at Big Bethel Church, mistakenly fires on another Union column from Fort Monroe near what is today the bridge over Newmarket Creek on Power Plant Parkway. Twenty-one soldiers are killed or wounded. The plans of Major General Benjamin F. Butler to surprise the Confederates are disrupted, as the sounds of the encounter are heard by them. After the error is discovered, the troops re-form themselves and move on to attack the Confederates.

1920—After intense lobbying by General Billy Mitchell, and following an unsuccessful attempt to buy a German zeppelin, the U.S. Army Air Service negotiates a contract with the Italian government to purchase the semi-rigid airship *Roma*.

JUNE 10

1861—Outnumbered almost four to one, Confederate forces under Colonels Daniel Harvey Hill and the recently arrived John Bankhead Magruder, cleverly hidden within well-constructed entrenchments near Big Bethel Church on the border between Elizabeth City and York Counties, in a three-hour battle soundly defeat an attacking Federal force under the command of Major General Benjamin F. Butler. It is the first planned land engagement of the Civil War. Elizabeth City County resident Hannah Nicholson Tunnel had risked her life at dawn to warn the Confederates of the approaching Union troops.

1887—Following the incorporation of the town of Hampton, John Brown is elected mayor, while J.W. Williams, James S. Darling, A.D. Wallace, James McMenamin, and J.W. Richardson are elected to the town council. P.W. Phillips is elected town sergeant.

1913—A carved stone monument over the grave of Hannah Nicholson Tunnel at St. John's Church cemetery is dedicated by the United Daughters of the Confederacy on the fifty-second anniversary of the Battle of Big Bethel. The National Soldiers' Home band plays "Dixie" as a Confederate flag is removed, unveiling the monument.

1941—To relieve tactical units undergoing training at Langley, the First Aviation Squadron (Separate), a segregated unit and one of the first African

American units in the U.S. Army Air Forces, is activated at the base. Commencing with 8 enlisted men, the group grows to 233 personnel by late July, performing maintenance and other responsibilities including police, guard duty, runway repair, fireman duty and truck driving.

1947—General of the Army Dwight D. Eisenhower visits Fort Monroe to attend the marriage of his son, John. Having served in World War II and the Korean War, John would transition to the U.S. Army reserves, where he would retire in 1974 as brigadier general. He also was appointed U.S. ambassador to Belgium, 1969–71.

JUNE 11

1791—Methodist circuit preacher James Meecham visits Fox Hill. He returns to preach again on July 8. Tradition says that the fishermen who settled Fox Hill were Methodists. A meetinghouse (as Methodist churches were then known) would exist by 1811. In 1827, brothers Johnson and Edward Mallory and their wives will convey land to the Methodist Society for a new meetinghouse. By the twentieth century, Fox Hill will be served by three Methodist churches.

1920—In combination with completion of its atmospheric wind tunnel, used to test scale models of aircraft, the Langley Memorial Aeronautical Laboratory is dedicated at NACA (now NASA). General Billy Mitchell leads a twenty-five-plane flyover of aviators from the U.S. Army and U.S. Navy in salute, and two giant dirigibles—the *Zodiac* and the navy's *C-3*—awe the thousands of spectators. Two of the airplanes are German and made entirely from metal and had been flown down from Washington, D.C., with their pilots plus five passengers each. Mitchell arranges an air display filled with what a *Times Herald* reporter calls "spectacular flying formations."

JUNE 12

1942—One of a dozen German submarines detailed in Operation Drumbeat to patrol the East Coast of the United States, the *U-701* lays fifteen mines in the Thimble Shoals Channel at the entrance to Chesapeake Bay. Five U.S. ships are

quickly damaged or sunk as World War II comes home to U.S. citizens just six months after war is declared on the Nazis. It is the brainchild of Admiral Karl Doenitz, and Americans are terrified. On June 15, stunned bathers at Virginia Beach witness the daytime explosion of a ship torpedoed by another U-boat. On July 7, the *U-701* is destroyed off Cape Hatteras by two depth charges dropped from a U.S. Army Air Force bomber; only seven men escape and are picked up in a life raft on July 9 near Thimble Shoal lighthouse, inside Chesapeake Bay. Many U.S. merchant ships are damaged or sunk before Doenitz calls his U-boats home to protect the Fatherland in the summer of 1942.

1943—Two of the new P-47D "Thunderbolt" heavy fighter-bomber aircraft stationed at Langley Field apparently collide while performing high-altitude training maneuvers, and they crash in rural New Kent County. The pilots, Second Lieutenants James R. Nall and Henry J. McCaffrey, are killed. Lanexa resident Clifton "Boogie" Davis—at sixteen one of many aircraft spotters who, because of the fear of German aircraft intrusions, were required by law to report all plane sightings—witnesses the crash.

2008—Phenix Hall on the grounds of Hampton University, used for many years as Hampton's high school for African Americans during the era of segregation, is damaged in a fire.

JUNE 13

2001—A groundbreaking ceremony is held for the Hampton History Museum's building. After years as a tenant in the Charles H. Taylor Arts Center and the Virginia Air and Space Center, among other locations, the museum finally obtains its own space and a climate-controlled collections area and galleries. The featured speaker is former state senate majority leader Hunter B. Andrews, like many other Hamptonians a strong supporter of the museum.

JUNE 14

1861—The mammoth "Union" gun, a twelve-inch muzzle-loading Rodman cannon, arrives at Fort Monroe and is placed on the beach. With hefty shells

ranging from 360 to 420 pounds each, the artillery piece itself weighs 52,000 pounds and is sixteen feet long.

JUNE 15

1861—The giant experimental twenty-four-pounder Sawyer Rifle at Fort Calhoun (soon to be renamed Fort Wool) shoots at Confederate batteries at Sewell's Point, three miles distant, striking the area several times with its fifty-three-pound shells. Fired again on June 19, General Butler reports to General-in-Chief Winfield Scott that the gun is a success. The rifled cannon can shoot farther and more accurately than smoothbore guns.

1942—Three Allied ships are destroyed by a German U-boat off Cape Charles. The smoke from the burning HMS *Kingston Ceylonite* is seen from the Chamberlin Hotel.

JUNE 16

2000—Hampton holds its first annual Blackbeard Festival, celebrating a rich local maritime heritage and the capture of the notorious pirate. A reenactment of the battle is staged, even though the actual engagement took place in coastal North Carolina.

JUNE 17

1617—By this date, Governor Samuel Argall of Virginia has divided the colony into four divisions: "the incorporations and parishes of James City, Charles City, Henrico, and Kikotan" (later called Elizabeth City, now Hampton).

1727—Because the old building was "so ruinous that it is Dangerous for them to Repair thither," Henry Cary Jr. commences construction on a new church building on an acre and a half on Queen Street. Despite some destruction in the Revolution, the War of 1812, and the Civil War, this restored building

is still being used by St. John's Episcopal Church. When it is built, the new building (then called Elizabeth City Parish Church) is at the western edge of the town of Hampton.

1942—Worried by the rash of attacks by Nazi submarines against U.S. shipping, especially off the New England, New York, Virginia, and Cape Hatteras coasts, the U.S. Army establishes the First Sea Search Attack Group at Langley Field to assess the equipment and tactics necessary to combat the U-boat assault, called Operation Drumbeat by the Nazis. Specially trained as airplane pilots to hunt submarines in order to defend against Nazi U-boat attacks, the unit would play a key role in the sinking of an enemy submarine off the Florida coast in August 1942, as well as in a probable sinking of another off the Virginia Capes in September 1942.

JUNE 18

1746—At twenty years old, George Wythe is licensed to practice law by the Elizabeth City County Court. Wythe would become prominent in his law practice and would be elected to the Virginia General Assembly and later to the Continental Congress. There he would become, with Thomas Jefferson and John and Samuel Adams, a leading proponent of independence for the United States. He would sign the Declaration of Independence and be a member of the Constitutional Convention. He would also become America's first professor of law, at the College of William & Mary. He would be the teacher and mentor of Jefferson and the teacher of John Marshall and Henry Clay, among many other distinguished lawyers, judges, and statesmen. He also would become an important and respected judge who freed all of his own slaves, courageously ruled against the enslavement of black people from the bench, and publicly proclaimed that slavery was wrong as well as a violation of Virginia's constitution. In his old age, despite his accomplishments and his eminence as a Revolutionary hero, Wythe would be publicly shunned by many for his views on slavery. Wythe is Hampton's most illustrious and noteworthy citizen.

1861—It takes all day at Fort Monroe for twenty-five men to drag the recently arrived mammoth "Union" gun fifty feet, since the cannon is

The "Union" gun, a twelve-inch Rodman Rifle prototype, was placed on a barbette carriage near the Old Point Comfort Lighthouse at Fort Monroe. *National Aeronautics and Space Administration.*

sixteen feet long and weighs fifty-two thousand pounds. Previously retrieved from the river bottom in Baltimore, where it had accidentally fallen, it is finally mounted and ready for action on August 9.

JUNE 19

1813—Three British frigates, two schooners, and a cutter station themselves off the mouth of Hampton Creek (now River), just outside Hampton Bar, during the War of 1812. When one frigate strays away from the others during the night, American forces in fourteen small boats mount an attack at 4:00 a.m.; however, a breeze springs up that allows the other frigates to come to the assistance of their beleaguered companion, and the American attack is halted. On June 21, the British move to attack Norfolk.

1916—The town of Kecoughtan is incorporated. The reviewing court denies the petitioners their first choice of a name, "Hampton Roads." Bordering on Hampton Roads and Salters Creek, adjacent to Newport

News, Kecoughtan lies within the borders of Elizabeth City County. Stretching along Hampton Roads to Pear Avenue and up to Pine Avenue, including the Buxton Hospital (later the Mary Immaculate), the town contains about 1,500 residents and an elementary school, a part of the county school system.

JUNE 20

1860—An agreement is signed between the commandant of Fort Monroe, Colonel Rene DeRussy, and Right Reverend John McGill, bishop of Richmond, to construct a Roman Catholic chapel. Known as St. Mary Star of the Sea, the chapel is rapidly built.

1897—Owned by J.S. Darling, the Buckroe Beach Hotel opens, with a large adjacent pavilion for dancing, along with an amusement park. Over the years, many visitors to the beach resort area of Buckroe enjoy their stay. The amusement park lasts well into the twentieth century. Eventually, its location becomes a large green open space with a bandstand.

1966—A U.S. Marine Corps A6A "Intruder" jet bomber on a routine weather mission crashes into a home on Sergeant Street in Buckroe and explodes, having collided with a similar jet over the Chesapeake Bay. The second jet falls into the water near Thimble Shoal Lighthouse. While the two-man crews each eject and survive, a mother and her infant son are killed on the ground, and more than forty people are injured. The plane begins to disintegrate on the way down, so there is damage to much property—roofs are blown off, walls collapse, automobiles are ruined, and gas mains are ruptured, flames shooting into the air. Eight homes are destroyed. One of the plane's wheels smashes through the window of a local bowling alley a half mile from the crash site, accounting for three of the injured.

JUNE 21

1851—After arriving by steamer at Fort Monroe early in the morning, President Millard Fillmore is greeted at the wharf by officers of the garrison

and their commander, brevet Brigadier General James Bankhead. Upon disembarking, he is welcomed with a twenty-one-gun salute.

1921—The First Provisional Air Brigade from Langley Field begins tests to use bombs dropped from aircraft to attack and sink captured World War I German warships. The submarine *U-117* is sunk in sixteen minutes by three Naval Air Service flying boats. On July 18, with much effort, the cruiser *Frankfurt* is sunk, and finally the battleship *Ostfriesland* is destroyed on July 21. All occurred in the Atlantic Ocean, off the Virginia capes.

JUNE 22

1807—Captain James Barron of Hampton, son and namesake of a captain in Virginia's Revolutionary naval forces, surrenders USS *Chesapeake* to the superior British frigate HMS *Leopard*, which—in the belief that deserters from the Royal Navy were serving onboard—had fired on his vessel in the Atlantic near Cape Henry. *Chesapeake*'s decks are crowded with crates and boxes, and most guns are stowed, as the ship is en route to the Mediterranean. Barron is able to fire only one cannon in defense. The British inflict great damage, killing three sailors and wounding eighteen, including Barron, who believed that further resistance would subject his ship and crew to destruction. While four deserters are found (three of them American citizens who had been pressed, or shanghaied, into the Royal Navy), the act is disavowed by the British government as unlawful. However, in 1808 Barron is nonetheless court-martialed for premature surrender and convicted of neglecting to clear his ship for action. In 1820, having returned to U.S. naval service, he kills Commodore Stephen Decatur in a duel.

1855—An explosion erupts in the arsenal at Fort Monroe, caused by mixing pyrotechnics. Of the three men there, artificers Francis M. Knight and Henry Sheffis are killed, while Lieutenant Julian McAllister survives, though he is badly burned. He believes that divine intervention saved him and donates much money toward the building of what would become the Chapel of the Centurion.

JUNE 23

1611—Near this date, a Spanish ship arrives off Point Comfort. Three men come ashore demanding a pilot. When navigator John Clarke is sent out to the vessel, with orders to lure the Spaniards within range of the guns of Fort Algernourne, the seafarers immediately leave Hampton Roads and sail for Cuba. The three marooned Spaniards are taken captive. One of them proves to be Francis Lymbry, a renegade Englishman, who is hanged by Sir Thomas Dale while en route to England on the same ship that carries Pocahontas, John Rolfe, and their child. Meanwhile, Clarke is imprisoned in Spain for five years, eventually making his way home to England, and sails for the New World again on the *Mayflower* in 1620.

1951—After the christening of the *United States*, built by the Newport News Shipbuilding and Dry Dock Company and the largest (soon to prove also the fastest) ocean liner plying the Atlantic Ocean, William Francis Gibbs, naval architect, and his engineer, Elaine Kaplan, who designed the massive propellers, have a congratulatory dinner with Gibbs's family at the Chamberlin Hotel. However, the glory days of ocean travel in the Atlantic were over, as travelers preferred the much shorter commercial airline crossings initiated after World War II. The *United States* would prove the last of its breed.

JUNE 24

1813—Stung by defeat on June 22 at the Battle of Craney Island during the War of 1812 in their attempt to take Norfolk, though they had vastly superior numbers, two thousand British infantry and marines under the overall command of Admiral Sir John Borlase Warren and led by General Sir Sydney Beckwith and Rear Admiral Sir George Cockburn land at Murphy's Farm near Indian River Creek to avoid the trap of militia crossfire that had defeated British naval forces entering Hampton Creek (now River) during the American Revolution. They march overland toward Hampton, passing along Celey Road, roughly parallel to the Hampton Roads shoreline, which today underlies parts of Kecoughtan Road.

1878—Two professors with eight students commence to use Fort Wool as an experimental laboratory in marine zoology. The educational venture ends on August 19. Several important papers are published on the marine zoology of the lower Chesapeake Bay as a result.

1883—Hampton Baptist Church dedicates its fifth, and present, sanctuary, all having been located near the corner of King Street and Lincoln Street. Founded as Elizabeth City Baptist Church in 1791, its present name was acquired by 1795. Pastor George Adams was arrested by Union troops in 1862 for aiding the Confederate cause, and he was held on the island of Fort Wool for the duration of the war. Dr. John H. Garber was pastor for thirty-seven years, from 1925 to 1961, followed by Dr. Chester Brown, who served from 1962 to 2001.

1913—The new Dixie Hospital opens. A teacher at Hampton Institute (now Hampton University), Alice Mabel Bacon, concerned about the health of poor African Americans living nearby, convinced the institute in 1890 to donate a two-room frame building near the "Emancipation Oak" for a hospital and a school for nurses. This was one of the earliest training schools for black nurses in the nation; during the era of segregation, schools for whites would not admit black students. The hospital is named Dixie, after Bacon's favorite horse, and is originally staffed with a single doctor and a superintendent of nurses. Bacon helped to raise $163,000 for the project. Eventually needing to expand, the Dixie Hospital Board acquired the site of President John Tyler's summer home and constructed this new three-story brick building, with operating theaters, advanced diagnostic capabilities, an emergency room, and sixty patient beds to serve the whole community. The building has long since been demolished, its facilities replaced by what is now Hampton General Hospital, sited elsewhere. Hampton University's grand new dining hall now rests at its old site.

JUNE 25

1813—In the War of 1812, the 2,000 British troops under General Sir Sydney Beckwith who had overnight landed near Indian River Creek defeat 450 local militia in a pitched battle near what is today the intersection of Queen Street and LaSalle Avenue (the British losing 5 men with 33

wounded, and the Patriots losing 9 men with 10 wounded) and march another half mile to seize the strategically unimportant town of Hampton in order to reward their men with loot and an easy victory. Looking down on the inhabitants as "peasants," the British rob many homes, commit excesses reportedly including rape, and kill one ancient bedridden Hamptonian "by mistake" in attempting to shoot his bothersome dog. The British fleet seizes Old Point Comfort; after using the lighthouse (built there by the Jefferson administration in 1802) as an observation tower, they sail into Hampton Creek to fire on American batteries on Blackbeard's Point and Cedar Point, driving away the gunners. They join the land forces in sacking the town. Admiral Sir George Cockburn and General Beckwith use the stately Westwood home on King Street as their headquarters.

1868—Henry Clark, owner of the Hygeia Dining Salon, a restaurant and stopover for transient military officers visiting Fort Monroe, is given permission to enlarge the hotel portion. Eventually, the expanded hotel would accommodate one thousand guests and would be promoted as a year-round resort worthy of its beautiful and historic surroundings. Even with its many attractive attributes, the second Hygeia Hotel will be pulled down in 1904 to make room for an addition to Fort Monroe that never materializes. Except for a decade's gap beginning during the Civil War, a resort hotel named Hygeia had graced Old Point since 1822.

1999—Although the experiment would terminate in 2002, the *Zephyr* reopens ferry service between Hampton and Norfolk this year. Ferries had been taking people and autos across Hampton Roads since at least 1907, when ferries began to operate from Manteo Avenue in Hampton to Pine Beach at Sewell's Point in Norfolk in order to increase attendance at the Jamestown Exposition of that year, held in Norfolk. When the exposition closed, ferry service ceased for a while. Using the same piers at Manteo and Pine Beach, it began again in 1912, but in 1914, the ferry's Peninsula terminus was shifted from Hampton to the Little Boat Harbor in Newport News. There soon arose an Old Point–Willoughby Spit ferry, but it was bought up by the Chesapeake Ferry Company in 1929; both crossing routes passed to the Virginia Department of Highways in the 1950s. With competition from the Hampton Roads Bridge-Tunnel too strong, ferries disappeared on Hampton Roads for more than four decades and reappeared in 1999 only because the bridge-tunnel cannot carry enough traffic for modern conditions.

JUNE 26

1813—Under a flag of truce during the War of 1812, Norfolk doctors John T. Barnard and William Grayson visit the flagship of British Admiral Sir John Borlase Warren in Hampton Roads and obtain a small boat plus permission to visit the village of Hampton in order to treat those wounded in the previous day's British attack. However, General Sir Sydney Beckwith, second in command there, refuses to allow the doctors to come ashore, and the two men wait anxiously through the evening. When the British evacuate Hampton at 3:00 a.m. on June 27, the doctors are finally permitted to land. While administering medical treatment, they view the town's desolation and hear stories of wanton British pillage and harm visited on the town's citizens.

JUNE 27

1813—The British forces under General Sir Sydney Beckwith occupying Hampton retreat precipitously at 3:00 a.m. when they hear of an American army's approach. They leave so hastily that they fail to burn the town. Major Stapleton Crutchfield and his Virginia militia forces reoccupy Hampton on June 28 and report that "several dead bodies lay unburied" (likely American soldiers) and that the British had pillaged the town and the surrounding countryside. When challenged by the outraged American commander in Norfolk, General Robert Barraud Taylor, Beckwith says that the depredations were committed entirely by French auxiliary troops. Whether rape occurred still rests in controversy, although several women made such claims.

1857—James Hawkins petitions the county court for a public road to be built from White Pine Bridge in Fox Hill to the edge of the Chesapeake Bay at Grandview Beach. The road, made of logs laid across the right-of-way, is ready to be inspected by June 30, 1860. In the 1890s, the road to Grandview, a popular meeting place for Hampton's young people because of its beauty, remoteness, broad sandy beach, and dance hall, would still be made of corduroy (derived from logs).

1904—Reverend William B. and Anna Belle Weaver open the Weaver Orphan Home, a twenty-five-acre farm, on West Queen Street in Hampton, where parentless African American children can find a place to live. Both of

the Weavers graduated from Hampton Institute (now Hampton University), and over the years, they and others will care for more than eight hundred children between the ages of four and seventeen. Their two-story frame house holds twenty-six cots and has neither running water nor indoor toilets for many years. The girls help with cooking and housework, and the boys work on the farm. After the deaths of the founders, their children will maintain the home until 1965.

1916—Civil War veterans, fire companies, civic organizations, and military bands lead the two hundred men in Hampton's national guard unit, Battery D, from its armory on Sunset Creek to the downtown train station, whence they depart for a training camp in Texas. They expect to reach the Mexican border as part of the United States' Punitive Expedition in pursuit of the populist bandit Pancho Villa, whose armed men had burned the village of Columbus, New Mexico, to the ground. More than fifteen thousand people raucously see the men off. Disappointingly, the Hampton troops never see action and return home on March 11, 1917.

1945—NACA (now NASA) establishes the Pilotless Aircraft Research Station at Wallops Island, Virginia. Rockets are launched from Wallops to learn more about high-speed and high-altitude flight. Some of NACA's participating personnel would later be tapped to form the Space Task Group at Langley.

JUNE 28

1851—Members of the Methodist Church are allowed to hold services in the Hampton Courthouse building.

1917—Langley Field, Virginia, is authorized as the location of the first National Advisory Committee on Aeronautics (NACA) field station. J.G. White Engineering Corporation of New York is awarded the contract to construct a research laboratory building.

JUNE 29

1914—The first Hampton Institute Ministers' Conference opens under the name the Conference of Negro Ministers of Tidewater Virginia. Organized by the Conference for Education in the South, the Negro Organizational Society, the Southern Educational Board, and the Cooperative Educational Board, members of all Christian denominations are welcome. Now titled the Hampton University Ministers' Conference, its 100th anniversary would be celebrated in 2014. Over the years, notable attendees have included Reverend Dr. Martin Luther King Jr., Reverend Jesse Jackson, Reverend Al Sharpton, and Barack Obama.

1923—A celebration of the centennial of Fort Monroe is held, featuring speeches by Harry Houston of Hampton, Congressman S. Otis Bland, and Major General John L. Hines, deputy chief of staff of the U.S. Army.

1953—Harry H. Holt passes away. The shrewd, engaging, and politically and economically astute "boss" of Hampton and Elizabeth City County during the Progressive era, the Roaring Twenties, and the beginning of the Great Depression, Holt served as clerk of courts in Hampton for thirty-four years (1899–1933) and worked with Virginia's political leaders, Senator Thomas S. Martin and Senator Harry F. Byrd, as a subordinate in the state's longtime Democratic "machine." A three-sport athlete at Virginia Military Institute, Holt also served on its board of visitors, although he never graduated, and was on the board of Eastern State Hospital for the mentally ill at Williamsburg. He was one of the prime movers in having Langley Field and NACA (now NASA) located in Hampton.

JUNE 30

1640—The legislature of Virginia agrees to the petition of Henry Hawley to keep a ferry "at the mouth of Hampton Roads in Kequotan" during his lifetime, restricting the toll that Hawley might charge to no more than one penny per passenger.

1836—The last of several companies of troops from Fort Monroe is sent to Florida to engage in war against the Seminole Indians for their refusal to

submit and be sent to a reservation in the western part of the United States. The war lasts for four more years, and by January 1839, with continued deployment to the front, the fort's garrison is reduced to three officers (including a chaplain and a surgeon) and nine enlisted men.

1861—A Massachusetts regiment is sent from Fort Monroe to occupy the town of Hampton, deserted by most of its white inhabitants. By July 3, a second regiment is in place. When the Massachusetts troops rotate home in mid-July, the First California Regiment replaces them in occupation. However, with the massive Union defeat at the First Battle of Manassas in late July, four and a half regiments are transferred from Fort Monroe to the defenses of Washington and Baltimore, and the Federal occupation of Hampton is terminated on July 26. The cessation of Federal troop occupation leads to Hampton's burning by Confederate troops in August.

1965—NASA opens its Lunar Landing Research Facility, designed to train the Apollo astronauts to land on the moon.

1987—After a two-year period of restoration funded by the donations of citizens, businesses, and schoolchildren, a 1920s carousel reopens in downtown Hampton. Built by Philadelphia Toboggan Company, the merry-go-round operates in the Buckroe Beach amusement park from 1921 through 1985. When the park closes, the popular amusement ride is purchased by the city (escaping the 1991 demolition of the rest of the park) and is one of the fewer than seven antique carousels still in operating order as of 2017.

The Hampton Carousel showcases forty-eight hand-carved wooden horses, two wooden chariots, forty-two oil paintings, thirty mirrors, and a 1914 Bruder band organ. *City of Hampton.*

July

JULY 1

1715—Lieutenant Governor Alexander Spotswood gives permission for the removal of the old courthouse in Hampton and the erection of a new one. He orders "the Sheriff to attend the Court there so soon as the House shall be fitt for the Reception of the Justices."

1943—The 3,850 housing units of Copeland Park are completed. The largest employer in the area, the Newport News Shipbuilding and Dry Dock Company, reported in 1940 that a local housing shortage prevented it from hiring sufficient workers. With U.S. entry into World War II, an influx of people comes to the Peninsula, and an eight-hundred-acre area on the border of Newport News and Hampton is targeted for a housing development. After a long while, the housing project's dwelling units would be removed, and the area is now the Copeland Industrial Park.

1952—A public vote ratifies the consolidation of two municipalities, the town of Phoebus and Elizabeth City County, into the city of Hampton. Later efforts to consolidate the Greater Hampton municipality with the city of Newport News and Warwick County would fail because portions of Hampton are opposed, although the latter two would vote to consolidate into each other as the city of Newport News.

1963—Ann Kilgore, a high school teacher, president of the Junior Woman's Club, and a member of the city council, is inaugurated mayor of Hampton. She is the first woman in Virginia to achieve such an office. Serving three terms, Kilgore's dynamism is responsible for much development, including the Hampton Coliseum and the Hampton City Hall. Land is also donated for Thomas Nelson Community College.

1973—Dixie Hospital on Victoria Boulevard changes its name to Hampton General Hospital. It has more than two hundred beds, a sharp contrast to the two wards of five beds each in Alice Mabel Bacon's earliest version of the Dixie facility.

1973—Fort Monroe becomes the headquarters for the U.S. Army's TRADOC (Training and Doctrine Command), overseeing army training throughout the United States.

JULY 2

1813—Major Stapleton Crutchfield, commander of Virginia militia forces in Hampton, dispatches former and current General Assembly delegates Thomas Griffin and Robert Lively to British Vice-Admiral John Borlase Warren, aboard his ship in Hampton Roads, to gain permission to bring needed medical supplies to the devastated town and arrange a prisoner exchange. The two delegates gain the needed permission and add their voices to those complaining of British pillage, rapine, and devastation following the attack made on Hampton during the War of 1812.

1973—Y.B. Williams serves on the Hampton City Council, its first African American member. Several black citizens held important offices in Hampton after the Civil War. Apothecary Isaiah Lyons served in the state senate from 1869 to 1871, while grocer Rufus S. Jones was in the House of Delegates from 1871 to 1875. Minister and farmer Thomas Peake was briefly deputy sheriff in 1865 and was repeatedly elected overseer of the poor in Elizabeth City County, 1870–87. These men were part of the powerful black political "machine" of physician Daniel M. Norton, a justice of the peace for forty years and state senator from York County for twelve years.

JULY 3

1862—A committee representing the more than one hundred Southern civilians imprisoned on the island bastion in Hampton Roads recently renamed Fort Wool complains to Major General George B. McClellan that they are "now covered with vermin" and are detained "without a change of clothes." They also criticize their lack of funds with which to procure necessities, promote cleanliness, and preserve health. A sympathetic Major General John A. Dix at Fort Monroe orders the release of all those not a threat. The situation at Fort Wool being quite difficult for prisoners, as Dix is overwhelmed with their plight, he releases ninety-three more on parole toward the end of July. A parolee promises to not engage in further hostilities or aid the Confederate military cause.

JULY 4

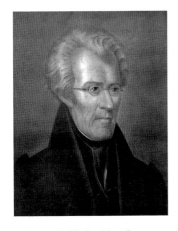

Infatuated with the island's remoteness and natural attributes, and to escape Washington's bustle and politics, Andrew Jackson used Fort Calhoun as his summer retreat. *Library of Congress.*

1831—During his summer visit to Fort Calhoun, President Andrew Jackson crosses over to Fort Monroe to preside over an evening of magnificent Independence Day fireworks. Steamboats convey visitors back and forth from Norfolk to the festivities.

1837—A dispute over school administration results in the murder on Queen Street of Thomas Allen of York County by Major John B. Cooper, Hampton Academy's school master. Founded and built in rural northern Elizabeth City County, the free school is remote from Hampton, where a large minority of the students reside, and there is a great civic dispute over whether to move it into town. The previous school master, Christopher Pryor, horsewhipped a supporter of leaving the institution in the county, and Allen was a vociferous disciple of Pryor's. Cooper flees with his family to New Orleans and is never prosecuted, while Pryor gets his old job back.

1844—A honeymooning President John Tyler brings his bride, the former Julia Gardiner of New York, to Old Point Comfort, where they remain for a month and host several social events. The officers of Fort Monroe march in formation to pay their respect to their commander in chief and his new spouse. The couple would return for a second visit on June 23, 1845. A hurricane would rip the roof and the porch from the Hygeia Hotel on June 28, while they are in residence.

1879—President Rutherford B. Hayes gives a speech at Fort Monroe on the occasion of a major naval review celebrating the nation's birthday. He visited Hampton Institute (now University) in 1878 and 1880, for the school's tenth and twelfth anniversaries.

1928—The Hampton Yacht Club holds its first annual sailing regatta. Founded as the Virginia Yacht Club in 1903 with a clubhouse built on pilings in Hampton Creek (now River) in 1906, the institution was reorganized and given its present name in 1926. In the early years, powerboat racing was emphasized, and the club awarded a Virginia Gold Cup for powerboat champions from 1933 to 1949. Its annual sailing regatta is still a prime event.

1930—Sportsman and millionaire playboy Horace E. Dodge Jr. sends four or five motorboats from his innovative Dodge Boat plant at the Little Boat Harbor in Newport News over to the third annual Hampton Yacht Club sailing regatta, to be used as patrol and officials' craft. Using assembly-line methods and an overhead monorail to move boats from one work station to the next, and employing seven hundred people in three shifts, Dodge Boat produces both pleasure yachts and speedy racing boats. Soon powerboating is added to the Hampton regatta's events, showcasing Dodge's products and attracting fans from all over the East Coast. In the summer of 1931, Dodge's sleek new D-1 race boat would attain speeds of more than fifty miles per hour before catching fire and exploding in Hampton Creek (now River), forcing designer Walter Leveau and chief mechanic Charles Grafflin to leap overboard. In a deepening Depression, with revenue drying up, a troubled Dodge Boat would be abruptly closed down in early 1936 by its "staggeringly drunk" owner.

JULY 5

1881—President James A. Garfield delivers a speech at Hampton Institute (now University) and visits the National Soldiers' Home after stopping at Fort Monroe where he met with its commandant, General George W. Getty.

1887—The Hampton Committee on the Fire Department requests of the county judge and the county supervisors permission to erect an engine house on the southwest corner of the Hampton Courthouse lot and dig a well thirty feet in diameter in the courthouse yard as a water source. They also request that five smaller wells be scattered in other sections of town.

1892—The cornerstone is laid for the Hampton Female College. Originally a private boarding school in East Hampton, the institution would burn in September 1899 and be reopened on North King Street. Soon it would move to College Place and begin to admit local girls as well as boarders; some young ladies will ride the trolley from Newport News to attend. Operated for several years by Bessie Fitchett, the school will be sold in 1913 and renamed Pembroke Hall. It will close just after 1920.

JULY 6

1610—Humphrey Blunt is captured by Indians and tortured to death. The newly arrived leader of the English colony, Sir Thomas Gates, had noticed an Indian longboat beached on the shore of the James River (near what is now Hidenwood in Newport News) and ordered Blunt to investigate. Although it is probable that the nearby and belligerent Nansemond tribe is responsible for Blunt's death, Gates seizes on the incident to send an expedition to "punish" the Kecoughtans.

1793—A French seventy-four-gun warship arrives at Old Point Comfort, carrying "unhappy & distressed" refugees from the slave revolt in Haiti. This would prove to be the most successful uprising of enslaved people in modern history, as the French are driven out and Haiti would be granted its independence in 1804. More than 100,000 Africans engage in the rebellion. The British are at war with France, and by coincidence on the same day, a British privateer from Jamaica puts into Hampton to get "wood and water" and to avoid the French ship.

JULY 7

1896—The tenth annual convention of the Virginia State Firemen's Association meets in Hampton. The conclave of amateur firefighters lasts for three days, discussing the best methods of dealing with fires to preserve life and property. The 126th annual conference would return to Hampton in August 2012, the eighth time the event is held in the city.

2000—There is a gala grand reopening of the American Theater in Phoebus. Originally built by Norfolk's A.M. Johnson and opened in 1908, the American was the first racially integrated theater in southeastern Virginia and is the last remaining of the venues built in Hampton to show silent movies and exhibit vaudeville productions. It originally had an ornate façade and twin towers with mythical figures. For more than a half century called the Lee Theater, the building was purchased in 1997 by the Hampton Arts Foundation and closed for extensive remodeling.

JULY 8

1916—The giant German "merchant" submarine *Deutschland* enters Hampton Roads on its maiden voyage. Two days later, it moors at its assigned berth in Baltimore, exchanging its cargo of concentrated dyestuffs for four hundred tons of crude rubber and ninety tons of nickel. At the time, the United States is neutral in the First World War, and Germany is desperate for war materiel. After a second mercantile voyage to New London, Connecticut, the largest submarine of its time is converted to German military use and dubbed the *U-155*. Following the end of hostilities, the vessel would be scrapped in 1922.

1982—Little England Chapel is placed in the National Register of Historic Places. George C. Rowe, a printer at Hampton Institute (now Hampton University), began a worship service in the 1870s in his home in Cock's Newtown, a neighborhood across Hampton River from the school on what is now Ivy Home Road that had been set aside by landowner Daniel F. Cock for freedpersons. The congregation grew and moved to a one-story wood-frame building constructed during 1878–80 by students of the school. Virginia's only known African American missionary chapel, it was named

Little England Chapel for the English plantation previously there. The chapel served also as a local freedmen's community center and, for a short time, as their schoolhouse.

JULY 9

1610—Sir Thomas Gates and an English military force from Jamestown attack the Indian village of Kecoughtan, ostensibly because of the murder of Humphrey Blunt three days earlier but actually to gain the Indians' two to three thousand acres of cleared and cultivated land. The previous winter had been the "starving time" at Jamestown, when only sixty of the nearly five hundred colonists survived. Fourteen or fifteen Indians are killed, and the rest flee into the Chickahominy Swamp, a place of refuge for the Powhatan Indians (to which the Kecoughtans belonged).

1829—On his way to inspect the new dry docks under construction at the Gosport Navy Yard in Portsmouth, President Andrew Jackson visits Fort Monroe for the first time. Soldiers line the ramparts, and throngs of civilians crowd the beach to get a glimpse of the famous man; the military band plays the "President's March." Before he departs for Portsmouth, there is a grand fireworks display.

JULY 10

1610—To protect their recent conquest of Kecoughtan, the English begin to construct Forts Charles and Henry, named for the two sons of King James I. (Prince Henry would die, probably of typhus, in 1612.) One of the forts encompasses the site of the Indian village, and the other probably is built to guard the extensive cleared and cultivated land seized from the Kecoughtans. The forts are a "musket-shot apart" from each other on the Strawberry Bank. Today, this is reckoned as the "founding" of what has become Hampton.

1829—Returning from his duties in Portsmouth, President Andrew Jackson is welcomed back to Fort Monroe by Commandant James House and

Hampton native Commodore James Barron. He inspects the continuing construction of Fort Calhoun, the man-made island of granite a mile offshore, and becomes so taken with the natural attributes of his surroundings that he chooses the two forts to be his summer retreat, to commence in mid-August. He would not return to Washington until August 31. Jackson will come back for lengthy stays in June 1831, July 1833, and July 1835. He will bring large numbers of relatives and friends with him on the last two occasions, but when the president wants solitude, he will stay at a small cabin on the island.

1876—Harrison Phoebus purchases the second Hygeia Hotel at Old Point Comfort from Samuel M. Shoemaker. Phoebus had served in the Civil War and then had become the agent of Adams Express Company at Old Point. Under Phoebus's competent management, the grand resort hotel, constructed in the Second Empire style, would expand, ultimately extending seven hundred yards along the waterfront from the Baltimore wharf nearly to the Old Point Comfort lighthouse. The resort features elegant bedchambers, speaking tubes, electric lights, and telephones and caters to vacationers and sightseers from north and south.

JULY 11

1920—The Langley Memorial Aeronautical Laboratory, named for aviation pioneer Samuel P. Langley, is dedicated as the official home of the National Advisory Committee on Aeronautics (NACA), now known as NASA. The research center would aid in the design and development of aircraft and, later, spacecraft and space flights.

1969—Apollo 11 lifts off for its lunar landing mission. After Neil Armstrong barely escapes death in a crash while testing the Lunar Landing Research Vehicle at Houston in May 1968, he and fellow astronauts Buzz Aldrin, Pete Conrad, and Alan Bean train for many hours at Langley in the Lunar Landing Training Vehicle preparatory to their Apollo 11 and 12 missions to the moon. They credit the extra training for their accomplishing the task of landing safely.

JULY 12

1919—The base's first non-rigid airship, an A-4, arrives at Langley Field from Akron, Ohio. Driven by a single engine, the dirigible can reach a speed of forty-five miles per hour.

1926—The Charles H. Taylor Memorial Library opens. Named for the editor and owner of the *Boston Globe*, the father of donor Grace Taylor Armstrong, it is the first free county public library in Virginia. Taylor was a journalistic innovator who added stock quotations, women's news, and sports coverage to broaden the appeal of his newspaper. In 1987, Armstrong's book collection would be transferred to the Hampton Public Library, and in 1989, after extensive renovation, the building would reopen as the Charles H. Taylor Arts Center.

JULY 13

2012—President Barack Obama makes his second visit to Hampton, arriving on Air Force One at Langley Air Force Base and giving a campaign speech at Phoebus High School.

JULY 14

1781—A party of four hundred British under command of Sir Henry Clinton, commander in chief of British forces during the American Revolution, surveys Old Point Comfort as a possible landing site for the army of General Charles, Earl Cornwallis, and to investigate whether to rebuild Fort George, destroyed by a hurricane in 1749. Cornwallis decides to fortify Yorktown and Gloucester Point instead, as the facilities remaining at Old Point are decrepit,

Sir Henry Clinton, a member of Parliament and later governor of Gibraltar, is shown in this portrait attributed to Andrea Soldi, circa 1762–65. *Wikimedia Commons.*

material for all repairs has to be brought from a considerable distance, no fresh water is available, and the low elevation allows plunging fire from ships. The Americans' allies, the French under Admiral Comte Francois-Joseph de Grasse, do, however, build an artillery battery and small earthen fort there on September 3.

JULY 15

1863—Major General John Gray Foster assumes command at Fort Monroe from Major General John A. Dix. Foster's authority in the Department of Virginia and North Carolina extends from Fort Monroe up the lower Peninsula to Williamsburg and includes Gloucester Point, Virginia's Eastern Shore, Norfolk, and Portsmouth, as well as the portion of North Carolina around New Bern, Beaufort, Plymouth, and Washington.

1944—The Fort Monroe Officers Beach Club, built in 1932, is destroyed by a fire of undetermined origins. Nazi sabotage is ruled out, but the mystery remains unsolved. There would be a new beach club by May 1945, replacing the giant tent used as a temporary substitute. The Fort Monroe Officers Club located inside the flag bastion and facing outward toward the moat could be reached at first only via a small barge nicknamed *Maid of the Moat*, which a passenger hand-pulled across the moat by using a rope. After World War I, a bridge would be built, but the club would be closed in 1959 due to water seepage and insufficient space. The Beach Club would become the new officers club.

JULY 16

1899—A resident of the National Soldiers' Home in Hampton is discovered to have yellow fever, apparently brought there by a soldier who served in Cuba in the recently terminated Spanish-American War. An emergency is declared.

JULY 17

1917—Ground is broken on a former Elizabeth City County farm for the nation's first aeronautics laboratory, at what would become Langley Field.

1935—Following devastating damage wrought by the 1933 hurricane, trolley service finally resumes to Langley over a recently constructed bridge, and streetcars rumble along newly relocated tracks toward the terminal on Douglas Street at Langley Field. Trolley service lasts at Langley for only another decade.

2015—NASA plans and organizes the first civilian use of a drone in the United States to deliver needed pharmaceuticals and medical supplies to a free annual outdoor health clinic in Wise County, Virginia. A Cirrus CR22 from NASA being flown remotely picks up the medical package, which had been delivered to Tazewell County Airport, and transports it forty miles to Lonesome Pine Airport in Wise County. The six-rotor Flirtey drone, flown by its owner, a private company, then takes the package to the hard-to-reach clinic in a test of drone technology approved by the Federal Aviation Administration.

JULY 18

1899—Beset with a yellow fever emergency, the National Soldiers' Home is cordoned off for weeks with a human wall of guards, but nevertheless one person in Phoebus becomes infected. Those with the ailment, including a person from Portsmouth, are taken by boat to Craney Island and held incommunicado. Hampton Roads communities are in uproar and fear, remembering the 1855 epidemic of the dreaded disease that killed more than 3,200 people locally. Every house is searched in Hampton, Newport News, and Phoebus. A line of men holding loaded guns guards Newport News against entry of anyone from Hampton. The last of twenty yellow fever deaths of persons from the Home occurs on September 5, by which time the panic is over and Craney Island is evacuated.

JULY 19

1887—I.T. Jones is elected clerk of the Hampton Town Council. An ordinance is passed issuing bonds not to exceed $10,000 for the purchase of equipment to extinguish fires and to provide water sources for the apparatus.

1918—Hampton's Battery D of the 111th Field Artillery arrives in Le Havre, France, for service in World War I.

JULY 20

Astronaut Neil Armstrong, a test pilot and naval aviator serving in the Korean War, was awarded the Presidential Medal of Freedom by Jimmy Carter. *National Aeronautics and Space Administration.*

1969—With Apollo 11 astronaut Neil Armstrong's words, "Houston, Tranquility Base here, the Eagle has landed," the U.S. Lunar Excursion Module (LEM) touches down on the moon with about twenty-five seconds of fuel remaining. Armstrong and Buzz Aldrin later spend several hours on the moon's surface. Celebrating one of the most significant undertakings in human history, many dedicated NASA researchers at Langley reflect on the long path to success begun decades earlier at the Hampton Research Center.

1976—The unmanned Viking 1 spacecraft rips through the thin atmosphere of Mars, its touchdown on an ancient floodplain called Chryse Planitia eased by a parachute and small rockets. Soon its twin, Viking 2, lands on the opposite side of the red planet. Their search for active microbes yields mixed results in a pioneer project managed by NASA Langley Research Center. NASA's Phoenix (2008) and Curiosity (2013) landers find no evidence of life either, under most scientific interpretations. Most scientists do not believe that evidence of life on Mars has yet been found, but other mechanisms sent since 2013 to further the search may yield different results; a minority of scientists interpret the findings positively, as demonstrating the existence at least of the kinds of microbial life found on comets and asteroids.

JULY 21

1910—In the most serious accident ever to take place at Fort Monroe, the breech of a twelve-inch disappearing rifle explodes during firing practice in the presence of the U.S. Army's chief of coast artillery and its chief of ordnance, as well as many other high-ranking officers. Fires result, and eleven men are killed, while several more are wounded. Captain J.L. Prentice and Lieutenant G.P. Hawes heroically and successfully run through the flames to remove unburned sacks of powder. A memorial service is held the following day, with a large number of military personnel and local citizens in attendance.

1921—After observing General Billy Mitchell's successful bombing and sinking of the captured German battleship *Ostfriesland* off the Virginia Capes in the Atlantic, the U.S. Army airship *D-2* has both engines fail on its return to Langley Field and makes a forced landing. The airship is smashed beyond repair, but fortunately there are no casualties.

A flight of seven bombers swept in, dropping two-thousand-pound bombs on the *Ostfriesland*. After the sixth projectile sealed its doom, it sank in twenty-two minutes. *Library of Congress.*

JULY 22

1781—During the American Revolution, the British land a foraging party of three hundred men at Mill Creek from their fleet in Hampton Roads. They plunder the farms and homes nearby.

JULY 23

1623—Captain William Tucker, commander at Elizabeth City (now Hampton) who lives on 150 acres in what in 1634 would become Elizabeth City County, on the north side of Hampton Creek (now River), attacks the Nansemond and Warrasqueake Indians in the area later called Virginia's Southside, destroying their corn supplies and habitations—along with "no small slaughter" of the Indians. He is retaliating for an Indian raid that had killed 4 people in Elizabeth City in 1622. In 1625, a native named Chouponke is living with Captain Tucker, and in the same year, three black people living with Tucker—Anthony and Isabell Tucker and their infant son, William—are identified as having been baptized into Christianity. Anthony, Isabell, and William are three of the four black people living in Elizabeth City, which has twenty stores and eighty-nine houses, twenty-four of which are fortified or "palisadoed." With 359 people, it is the largest English settlement in the colony; it has four thousand acres patented (that is, claimed under a written grant from the king), most of which is cultivated.

1785—A great "gust of wind" destroys all of the tobacco and corn crops in Elizabeth City County, tearing down chimneys and fences, uprooting large trees, and knocking structures off their foundations. The schooner *Patriot*, piloted by African American Cesar Tarrant, is stranded and bilged near Hampton, while many smaller vessels are "torn to pieces." The next day, the tropical storm passes directly over George Washington's northern Virginia plantation at Mount Vernon.

1933—Hampton fireman Rodman R. Cunningham rescues a young child from drowning. He is later recognized by the American Red Cross Association for his heroic efforts.

JULY 24

1699—A hurricane batters the only British warship guarding the entrance to Chesapeake Bay, the HMS *Essex Prize,* on this and the next day.

1861—An expedition, consisting of both land and sea forces, is sent from Fort Monroe by Major General Benjamin F. Butler to attack a Confederate battery on Back River, built soon after the Rebels won their victory at the Battle of Big Bethel in June. They were expecting another Union assault. A second foray to Back River is launched the following day with three hundred men, seven field pieces, the USS *Fanny*, and six launches. This attack is successful, surprising and burning nine Confederate sloops and schooners.

1862—Dr. John Herr Frantz is appointed chief medical purveyor (doctor) at Fort Monroe, an appointment he would retain through December 1863. After holding other positions in the U.S. Army's medical corps, he would return to Fort Monroe as chief surgeon on July 22, 1865, serving until March 21, 1866. While there, he will marry Louise Sewall, a local woman, in the Chapel of the Centurion.

JULY 25

1823—Captain Mann P. Lomax, scion of an old Virginia family, and his Company G of the Third U.S. Artillery embark from Fort Nelson in Portsmouth, crossing Hampton Roads on the regular Hampton steamboat to become the first commandant and first garrison stationed at Fort Monroe. They guard the convict laborers who are building the structures. Ten more artillery companies would be assigned there in the spring of 1824.

1861—John LaMountain, hired privately by Major General Benjamin F. Butler after failing to convince the U.S. Army to award him the position of "chief aeronaut," rises from Fort Monroe in *Atlantic*, a hot-air balloon, to observe the build-up of Confederate forces on Back River. LaMountain would make two more ascensions on July 31, the second gaining an altitude of 1,400 feet, allowing him to scan a radius of thirty miles; in a third, on August 1, he is able to report that Hampton is no longer occupied by Confederate troops. Further balloon observations would follow.

JULY 26

1818—After a contract is made with the U.S. government, Elijah Mix begins to provide 150,000 perch of stone from the banks of the York River, to be used in the construction of Fort Monroe. The local stone proves unsatisfactory, and Mix furnishes stone from quarries on the Potomac River near Georgetown. Actual construction would not commence until March 1819.

JULY 27

1699—The pirate John James in *Providence Galley* captures the *Roanoke Merchant* at Lynnhaven Bay while the hurricane-battered British warship HMS *Essex Prize* hides behind the guns at Old Point Comfort, fearing the pirates' superior firepower.

JULY 28

1867—No Elizabeth City County courts have been held for six years because of the chaos caused by the Civil War. The 1715 courthouse is burned when the town is torched by Confederate troops in August 1861, apparently to prevent Northern troops and enslaved persons from living in the houses of the town, emptied of whites, who fled in the spring and early summer of that year. The first session of court is now being held in the recently repaired old courthouse. At considerable expense, a new courthouse will arise in 1876. The building will gain a pedimented portico when it is remodeled in 1910. After another remodeling in 1939, wings will be added in 1962 and 1975.

JULY 29

1940—President Franklin Delano Roosevelt, arriving on the presidential yacht *Potomac* at Fort Monroe's steamship wharf, visits Fort Monroe and

After earlier viewing a thirty-five-millimeter antiaircraft gun–firing demonstration at Fort Monroe, President Franklin Roosevelt's motorcade departs Langley Field en route to visit Newport News Shipbuilding. *National Aeronautics and Space Administration.*

Langley Field as a part of his tour of U.S. military bases. He observes a firing demonstration. After a stop in Newport News, FDR returns to the *Potomac*.

1958—President Dwight D. Eisenhower signs the National Aeronautics and Space Act, establishing the National Aeronautics and Space Agency (NASA), into which NACA is folded.

JULY 30

1619—Captain William Tucker and William Capps, as members of the House of Burgesses, represent Kecoughtan in the first session of Virginia's new legislature, the General Assembly, held at Jamestown Island. At their urging, the assembly changes the name of the "ancient borough" of Kecoughtan to Elizabeth City (it is now Hampton).

1699—The British Chesapeake Bay guardship HMS *Essex Prize* under Captain John Aldred emerges from the shelter of Old Point Comfort and attempts unsuccessfully to draw John James's superior pirate vessel *Providence Galley* into shallow water. James menaces Aldred, who then beats a hasty retreat to Hampton and anchors again off Old Point.

1899—Two specially dispatched trains leave with more than six hundred guests of the Hygeia, Chamberlin, and Sherwood resort hotels on Old Point Comfort to escape the rampaging local yellow fever epidemic—but not before each refugee had been interviewed, examined, and issued a health certificate. Many of Hampton's residents join the mass flight from the Peninsula. One Hamptonian reports, "About half the town left for Richmond."

JULY 31

1899—A quarantine of the post at Fort Monroe is in effect after the outbreak of yellow fever two weeks earlier at Hampton's National Soldiers' Home. The quarantine is lifted on August 15, but the garrison does not return from its Plum Tree Island retreat (on the York River) until September. For many years after the establishment of Langley as an air base, Plum Tree Island would be used as a bombing range. In 1972, it will be transferred to the U.S. Fish and Wildlife Service and become a National Wildlife Refuge, but because of unexploded ordnance, it would still be considered off limits for tourist visitation.

August

AUGUST 1

1781—During the American Revolution, Colonel Banastre Tarleton moves his British cavalry troop from Suffolk by boat, landing at Hampton and marching overland to rejoin the main army of General Charles, Earl Cornwallis, at Yorktown.

1984—Hampton Institute changes its name to Hampton University in recognition of its several graduate programs of study. In 2017, PhD's would be offered in six disciplines.

AUGUST 2

1821—The first Hygeia Hotel is completed at Old Point Comfort, outside the moat of Fort Monroe. The hotel becomes a major American resort and tourist destination. Since Virginia is about midway on the Atlantic coast, northerners visit almost as frequently as southerners.

2017—A homecoming dedication is held for Hampton's Streetcar no. 390. Originally delivered in 1918 to the Newport News Hampton Railway, Gas,

and Electric Company, it was one of forty trolleys operating on the Virginia Peninsula, transporting riders to work, shopping, leisure activities, and (for the line going to Old Point's ferry docks) travel to distant destinations. Its final run had been in January 1946. It is acquired by gift from the Baltimore Street Museum, where it had been warehoused since 1977.

AUGUST 3

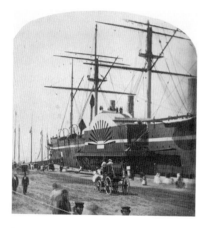

The magnificent sailing steamship SS *Great Eastern* finished life as a floating tourist attraction. With its revolutionary design, it was never a commercial success. *Wikimedia Commons.*

1860—The English steamship SS *Great Eastern*, the largest vessel in the world at the time of its launch in 1858, docks at Old Point Comfort. Being met by steamers crowded with passengers, it is saluted by the guns at Fort Monroe as it approaches the dock. The ship has the capacity to carry four thousand passengers around the world without refueling. Its 692-foot length would not be surpassed until 1899. However, there is never sufficient trade for it to run to the Orient, as it was designed for, so it plies an Atlantic Ocean served by swifter and better-performing vessels. Converted into a cable-laying ship, it puts down the first lasting transatlantic cable in 1866.

1861—John LaMountain launches in a hot-air balloon from the deck of the USS *Fanny* in Hampton Roads, considered to be the first flight from an aircraft carrier. He rises 2,000 feet to observe the enemy works at Sewell's Point, finding that the Confederates, screened by a line of trees, are digging gun pits and making embrasures for cannons. He makes five ascensions on August 10, reaching 3,500 feet, but he exhausts his supplies and moves to Washington to work with the Army of the Potomac.

AUGUST 4

1914—After an appropriation of $20,000 by Congress to construct the new post office on east Queen Street in Hampton, planning is underway for the structure to be built along classical lines. When completed, it is a distinct addition to downtown. However, it would be closed in the 1980s, and the building would come to house several restaurants, all of which fail.

AUGUST 5

1938—Three Langley-based B-17s take off on a goodwill flight to Colombia to attend the presidential inauguration of Dr. Eduardo Santos. While in Bogotá, the crews appear at the Presidential Ball, visit Colombia's equivalent of the U.S. Military Academy at West Point, and are guests of honor at the ceremonies marking the 100th anniversary of the capital.

AUGUST 6

1997—George E. Wallace serves as Hampton's first African American city manager. Having worked previously for the Tidewater cities of Norfolk and Newport News, Wallace served as an assistant city manager in Hampton from 1975 to 1997. He will complete two terms as city manager, 1997–2005, and will be elected to the city council in 2008. The council will make him the city's vice-mayor in that same year.

AUGUST 7

1861—Late in the evening, Confederate troops led by local inhabitant Captain Jefferson Curle Phillips systematically burn the town of Hampton to prevent its being used to house both Union troops from Fort Monroe and escaping slaves (contrabands). While most local whites had long since left town and the few remaining local supporters of the Confederacy are given warning, several people are taken by surprise and

escape the flames only just barely. Inhabitants of the entire Hampton Roads area are astounded at the flickering glow and flames darting to the heavens, visible for miles.

AUGUST 8

1861—Following the burning of Hampton during the Civil War, a journalist for the *Philadelphia Inquirer* reports, "A more desolate sight cannot be imagined than is Hampton today. Last evening it was one of the most beautiful villages on the continent, with a wealth of cottages and villas embowered in luxurious foliage. Nothing but a forest of bleak sided chimneys and walls of brick houses tottering and cooling in the wind, scorched and seared trees and heaps of smoldering ruins mark the site." Confederate soldier Robert S. Hudgins II lamented, "I thought of how my little home town was being made a sacrifice to the grim god of war."

1861—U.S. Army General-in-Chief Winfield Scott telegraphs Major General John E. Wool at Troy, New York, with an offer to "assume command of the department of which Fort Monroe is the place of headquarters." Wool accepts and arrives on the seventeenth, assigning the previous commander, Major General Benjamin F. Butler (disgraced by the Union's defeat at the Battle of Big Bethel on June 10), to the command of all departmental forces outside the fort's walls. In effect, Butler would command Camp Hamilton (now Phoebus) and Camp Butler (now Newport News).

AUGUST 9

1949—Hampton electronics inventor Charles Hastings is able to demonstrate the worth of his position-tracking device, Raydist, by placing a transmitter on an Old Point ferry and noting its positions as it crossed Hampton Roads. Having resigned from NACA (now NASA) in January 1946 to pursue independent research and development, Hastings hits it big with this innovation useful in hydrography, commercial and military marine navigation, as well as oil exploration. Teledyne would buy out Hastings Instruments in 1968.

1978—Attorney Inez Fields Scott passes away. The daughter of Hampton attorney George Washington Fields, Inez graduated from Hampton Institute (now University) at age nineteen in 1914 and from the Boston University School of Law in 1922. She practiced in Massachusetts for six years, earning a good reputation in criminal defense work, but moved back home to aid her aging and blind father. She was only the third black woman licensed to practice law in Virginia. Scott did a good deal of work on women's civic needs, on education, on voting rights, and on economic aid to the poor during the Great Depression.

AUGUST 10

1755—British troops begin evacuating Acadians to the thirteen American colonies. Acadia was a French colony in eastern Canada that the British seized in 1710. The Acadians refused to sign oaths of allegiance, and during the French and Indian War, they refused to supply or trade with their conquerors, which leads to the policy of mass deportation. Several of the colonies welcome the new settlers, but those sent to Virginia, arriving first at Hampton and then mostly confined in Williamsburg, where hundreds die of malnutrition and disease, are eventually rejected and sent to England.

1921—The disassembled airship *Roma* arrives at Langley Field from Italy in several large crates, and its reassembly begins.

AUGUST 11

1889—Hampton's town council recently appropriated $100 to Fire Chief William Weymouth for the purchase of a bell for the fire engine house.

AUGUST 12

1917—The air base constructed in Elizabeth City County enjoys its official name, Langley Field, honoring aviation pioneer Samuel P. Langley. It

has been declared a permanent military station and will also serve as the experimental facility for NACA (now NASA), the developmental laboratory for U.S. military aviation also located there.

AUGUST 13

1700—Governor Francis Nicholson, who spent much time in improving Virginia's militia forces, orders the militia of Elizabeth City County to establish "coast watchers." Nicholson is worried about encroachment on British North America by its rivals, the French, Dutch, and Spanish.

2003—Evelyn McCormick Brown passes away. She was the widow of Raymond "Coca-Cola" Brown, founder and longtime owner of the local Coca-Cola franchise but best known as inventor of the popular soda drink's metal bottle opener. Mrs. Brown has resided in the Browns' magnificent brick mansion on Chesapeake Avenue in the Wythe district for sixty-nine years.

AUGUST 14

1862—On land that is now the site of Hampton University, the U.S. Army opens Hampton Hospital for injured enlisted men in the Union army. It is a large, triangular, single-story wooden structure, supplemented by field tents, with a capacity for thousands of injured men. Its first patients come from the march of the Army of the Potomac from Harrison's Landing to reinforce the army of General John C.F. Pope.

AUGUST 15

1941—The College Court Housing Project in Phoebus, for noncommissioned officers stationed at Fort Monroe, is opened.

AUGUST 16

1715—Under the English legal union of church and state, all persons, of whatever religious beliefs, are required to attend an Episcopal church meeting every Sunday, and failure to do so can result in a fine. All people are also taxed to pay the salary of the Episcopal minister. Fourteen persons are determined to have violated these rules and on the following day will be brought to court in Elizabeth City County for failure to attend church.

AUGUST 17

1697—The death of John Neville is reported. He was a vice-admiral in the British navy and is buried at the Elizabeth City County cemetery at Pembroke Farm, now adjoining Pembroke Avenue. His grave site is still visible.

1861—Major General John E. Wool, the senior officer in active service in the U.S. Army, assumes command at Fort Monroe from Major General Benjamin F. Butler, in large part due to the devastating defeat suffered by Union forces at the Battle of Big Bethel the previous June 10.

1887—The death of Reverend Young Jackson, third pastor of the First Baptist Church of Hampton and the initiator of the brick structure that is its present home, is reported. From 1791 to 1863, African American Baptists were relegated to worshiping from the balcony of Hampton Baptist Church. Under the leadership of Reverend Zechariah Evans, they split off, building their own frame church in the Pee Dee section of Hampton in 1865 on land donated by freedman Jim Bailey. The congregation would move to its present North King Street location during the pastorate of Evans's successor, Reverend William Taylor.

AUGUST 18

1821—French botanist Auguste Plee leaves Hampton Roads aboard *Juno*. A traveling naturalist for the French government, Plee makes sketches in his journals of the villages that dot America's Atlantic coastline during the administration of President James Monroe. One of them depicts Fort Monroe and Fort Calhoun (later Fort Wool) under construction, plus the lighthouse at Old Point Comfort, from the standpoint of the entrance to Hampton Roads. Plee would pass away in 1825 at thirty-eight from chronic illness.

1862—The diary of Jacob Heffelfinger of the Seventh Pennsylvania Reserves, a part of Major General George McClellan's huge army moving to attack Richmond's environs in the Peninsula Campaign, notes his visit on this day to "the ground once occupied by the village of Hampton." Severely wounded and captured on two occasions, after the war Heffelfinger would choose to move to Hampton in 1866. Wedding local resident Louisa Whiting, he will establish a lumber company, helping to rebuild the town, and become a pillar of the community over the succeeding forty-five years.

AUGUST 19

1885—More than five thousand people witness a sailing regatta at Old Point Comfort. A grand ball follows at the Hygeia Hotel.

1917—The first foreign-manufactured aircraft reach Langley Field, when a shipment of Italian-built Caproni CA-3 bombers arrives. Various Italian aircraft and seaplanes would be tested in the ensuing months, and the field's "Italian colony" grows into the largest local contingent of airmen who were citizens of nations allied to the United States during World War I.

1967—An era ends as Hampton's last downtown indoor movie theater, the Langley, closes its doors. Opened as the Scott Theater on Queen Street on August 25, 1919, 766 patrons could be seated. It became the Langley in April 1932. Other major movie houses had already given up the ghost. The Rex Theater on King Street, which opened as the Apollo before 1920 and was renamed in the early 1940s, ceased doing business about 1955.

Sleek cars lead a parade past the Langley Theater as throngs of enthusiastic onlookers enjoy the procession along Queen Street in downtown Hampton. *Hampton History Museum.*

The Basie Theater on Queen Street, which opened before 1920 as the Lyric but changed marquees in 1947, lasted until 1955. Neighborhood cinemas fared little better. The Wythe Theater on Kecoughtan Road, opened in 1939, would show its final motion picture in 1981. The Center Theater in the Southampton Shopping Center on Kecoughtan Road endured less than a decade, ceasing operations in 1955. The Lee Theater on Mellen Street in Phoebus, which opened as the American Theater in 1908 with seating for 600, including balcony chairs for African Americans, also closed in 1955, and the building was abandoned (although in 2000, after extensive renovation, the American would reopen as an "acoustically perfect" legitimate theater).

AUGUST 20

1619—The first Africans known to have been brought to British North America arrive at Old Point Comfort aboard the pirate ship *White Lion*. Captured from a Portuguese slaver in the Atlantic, these men appear to have been treated under English law as indentured servants. An Angolan named Anthony Johnson living at Jamestown as early as 1620, and perhaps one of the *White Lion* group, would win his freedom from indenture around 1630 and become a successful tobacco farmer and property owner. In 1655, he would be the first person in British North America to own an enslaved black African. Most subsequent North American slave owners would be white.

1905—The Hampton Roads Golf and Country Club sponsors the first tennis championship on the Peninsula, with women's and men's singles matches held at the club's courts near the intersection of Kecoughtan Road and Hampton Roads Avenue. The first-place trophy would later be adopted by the Kecoughtan Tennis Club, formed in 1922, and would be awarded to winning players long into the 1930s.

1952—The new Syms-Eaton Museum opens its doors to the public. Originally founded by Margaret Sinclair in a room in the Syms-Eaton Academy Building, the museum displays memorabilia concerning the origins and history of the city of Hampton. It is the forerunner of the Hampton History Museum, and some of its artifacts are now on display there.

AUGUST 21

1831—Elements of the First Artillery are sent from Fort Monroe to Southampton County, Virginia, to help quell Nat Turner's Rebellion. Turner, an intelligent and literate slave who acted as a preacher for local black people, understands solar eclipses occurring on February 11 and August 13 to be signs from heaven for him to seek his freedom by leading a rebellion. He and a few trusted friends go from house to house, freeing slaves and killing most of the white people encountered. Several poor whites are spared, but a total of sixty people are killed. The local militia ends the rebellion in two days, but Turner himself is not apprehended

until October 30. He is quickly convicted of "conspiring to rebel and making insurrection," sentenced to death, and hanged on November 11. Virginia authorities execute fifty-six other slaves for complicity in the rebellion.

AUGUST 22

1896—John Chamberlin, owner of the first Chamberlin Hotel at Old Point Comfort, dies of Bright's disease at Saratoga Springs, New York.

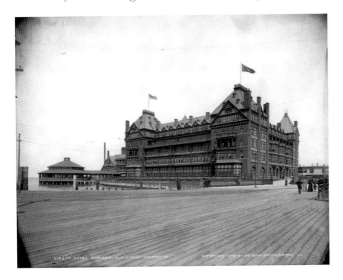

The Hotel Chamberlin opened in 1896 as one of the grandest resorts in America, offering medicinal baths, tennis, bowling, sailing and excellent Chesapeake Bay cuisine. *From* Souvenir of Fortress Monroe.

AUGUST 23

1832—It has taken Congress a long time to pass a law allowing pensions to Revolutionary War veterans. Hampton's William Jennings, who had been the chief pilot helping to convey the French fleet to Yorktown for the final battle in 1781, appears in the Elizabeth City County Court in his eighty-first year on this day to qualify under the federal pension law enacted the previous June. Jennings tells of his enlistment as a seaman on the *Patriot* under Captain Richard Barron in 1777, where he served until the French fleet arrived. He was then made pilot of France's seventy-four-gun *Northumberland* and stayed on board after Cornwallis's surrender, piloting the vessel to the tiny French

islands of St. Pierre and Miquelon, near Newfoundland. Captured by the British while returning home, he was held for four months on one of their notorious prison hulks off New Jersey, finally gaining his release through the agency of a British officer he had treated well when the latter was a prisoner on the *Northumberland*. He returned in bad health to Virginia just before peace is proclaimed in 1783 and rejoined Barron's crew on the *Patriot*.

1885—Legrand Donohoe receives his commission as the first postmaster at the Phoebus Post Office, in what was then called Chesapeake City. The federal government names the post office after local entrepreneur Harrison Phoebus, and later the town would rename itself also to honor the enterprising businessman.

1933—The long-remembered "Great Storm of '33," a hurricane, scores a direct hit on the lower Peninsula, destroying Grandview and the African American amusement park at Bay Shore, while also devastating Fox Hill, Buckroe Beach, Langley Field, Phoebus, Old Point Comfort, and Hampton, as well as many other communities and rural places in eastern Virginia. Bay Shore is so damaged it does not reopen for seven years. It is the first passage of the eye of a hurricane directly over Hampton Roads since 1821. It sets a record with water reaching nearly nine feet above normal sea level in several places, and as much damage results from flooding as from the high winds. The trolley lines along Chesapeake Boulevard from Newport News to Hampton are destroyed and never rebuilt.

1954—The Hampton-Wythe Little League All-Stars open play in the Eighth Little League World Series in Williamsport, Pennsylvania. Although they had won all nine previous tournament games in district, state, and regional play in what was at the time a single-elimination affair, they lose to a California team, 4–2.

AUGUST 24

1683—The previous April, pirates William Dampier and Edward Davis, hiding out in Hampton, had joined up with other buccaneers arriving on the *Revenge*. Having rested in the raw port town for the spring and summer, they and their crew are now under sail for Guinea in Africa. There, in a card

game with some Danes, they will win a better ship, the *Batchelor's Delight*, and will sail around Cape Horn to successfully plunder Spanish silver ships plying the west coast of South America.

AUGUST 25

1917—Hampton's local National Guard unit, Battery D, is assigned to the 111th Field Artillery, 29th Division. Mobilized to Camp McClellan, Alabama, they train for several months before deployment to France in World War I. The regimental flag of the 111th would be been rediscovered at the Virginia War Museum and displayed.

AUGUST 26

1772—Joseph Pilmore is thought to have preached the first Methodist sermon in Hampton, in a large dining room before a congregation "of that genteeler sort." Pilmore and another missionary minister, Richard Boardman, were appointed in October 1769 by John Wesley, the founder of Methodism, to begin the task of organizing congregations of their religion in America. Earlier in August, Pilmore had preached in the Great Bridge area close to Norfolk, and in November, he would preach in Portsmouth.

AUGUST 27

1667—A great hurricane strikes Elizabeth City County with a twelve-foot storm surge. Approximately ten thousand houses are destroyed in all of Virginia by the vicious storm, tobacco and corn crops are lost, many cattle are drowned, ships are greatly damaged, and rain falls for the next twelve days.

1781—Thanks to messages recently sent from the Marquis de Lafayette in Virginia borne by Captain John Sinclair of Hampton on the *Little Mollie*, the fleet of French Admiral Jacques-Melchoir Saint-Laurent, Comte de Barras, leaves anchorage off Newport, Rhode Island, to join the American and

other French forces threatening the British army under General Charles, Earl Cornwallis, at Yorktown. De Barras arrived too late to participate in the Battle of the Capes, won on September 5 by French ships under Admiral Francois-Joseph-Paul, Comte de Grasse, against the British fleet of Admiral Thomas Graves—a battle that truly decided American independence by preventing any shipborne British aid to Cornwallis for his fight at Yorktown in October.

1932—Having opened on Kecoughtan Road next to the Wythe Fire Station, Bill's Barbecue begins a six-decade restaurant business. It becomes one of Hampton's favorite eateries, featuring homemade barbecue, milkshakes, and other menu specialties, and it is the first local restaurant to offer drive-up curbside service, with some waitresses on roller skates. It is one of the first local businesses to use neon lights in signage. A signature painted sign on the rooftop features a blue whale, while another closer to the ground shows a rosy pink pig.

AUGUST 28

1861—The Civil War's first amphibious operation, under Major General Benjamin F. Butler, in command of 930 men, is underway from Fort Monroe to invade coastal North Carolina. Within several days, Hatteras Inlet is captured. The small triumph was one of the Union's first in the war and greatly delighted President Lincoln. Butler begins to redeem himself for the Federal disaster at Big Bethel months earlier.

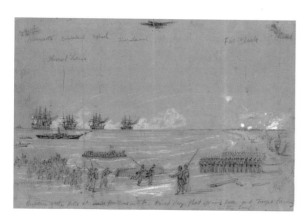

General Butler's expeditionary force captured Forts Hatteras and Clark in the first combined operation of the Union army and navy in the American Civil War. *Library of Congress.*

AUGUST 29

1775—The eye of the savage "Independence Hurricane" crosses Hampton Roads, as the winds and waters devastate wharves and storehouses, uproot crops, and throw several small vessels onto the shore. The storm lasts for six days and causes the deaths of at least twenty-five people.

AUGUST 30

1945—Busloads of Hampton's Red Cross workers are invited to Newport News to help greet five troop ships of soldiers returning from World War II.

AUGUST 31

1861—Major General Benjamin F. Butler's Civil War naval expedition to coastal North Carolina, where he captured Forts Clark and Hatteras, returns triumphantly to Fort Monroe.

1939—Christened by First Lady Eleanor Roosevelt, the transatlantic ocean liner SS *America* is launched at the Newport News Shipbuilding and Dry Dock Company, with 30,000 people in attendance. Half of the more than 1,000 specially invited guests staying at the Hotel Chamberlin arrive on special trains from Washington and New York City. The outbreak of World War II in Europe the next day would prohibit any transatlantic passenger business for *America* until 1946, as the great vessel (with berths for 1,202 passengers) is converted into a wartime troop and refugee transport (with a maximum capacity of 9,305 persons). The speedy boat, at twenty-two to twenty-five knots, could outrun enemy submarines and most other surface ships. Back in peacetime service, the elegant and comfortable liner would ply the Atlantic until competition from airplanes forces its retirement in 1963.

September

SEPTEMBER 1

1917—The government purchases the farm Big Marsh, with 3,059 acres along the northern edge of the Langley flying field, as the last major extension of the air base's property before World War II.

SEPTEMBER 2

1775—Elizabeth City County residents set fire to the HMS *Liberty*, an auxiliary British vessel of war under the general command of Virginia's last royal governor, John Murray, the Earl of Dunmore, and under the specific command of Captain Matthew Squire (whose pilot is Joseph Harris, escaped from slavery in Hampton), after the "Independence Hurricane" separates it from other British warships and drives it to shelter in Back River. The craft is a tender of the HMS *Otter*, which had been raiding and burning plantations in an attempt to stanch rebellious activity by Virginians. Squire had demanded the return of the *Liberty*, but Hampton's citizens had refused unless Squire would send Harris and other enslaved black refugees back to them. Squire demurred, and the *Liberty* met its fate.

SEPTEMBER 3

1861—Reverend Lewis C. Lockwood of the antislavery American Missionary Association surveys the situation in Elizabeth City County to ensure that the Brown and Herbert Schools for newly freed slaves can operate openly and can grow. The association, based in Albany, New York, attempted to aid freedpersons through education. By the end of the Civil War, it had placed teachers in many of the one hundred contraband camps throughout the South, and after the war, it would found, among others, Berea College in Lexington, Kentucky; Atlanta University; Fisk University in Nashville; Dillard University in New Orleans; Tougaloo College near Jackson, Mississippi; and Talladega College in Talladega, Alabama, as well as Hampton Institute (now Hampton University).

SEPTEMBER 4

1860—The niece of President Franklin Pierce, Mary Brewerton Ricketts, is married in the Chapel of the Centurion at Fort Monroe. Her birth name, later changed by her father, was "Aroostine," given at the behest of the Aroostook Indians when she became the first white child to be born at Fort Fairfield near their villages on the Aroostook River in Maine, where her army officer father was stationed.

1915—Fire companies from Hampton are among those that respond to a spectacular and costly fire that breaks out overnight at the massive eleven-story grain elevator on the Newport News waterfront. Within minutes, flames reach hundreds of feet into the air and are visible for twenty miles, and the heat is so intense that the firemen at first cannot get within blocks. The facility, on the C&O Railroad tracks, handles a substantial portion of the grain shipped to Europe from the Midwest. At about 1:00 a.m. the thirty-year-old building collapses. The inferno is finally controlled after a three-hour battle. Remarkably, the only death is suffered by a watchman stationed inside the building.

SEPTEMBER 5

1781—In a battle off the Virginia Capes in the Atlantic, a French fleet under Admiral Francois-Joseph-Paul, Comte de Grasse, emerges from Lynnhaven Bay to defeat and drive off a British fleet under Admiral Thomas Graves, ensuring that no help would come for General Charles, Earl Cornwallis, whose army will be hemmed in at Yorktown by Patriot forces under General George Washington. This act makes Cornwallis's surrender inevitable, ensuring the nation's independence. Subsequently, many French sailors and troops are billeted in Hampton houses well into 1782, as it is uncertain whether the British will pursue the war at this point. Hampton's courthouse becomes a hospital for the wounded French. A preliminary peace treaty would not be signed until November 30, 1782.

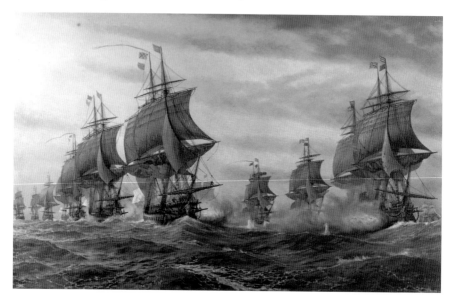

This 1962 painting of the Battle of the Virginia Capes is the work of a member of the U.S. Navy. *Library of Congress.*

1899—The last of twenty yellow fever deaths of persons at the National Soldiers' Home occurs. The victims are among the twenty-two burials at the Hampton Veterans Affairs National Cemetery, located on site at the Home, as no one was allowed to enter or leave the station during the epidemic.

SEPTEMBER 6

1902—By order of Secretary of War Elihu Root, the recently closed second Hygeia Hotel, a fading grand resort at Old Point Comfort, is razed to make way for enlargement of the post at Fort Monroe. The "enlargement" turns out to be a park. By a strange coincidence, the order falls on the fortieth anniversary of Secretary of War Edwin L. Stanton's order to begin demolition of the first Hygeia in 1862.

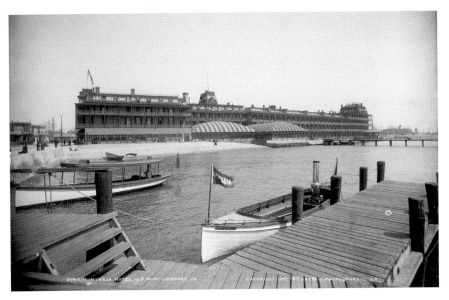

Offering amenities like hydraulic elevators, electric room bells, and hot sea baths, the second Hygeia Hotel became one of the nation's premier resorts. *Library of Congress.*

SEPTEMBER 7

1780—James Barron of Hampton serves as the third commodore of the Virginia Navy, the largest of the state navies that fought during the American Revolution. Barron, who would command through the end of the war, and his predecessors established the navy's headquarters at Cedar Point in Hampton on Sunset Creek. On December 29, a British naval force under Benedict Arnold would enter Hampton Roads, and in late April 1781, at a battle in the James River just below Richmond, Arnold would destroy or capture all but one of the ships of Virginia's fleet, to Barron's dismay and disgrace.

SEPTEMBER 8

1909—The Virginia School for Colored Deaf and Blind Children opens. Eventually, its Hampton campus would cover one hundred acres. The first white resident enrolls in 1973, after integration. Because of declining need, the facility would be closed on June 30, 2008, and its remaining residents and faculty relocated to a similar institution in Staunton, Virginia.

1953—Y.H. Thomas Junior High School, the only junior high in Hampton built exclusively for African Americans, serves its community. It was named for the former principal of Union Street School who held the job for twenty-five years. In 1968, it will become an elementary school, but it will be converted to other city purposes in 1973 and eventually abandoned. A black organization, the Coalition for Community Pride and Progress, persuades the city to renovate and reopen the building in April 1996 as the Y.H. Thomas Community Center.

SEPTEMBER 9

1622—Local Indians strike Hampton (then Elizabeth City), assaulting workers in the field and killing four settlers. It is the first native attack on English colonists since the great massacre led by paramount chief Powhatan's brother and successor, Opechancanough, the previous March, when perhaps one-third of the English in Virginia had been killed and several survivors had found protection at Hampton—which the first 1622 massacre did not reach. The Indians in September hide in cornfields and escape at night, without loss. Fear causes a cessation of agricultural labor, and the newly installed vineyards at Buckroe are "greatly bruised" by roving deer.

SEPTEMBER 10

1959—After winning state and regional tournaments, Phoebus Post No. 48 makes it to the American Legion World Series baseball championship game but loses to a team from Detroit. Pitcher Bobby Ball and his dad and coach, Bill, were also members of the Hampton-Wythe Little League World

Series participants of 1954. Other local teams to reach the American Legion World Series include Hampton Post No. 31 in 1962 and Phoebus Post No. 48 in 1991, but neither reaches the title game.

SEPTEMBER 11

1626—Joane Wright, who lives with her husband and two children at Anthony Bonall's plantation at Elizabeth City (later Hampton), is charged by two other women with being a witch. Since later records show that Wright was still alive, she was not put to death for this crime and may have been acquitted.

1931—Jenny Kane, the wife of Dr. Elisha Kent Kane III, drowns while swimming with him near Back River Lighthouse on Grandview Beach. Dr. Kane, a wealthy Pennsylvanian with a prominent ancestry who is professor of Romance languages at the University of Tennessee, will be tried and acquitted of murder. The trial, in December, is a sensation, with crowds of people standing outside the Hampton courthouse, unable to obtain a seat.

1997—Hampton's Convention and Tourism Bureau accepts the Swan Allen Tourism Merit Award for "Family Tree: A Campaign to Promote African-American Travel to Hampton."

2002—The City of Hampton celebrates its first Day of Remembrance and Hope, in memory of those who died in the airborne terrorist attacks made against New York, Pennsylvania, and Virginia on September 11, 2001. The names of the deceased are read, while attention is paid to the acts of sacrifice and gallantry of emergency responders and service members from our region who made the supreme sacrifice for their country in support of combat operations since that date.

SEPTEMBER 12

1570—Eight Spanish Jesuits, with their ship's crew, stop at the Kecoughtan Indian village en route to establishing the Ajacan Mission

and settlement, probably near the Indian town of Chiskiak on the York River. The Spanish precede the English in exploration of the Chesapeake Bay region, which they call "Bahia de Santa Maria," and the Jesuits bring with them "Don Luis," an Indian child kidnapped from Chiskiak in 1561. Reared in Madrid, "Don Luis" escaped as soon as the group arrived near his village, and in February 1571, he would return with a war party to massacre the Jesuits. Only a single child would be spared, and the arrival of a resupply ship in 1572 would enable him to tell the story. A Spanish military expedition would later hang eight natives in retaliation.

1843—The schooner *Perseverence*, built in Elizabeth City County by William H. Ruggs, receives its carpenter's certificate. It is one of at least twenty-two schooners, skipjacks, and other fishing vessels constructed during the period 1825–90 by a thriving set of small shipyards in Hampton and in Fox Hill on Back River and Harris Creek, owned by Thomas Dobbins, William and John Stores, and others.

1960—Slow-moving Hurricane Donna, a giant storm with winds gusting to 128 miles per hour and an eye nearly 50 miles wide, smashes directly through Hampton Roads. It causes the deaths of three people in Tidewater, forces the evacuation of Grandview Beach, floods low-lying areas, topples hundreds of trees and many tombstones in Hampton and elsewhere, and wreaks devastation on stores and homes from Norfolk past Williamsburg. Setting a record low barometric pressure of 970.7 millibars, as recorded at the Norfolk airport, which was not broken until Hurricane Irene struck in 2011, Donna lifts the Newport News ferry dock off its pilings and virtually destroys piers at Huntington Park and Hilton Village. However, damage is somehow considerably less than suffered during Hurricane Hazel in 1954 or the "Great Storm of 1933" because Donna hits at low tide.

SEPTEMBER 13

1965—Two movie theaters are built, expanding the Newmarket Shopping Center (later called Newmarket South), located on the border between Hampton and Newport News. When the shopping center opened in 1956, it

was the largest in Virginia, with thirty retail and service outlets. The center tends to flood in heavy rains, and with the advent of shopping malls, its business would decline.

SEPTEMBER 14

1843—Using Old Point Comfort as his presidential retreat, President John Tyler hosts a spectacular dinner at the Hygeia Hotel for all officers of the Fort Monroe garrison. Afterward, the entire party adjourns to the resort hotel's ten-pin bowling alley for some recreation.

2015—A crowd gathers at the former Newmarket Theater to witness the opening of a time capsule sealed in 1965 and buried under its steps. Items in the treasure-trove include an autographed photo of the Beatles, letters attempting to predict what the future would look like (one of them expecting "air cars"), a promotional 16mm film in color from three local television stations, a photograph of two eleven-year-old girls who won a radio station's contest to have it placed in the capsule, and a 1965 phone book containing party lines but no area codes.

SEPTEMBER 15

1887—The death of James Barron Hope, a grandson of the U.S. Navy Commodore James Barron, who fought a famous duel with Commodore Stephen Decatur, is reported. Hope was schooled in Hampton before graduating from the College of William & Mary. A lawyer, a journalist, and an editor who founded the *Norfolk Landmark* newspaper, as well as a captain in the Confederate quartermaster corps whose wartime service broke his health, Hope would gain great acclaim as a poet.

1898—The De LaSalle Institute for Boys, a Catholic school, is opened on the corner of what would be named LaSalle Avenue and Chesapeake Avenue (the Boulevard). It is staffed by the Christian Brothers order. It came at the insistent urging of Hampton seafood entrepreneur James McMenamin and is lodged in a large multistory structure near the shore of Hampton Roads.

After going through several reincarnations, the school would close in 1904. The building would be transformed into a hotel called the Boulevard Inn. A decade later, it would become a rooming house for soldiers stationed in the area. It will be demolished in 1987 to make room for modern condominiums.

2011—After nearly two centuries of service to the nation, Fort Monroe, the largest moated fort ever built in North America, is decommissioned as a military base. The title reverts to the Commonwealth of Virginia. A Fort Monroe Authority is established to work out the details of the transfer of property. President Barack Obama would soon designate a large portion of the former base as a National Monument.

Completed in 1834, Fort Monroe, called the "Gibraltar of the Chesapeake Bay," today houses the Casemate Museum, chronicling the history of Fort Monroe and Old Point. *Library of Congress.*

SEPTEMBER 16

1861—A Sunday school is opened by Reverend Lewis Lockwood of the American Missionary Association for contrabands (escaped slaves) living in Hampton and the surrounding area. It is held in the house of former President John Tyler, who is supporting the Confederacy and has left town.

SEPTEMBER 17

1826—With an elaborate ceremony, the cornerstone of Fort Calhoun (now Fort Wool) is laid at the island of stone in Hampton Roads by Major General

Jacob Brown, the commanding general of the U.S. Army and a hero in the War of 1812. This is followed by the raising of the colors and a salute fired from Calhoun's guns, answered by the guns at Fort Monroe.

1849—Edgar Allan Poe presents his last public poetry reading on the veranda of the Hygeia Hotel at Old Point Comfort. He would die in Baltimore three weeks later, on October 7, at age forty.

Mary Peake was an American teacher and humanitarian. The Mary Peake Center of Hampton Public Schools and Mary Peake Boulevard are named in her honor. *City of Hampton.*

1861—Mary S. Peake, a free-born African American woman, begins offering education to contrabands. Although it was illegal during the Confederacy to educate slaves, Peake had taken the extreme risk of teaching surreptitiously for many years in her home. When Hampton was burned on August 8, she moved her school to the Brown cottage near Hampton Institute (now Hampton University). On this date, she begins teaching openly under an oak tree on the grounds of Hampton Institute, and men, women, and children hungry for learning and advancement flock to her classes. She would later be paid for her work by the American Missionary Association. She will perish of tuberculosis on February 22, 1862.

1862—The Thirty-Second Virginia Infantry Regiment, a Confederate unit from Hampton and Elizabeth City County, suffers nearly 50 percent casualties at the Battle of Antietam in Maryland. It is the bloodiest single day in American history, with more than twenty-two thousand total casualties.

1956—The last fire alarm to be received at Hampton's aging fire station comes in for a blaze at a site near the corner of Lincoln and Eaton Streets. The station would soon close, replaced by a brand-new facility on Pembroke Avenue.

SEPTEMBER 18

1923—In an experiment to transform an airship into a "flying aircraft carrier," an aviation milestone is reached at Langley Field when Lieutenant Rex K. Stoner flies a Sperry "Messenger" under the airship *D-3*, where it engages the dirigible's trapeze for more than one minute.

2003—Hurricane Isabel strikes Hampton. A storm surge that pushes water levels to about eight feet over normal, plus heavy rainfall reaching ten-plus inches, affects boats and homes along waterways. Waves offshore crest at more than twenty feet. Flooding is severe. Many power lines fall. All piers into Hampton Roads along Chesapeake Avenue and the Boulevard, plus the seventy-year-old fishing pier into Chesapeake Bay at Buckroe Beach, are destroyed, while traffic signal outages result in multiple automobile accidents. The old Hotel Chamberlin suffers major water damage. Tidewater residents experience Virginia's first mandatory disaster evacuation, including six thousand workers at Langley Air Force Base, which is particularly vulnerable to flooding.

SEPTEMBER 19

1659—The will of Thomas Eaton, a Hampton physician, bequeaths five hundred acres in rural Elizabeth City County plus other property to provide a free education to children of the county. The Eaton School serves the local populace for many years, and in 1805, at the behest of the Virginia General Assembly, upon petition by local citizens, it will be consolidated with a similar school founded in 1634 by the will of Benjamin Syms. The resulting combined school will be moved to a structure on Cary Street in downtown Hampton, called Hampton Academy.

1956—The first fire alarm call is received at the Hampton Fire Department's new station on Pembroke Avenue and answered for a site on Curle Road, where a burning shed is destroyed.

SEPTEMBER 20

1881—David Kalakaua, king of the Hawaiian Islands, visits Hampton as a guest of Hawaiian-born Samuel C. Armstrong, principal of Hampton Institute (now University). The last ruling king of Hawaii, Kalakaua becomes the first reigning monarch to travel around the world. Most power is taken away from Hawaii's monarch by the United States–imposed constitution of 1887, known to native Hawaiians as the "Bayonet Constitution" because of their view of the manner of its becoming law. Kalakaua would die in 1891, while Hawaii would be annexed by the United States in 1898 and would become the fiftieth state on August 21, 1959.

1944—In a planned maneuver to learn what occurs during the ditching of an aircraft into the sea, NACA (NASA's predecessor) has a B-24 Liberator from Langley Field, flying parallel to the James River Bridge, crash at just over one hundred miles per hour into the James River. Two test pilots who risked their lives emerge unscathed, but the plane is damaged beyond expectation. The lower fuselage crumples like tinfoil, all four propeller engines are ruined, and the nose section is nearly severed. The wreckage is picked up by a floating derrick. The information gained would help many later pilots ditch their planes more safely.

SEPTEMBER 21

1909—The Virginia State Corporation Commission issues a charter of incorporation to the Galilean Fishermen's Bank Inc. It is the third attempt of Hampton's African Americans since 1901 to establish a bank that would serve them, each affiliated with the Grand United Order of Galilean Fishermen, a black fraternal organization begun in 1857 in Baltimore, Maryland, to offer banking and insurance services to people that white-owned institutions would not provide in the era of segregation. By 1920, the Fishermen's Bank would be defunct.

SEPTEMBER 22

1953—Local media visionary Thomas P. Chisman guides Hampton's first television station, WVEC. Its NBC affiliation would be changed to ABC in 1959. Chisman and his business associates sell the station to Corinthian Broadcasting Company in 1980. With the help of family and friends, Chisman had previously opened Hampton's first radio station in 1948.

SEPTEMBER 23

1933—The Hotel Willard, one of two hotels serving black citizens at Bay Shore Beach, burns to the ground one month after the "Great Storm of 1933" devastates the resort. Developed by nine African American entrepreneurs, including seafood magnate John Mallory Phillips, Bay Shore Beach opens for black patrons in the summer of 1898, on one hundred yards of sandy beach next to the whites-only resort of Buckroe Beach. Bay Shore's amusement park eventually would boast a roller coaster called the Dixie Flyer, a carousel, a Ferris wheel, and bumper cars. The resort would become one of the premier vacation spots for African Americans. Performers at its popular dance pavilion would include Fats Waller, Dizzy Gillespie, Cab Calloway, James Brown, Redd Foxx, Duke Ellington, Ella Fitzgerald, and Louis Armstrong, and many whites break the color line to listen, laugh, and dance. It takes seven years after the devastating 1933 storm and the Willard fire for Great Depression–ridden local African Americans to reconstitute the resort. Integration and competition would eventually force the closure of Bay Shore Beach, and the land will be sold to real estate developers in 1973.

SEPTEMBER 24

1853—A countywide tax of three dollars per year, payable by white males, is established to support public schools in Elizabeth City County.

1955—In one of the worst accidents to occur at Langley Field Air Force Base, four (of sixteen) F-84F Thunderstreak jets destined for an air base in England crash soon after takeoff. All are overburdened with extra fuel tanks,

use a runway too short for such heavy planes, and fly in gravely overcast conditions. Within a span of four minutes, one goes down immediately, a second falls into the Chesapeake Bay, and two others collide in the cloud cover overhead. All the doomed pilots probably had their sight affected by the explosion of two of the extra fuel tanks and the resulting fire dropped by the fourth pilot at the end of the runway so he could get his jet airborne. The planes must refuel twice on the trip. Another aircraft is lost on the flight, with its wreckage never found, so that only eleven reach their destination.

SEPTEMBER 25

1968—Classes are in session at Thomas Nelson Community College in Hampton, with 1,232 students enrolled. The 1966 Virginia General Assembly established a statewide system of comprehensive community colleges to provide for the first two years of post–high school studies in several Virginia locations. Having opened on September 19, 1968, Thomas Nelson's first class graduates with associate degrees on June 13, 1970.

SEPTEMBER 26

1956—Hurricane Flossy strikes Hampton Roads, bringing flooding to many low-lying areas; destroying piers, docks, and the main wharf at Old Point Comfort; downing trees and telephone lines; and sinking a vessel in Norfolk. The remains of the Back River Lighthouse at Grandview, built in 1829 at a cost of $4,250, are destroyed (as well as the nearby Grandview Ballroom,

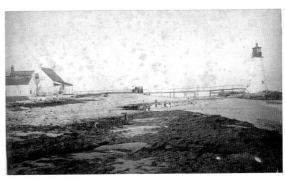

Back River Light (also known as Grandview Light) was a thirty-foot conical masonry tower similar to other lighthouses around the bay. *City of Hampton.*

supposedly protected by a new bulkhead). Confederate raiders had damaged the lighthouse structure in 1862, but the light was back in action the next year. Originally on dry land, at the time of its demise the lighthouse rested slightly offshore. A 144-foot wooden bridge once joined the whitewashed 30-foot-high round tower to a brick one-story keeper's house. Although a second story was added in 1894, the home and the bridge were demolished in 1914, when the facility became automated. The beacon went dark in 1936 when the lighthouse was discontinued, and today only a pile of rocks marks the site.

SEPTEMBER 27

1957—Rosa Parks is greeting visitors and diners as a hostess at the Holly Tree Inn, the faculty's dining area at Hampton Institute (now Hampton University). She will maintain the position for a year and then return to Detroit. Parks made nationwide headlines when in 1955, as a part of a well-planned local civil rights campaign in Montgomery, Alabama, she refused to move to the back of a bus to give her seat to a white person. Although the year-long Montgomery Bus Boycott was eventually successful, ending segregation in public transportation, Parks and her husband were abused and threatened, so they moved to Detroit.

SEPTEMBER 28

1855—Samuel Barron, son of Commodore Samuel Barron and a member of a famous Hampton naval family, serves in the U.S. Navy following his promotion to captain two weeks earlier. He was on the frigate USS *Brandywine*, which transported the Marquis de Lafayette home to France in 1825. Barron commanded ships off Africa in 1849–53 and in the Mediterranean in 1858–59. In charge of the naval defense of Virginia during the early days of the Confederacy, he will deal in Europe with construction of Confederate naval vessels in 1863–65.

SEPTEMBER 29

1855—Ann Key Taney, wife of U.S. Chief Justice Roger B. Taney and sister of Francis Scott Key, dies of a stroke. The next day, Alice, the Taneys' youngest daughter, dies of yellow fever at Old Point Comfort. During the summer and fall of 1855, more than 3,200 people die in Norfolk and Portsmouth in the worst outbreak of that dreaded disease in the history of Tidewater Virginia. Other towns in Virginia proscribe any visitation from the afflicted areas, including Hampton, and Alice Taney's is the only known death from yellow fever there during the epidemic.

SEPTEMBER 30

1668—In a letter to the governor of Virginia, the king of England recommends that Thomas Beale be appointed commandant of his majesty's fort at Point Comfort, as the fort had been devastated in the "Dreadful Hurry Cane" of 1667 and had fallen into decay.

2010—The Hampton Downtown Historic District is added to the Virginia Landmarks Register, reflecting the rich heritage and high-style architecture of the buildings included.

October

OCTOBER 1

1863—The 4th United States Colored Troops, an infantry regiment from Baltimore, marches to the beat of drums from Old Point to its duty station at Yorktown, accompanied by a full military band. The first African American soldiers seen by local whites are jeered, spat at, and assaulted, as armed black men are greatly feared. With the return of Major General Benjamin F. Butler to command at Fort Monroe in December, the 10th United States Colored Troops, two regiments of cavalry, and an artillery unit are formed by the end of January 1864 from contrabands (persons renouncing slavery) living in camps in Hampton, Newport News, and Craney Island.

1958—More than eight thousand NACA employees across the nation find that their agency has been replaced by a new National Aeronautics and Space Administration (NASA). Also included in the new agency are research centers in California and Ohio, the Ames Research Center at Langley, and the Wallops Island Flight Facility. Those at Langley gather to be sworn in as members of the new organization, marking the end of the agency's concentration solely on terrestrial flight and the beginning of its research into spaceflight.

2010—Fort Eustis, in Newport News, and Langley Air Force Base, in Hampton, are merged under a joint command following the mandates of BRAC, the Defense Base Realignment and Closure Commission, as a part of a nationwide attempt to cut costs.

OCTOBER 2

1776—The Company of Minute Men, organized by Hampton's Miles King, is taken into state service as part of the militia. It keeps busy during the Revolution attempting to guard Elizabeth City County's lengthy and exposed shoreline. The home of King, also a member of Hampton's Committee of Safety and Governor Thomas Jefferson's local "eyes and ears" during the troubled times, is "the scene of the most unbounded hospitality to the suffering troops of our country." King clothes and feeds many of the troops from his own pocket. When the British cavalry of the notorious Major Banastre Tarleton make a surprise visit during the dinner hour, King is taken prisoner to Yorktown and kept there until he is paroled. King moves to Norfolk after the war is over and eventually becomes its mayor.

1866—Thanks in large part to the insistent urging of Fort Monroe medical officer Lieutenant Colonel John Craven, a weak, depressed, and unhealthy former Confederate President Jefferson Davis is moved from his casemate cell to a larger, more airy apartment in Carroll Hall, an officer's quarters at Fort Monroe where Davis would spend about half of his two years' imprisonment. Davis is now allowed nightly exercise on the ramparts, correspondence with friends and family (though it is censored), and occasional visits from his wife. His health begins to improve.

1933—A license is granted for the Driskill and Barkley Flying Service to work out of an airstrip at the corner of Hampton's Aberdeen and Shell roads. Its turf runways are 2,600 feet long. The airstrip closes in 1941.

OCTOBER 3

1609—George Percy, president of Virginia's Colonial Council, sends the recently arrived Captain James Davis, his sixteen men, and Captain John Ratliffe with a company of soldiers to Point Comfort to build a new fort, Algernourne Fort, named in honor of the ancestor of Percy who came to England with William the Conqueror. The fort would burn down in 1612 but would be rebuilt.

1867—The cornerstone of the Soldiers' Monument is dedicated at Hampton National Cemetery. More than 2,300 deceased Union veterans of the Civil War are initially buried there, gathered from nearby battlefields and brought from the massive 1,800-bed Union army hospital complex near Fort Monroe, which even after the war ends witnesses a continuous stream of deaths in desperate and lingering cases. Through 1869, because of threatened and actual desecration by Southern farmers and others, thousands more Union soldiers would be reinterred there, taken from at least twelve graveyards in southeastern Virginia (including Fort Monroe) and the Eastern Shore. Thousands more would be laid to rest at Yorktown National Cemetery.

1944—A B-24J bomber takes off from Langley Field at 7:24 a.m. heading north, for a test run of its high-altitude radar navigation. At about 7:50 a.m., Mathews waterman Leslie Hudgins calls Langley to report the crash of an airplane a mile or so off New Point Comfort, in the Chesapeake Bay, which he witnesses while fishing his gill nets. The airplane had nosedived and exploded when it struck the water, scattering debris over a large area and killing all seven crew members. Two weeks later, walking along the beach at Winter Harbor, Hudgins would find the body of one of its pilots, Lieutenant David Kitko from Ohio. The cause of the crash remains unexplained.

OCTOBER 4

1956—The initial supersonic "Super Sabre" fighter jet, the F-100, is christened *Miss Hampton* at Langley Air Force Base. It is the first U.S. Air Force airplane to be capable of flying faster than the speed of sound. The plane would later be discontinued because of its many problems.

OCTOBER 5

1908—Janie Porter Barrett, an 1885 graduate of Hampton Institute (now Hampton University), founds the Virginia State Federation of Colored Women's Clubs. Barrett gained a national reputation from her development in Hampton of the Locust Street Social Settlement, begun in her home in the 1890s when she taught at her alma mater. After she married Harris Barrett in 1899, they built a separate structure on their property for the settlement house. During the Progressive era, there was an organized attempt to lessen class tensions by establishing "settlement houses" in poor urban areas in which volunteer middle-class "settlement workers" live and teach, hoping to share knowledge and culture with their low-income neighbors and thus help alleviate their poverty, as well as to encourage the two groups to become familiar with each other. The Locust Street house provides social clubs for children, women, and senior citizens, as well as recreational opportunities and classes in domestic skills, all for African Americans in an era of segregation. Barrett used the connections of Hampton Institute with northern philanthropists to find funds for the project.

OCTOBER 6

1939—The first neighborhood movie theater on the lower Peninsula, the Wythe Theater, opens in Elizabeth City County. With six hundred seats, construction cost $35,000. It has modern amenities, such as a remote control stage curtain, indirect cone lighting, a smoking room for men and a powder room for women. Its first film is *The Rains Came*, which stars Myrna Loy and Tyrone Power, playing to 581 customers at the grand opening.

OCTOBER 7

1880—The forty-four-gun sailing frigate USS *Constitution* lies at anchor in Hampton Roads during a three-day stay. One of the first warships built by the United States, *Constitution* was launched in Boston on October 21, 1797. Engaging fully in the Quasi-War with France (1798–1800) and the war with the Barbary Coast pirates (1801–5), *Constitution* defeated all four

The wooden-hulled, three-masted USS *Constitution* was named by George Washington and is the world's oldest commissioned naval vessel afloat. *Library of Congress.*

British warships it faced during the War of 1812. Retired from active service in 1855, it became a training ship. Still today a commissioned and seaworthy U.S. warship, *Constitution* is berthed in Charlestown, Massachusetts, and can be visited.

OCTOBER 8

1692—Trustees lay out the streets for the town of Elizabeth City, on Hampton Creek (now River), after an act of the General Assembly establishes it as a port of entry and directs a custom house to be built in the new town.

OCTOBER 9

1939—Hampton's Wythe Shopping Center has expanded into the first "strip mall" development in the area. It contains a grocery store, a drugstore, the Wythe Theater, and a soda fountain. Later growth across Kecoughtan Road would include a second-story bowling alley (over a hardware store), and nearby is the first drive-up window for any Hampton bank, as well as some smaller shops. Not far away are iconic restaurants the Rendezvous and Bill's Barbecue, and by the 1940s, there would be a Chinese takeout. Hampton's first planned shopping center would be Newmarket Shopping Center, which opens in 1956.

OCTOBER 10

1624—The Elizabeth City (today, Hampton) Town Council orders payment to workers for the construction of a second Episcopal church building for Elizabeth City Parish. The frame structure is erected on the eastern side of Hampton Creek (now River), on land now within the grounds of Hampton University. It would be abandoned as a church in 1667 after suffering under the twelve-foot storm surge of the terrible hurricane of that year, and it will be demolished in 1698. The new (and third) church building would be built on Pembroke Farm west of Hampton, closer to many rural parishioners, and away from possible piratical depredations.

2014—Armstrong School of the Arts, an elementary school in Hampton, has recently been selected by the U.S. Department of Education to be a Blue Ribbon School. Only 7 of Virginia's 1,775 schools receive this achievement award in 2014, granted because leadership and teaching have demonstrated consistent excellence, have made progress in closing gaps in student achievement, and have produced outstanding results for all pupils. Principal Lelia Stovall gives credit for assistance to Armstrong's community partners, including Joint Base Langley-Eustis.

OCTOBER 11

1627—Because of a dispute between Benjamin Syms and Joan Meathart, a servant whose passage was paid to Virginia by Syms "with an interest to make her his wife," the Virginia Council orders that Joan work for John Gill for two years instead, while Gill must pay Syms one hundred pounds of tobacco and "deliver him one man servant as soon as any shall arrive here" for three years' service with Syms.

1879—The recently established Town Improvement Association of Hampton, with Jacob Heffelfinger as president, is functioning as another typical Progressive era endeavor. Its goals are to keep the town's streets clean and to grade and resurface Queen Street with oyster shells, starting from the Hampton River Bridge across the intersection with King Street and into the county beyond St. John's Church, financed by contributions from interested citizens.

OCTOBER 12

1861—Hampton's Confederate cavalry unit, the Old Dominion Dragoons, captures twelve Federal soldiers while reconnoitering near what is now Newport News.

2001—The death of Andrew T. Smith Sr., the third-generation proprietor of Smith Bros. Funeral Home in Phoebus, is reported. A Mason and a member of Queen Street Baptist Church, Smith is a 1939 graduate of a New York City embalmers' school.

OCTOBER 13

1691—Following the passage of the Virginia General Assembly's Act of Ports, Hampton is designated as an official port, creating a custom house there for the Lower James River District. The jurisdiction stretches from Hog Island (across from Jamestown) down the James River and around Elizabeth City County to the Back River, also including the Norfolk side of

Hampton Roads, Lynnhaven Bay, Cape Henry, and the Atlantic coastline to the North Carolina border. All ships entering or leaving this large area must stop at the custom house for inspection and tolls. With the buildup of the shoal known as Hampton Bar making entrance to Hampton Creek (now River) much more difficult, eventually the custom house would be shifted to Norfolk, but records demonstrate that all ships would still need to clear Hampton in the late 1740s.

2016—Demolition commences on the fifty-year-old CF4 wind tunnel at NASA Langley Research Center. With its giant tall sphere visible for miles, the CF4 is a "blowdown" tunnel using extremely fast, furious and brief blasts of air, lasting no more than twenty seconds, against steel or ceramic models in superheated tetrafluoromethane gas to simulate the extreme conditions of reentry into the earth's atmosphere. The tunnel played a key role in discovering what caused the breakup of the space shuttle Columbia upon reentry in 2003. Computer simulations have rendered the structure superfluous.

OCTOBER 14

1947—After much wind tunnel testing at Langley in transonic research, the Army Air Force's Captain Chuck Yeager reaches Mach 1.06 in a historic test flight over Muroc Dry Lake, California, supported by a team of NACA (now NASA) engineers, instrumentation specialists, and observers from Langley looking on.

Chuck Yeager's rocket-powered Bell X-1 aircraft, christened *Glamorous Glennis*, was launched from the bomb bay of a modified B-29 for the record-setting flight. *Library of Congress.*

OCTOBER 15

1905—The death of William N. Armstrong, the brother of Hampton Institute founder Samuel Chapman Armstrong, is reported. As attorney general of his native Hawaii, he accompanied Hawaiian King David Kalakaua on his 'round-the-world trip in 1881, during which they visited Hampton Institute. As the king desired to legitimate his reign with an expensive coronation upon his return, Armstrong resigned his office in protest and moved to Hampton, where he bought up a great deal of real estate in what would become the areas of Wythe and Merrimac Shores.

1954—Hurricane Hazel, one of the most destructive storms ever to strike the eastern United States, has its eye pass over Hampton. Hazel produces Virginia's broadest-measured swath of hurricane-force winds of any twentieth-century storm, downing trees, power lines, and radio towers and causing many power failures. Buckroe and other beaches suffer severe damage, with the blasts much stronger than in Hurricane Isabel. Hampton records its greatest-ever wind speed, a gust of 130 miles per hour, while Washington, D.C., and New York City also have their highest recorded gales from this tempest.

OCTOBER 16

1881—The tracks of the Chesapeake and Ohio Railroad are completed from Richmond to Newport News, the United States' largest ice-free port, primarily for the purpose of getting West Virginia coal to large ships that would carry it to northern and international customers of Collis P. Huntington, one of the great "robber barons." The first passenger train passes along them on October 19. This would prove to be a precursor for providing rail service to Hampton when a spur is extended the following year, completed in December 1882. By 1890, the spur would be extended across Mill Creek on a long trestle to Fort Monroe. The C&O's Milepost Zero is still visible on Old Point Comfort, although rail service has been discontinued for many years.

OCTOBER 17

1751—The vestry of what will become named St. John's Church levies sixteen thousand pounds of tobacco from the congregation to pay the annual salary of Reverend William Fyfe.

1922—En route back to Langley Field after a sixty-seven-hour transcontinental flight to Ross Field, California, the hydrogen-filled airship *C-2* bursts into flames in high winds at Brooks Field, Texas, and leaves a mass of smoking, tangled wreckage. While exiting its hangar, the U.S. Army's "biggest and best" dirigible is blown to the ground by several gusts of wind, a hole is scraped in its bag, and it ignites and explodes. Seven of the eight people on board are injured, although there is nothing more serious than broken limbs, while the pilot escapes unharmed. The incident induces many to call for the use of nonflammable helium in airships.

OCTOBER 18

1918—The only newspaper published in Hampton, the *Hampton Monitor*, ceases publication. Commencing in 1896 by renaming the *Hampton News* (which in 1892 had been the *Monitor Advance*, which in turn had in 1890 absorbed the original *Hampton Monitor*, begun in 1876), publisher Thomas G. Elam sells it to local printer Harry Houston in 1901. He had switched to a daily publication, but it was unsuccessful and Houston soon resumed the weekly format.

OCTOBER 19

1749—A huge offshore hurricane greatly affects the Hampton Roads region with powerful northeast winds becoming fierce by midafternoon. Torrents of rain and flooding result in drownings and structures being carried away. In Hampton, water rises to a depth of four feet in the streets, with many trees snapped or uprooted. Commodore James Barron, whose grandfather witnessed the storm while stationed at Fort George on Old Point Comfort, related: "One could hear the sand picked up by the wind from the beach

outside and blasted against every object that withstood the gale. The waves were pounding the shore, finally to the very foot of the outside wall of Fort George. Shortly afterward, the seawall lurched and sank." The fort is destroyed in the storm.

2011—President Barack Obama, along with First Lady Michelle, visits Langley Air Force Base. The presidential couple eat pizza at a Hampton restaurant and stop at a farmers' market to obtain a pumpkin for Halloween.

OCTOBER 20

1861—The *Seahawk*, owned by Isaac Williams of Fox Hill, is commissioned a Confederate privateer. Many private vessels were given such commissions pursuant to international law, by both sides in the Civil War, to prey on the shipping of the other nation. Thus, privateers are legal pirates.

OCTOBER 21

1953—Electric Avenue has its name changed to Victoria Boulevard. The first trolley lines laid from Hampton to Newport News, to carry people to their jobs at the Newport News Shipbuilding and Dry Dock Company, pass along this direct route—at first with no road parallel to them for a good deal of the distance through fields and woods. When inevitably a street appears next to the tracks, it is named "electric."

OCTOBER 22

1956—A new Hampton High School complex is under construction on West Queen Street. It will become the third site of an institution founded in 1914. Students would finally begin to take classes there in the fall of 1958. The new facility is overcrowded from its opening, with pupils by 1962 required to attend in shifts. The situation is made worse when Hampton Institute refuses to renew the city's lease on the George P. Phenix High

School building because Hampton persists in keeping its schools racially segregated. New city-built Kecoughtan High School and George P. Phenix High School would be dedicated in 1962 and 1963, respectively. When the city fully integrates in 1968, the name of the latter is changed to Pembroke High School, over some protest.

OCTOBER 23

1780—British forces under General Alexander Leslie attack and occupy Hampton during the Revolutionary War, preparing for a thrust westward toward Petersburg and Richmond. Soon news arrives of the major British defeat at King's Mountain on the borders of South and North Carolina on October 7, and Leslie departs Hampton on October 28, moving to take Suffolk. He would evacuate Suffolk and Portsmouth, his primary base, on November 15.

1917—The Langley School of Aerial Photography is established at Langley Field under Sergeant (later Captain) Malcolm A. McKinney Jr., who before the First World War was a commercial photographer. It is sponsored by the Eastman Kodak Company and trains officers and enlisted men in the skills necessary to produce behind-the-lines reconnaissance. The school would finally open on January 30, 1918. The trainees would use a JN-4 Curtis Jenny biplane, with an easy maneuverability that allows the pilot and the photographer to work well together. A building would be completed in 1920, when 10 officers and 131 enlisted men graduate from the program.

The Langley School of Aerial Photography trained personnel to record information in normally inaccessible areas. Two-seat biplanes allowed pilot and cameraman to work together. *Air Combat Command History Office.*

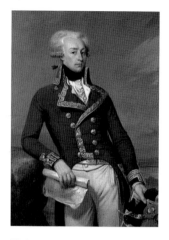

Welcomed by vast crowds throughout his American tour, the Marquis de Lafayette visited George Washington's tomb and spent a week with Thomas Jefferson in Virginia. *Wikimedia Commons.*

OCTOBER 24

1824—The Marquis de Lafayette, the last surviving major general on the Patriot side in the American Revolution, visits Fort Monroe, where he inspects and reviews the troops and then crosses over the Hampton Roads channel to observe Fort Calhoun (now Fort Wool) during his nostalgic grand tour of the United States.

1834—Second Lieutenant Robert E. Lee of the U.S. Army completes his tour of duty at Fort Monroe, where as an engineer he had been instrumental in finishing its construction and in work on Fort Calhoun (now Fort Wool), and is reassigned to Washington, D.C. He marries Mary Anna Randolph Custis at Fort Monroe in 1831, and their first child, George Washington Custis Lee, is born there.

1890—A potentially catastrophic fire breaks out in Blackmore's Feed Store in downtown Hampton, but a repeat of the disaster of 1884 is averted by the quick and thorough work of the now adequately equipped Hampton Fire Department.

1942—Commanding a total of twenty-eight cargo vessels and transport ships carrying thirty-three thousand men, Major General George S. Patton and the U.S. Army Western Task Force sail past the shores of Hampton Roads en route to attack Axis forces in French North Africa as part of Operation Torch in World War II.

1984—The Chamberlin Hotel is placed in both the National Register and the Virginia Register of Historic Landmarks.

OCTOBER 25

1832—Joseph Ranger, an African American living in Elizabeth City County, files a petition requesting a pension from the U.S. government for his service during the American Revolution, under an act passed June 7, 1832. Ranger served as a seaman on five vessels in the Virginia Navy, including four years' duty on the *Dragon*. Captured following an engagement on the James River just previous to the Battle of Yorktown, Ranger was exchanged when the American forces won that engagement.

1976—The death of Claude Vernon Spratley of Hampton, who served on the Virginia Supreme Court of Appeals, Virginia's highest court, from 1936 to 1967, is reported. Judge Spratley graduated from the College of William & Mary in 1901 and from the University of Virginia Law School in 1906.

OCTOBER 26

1768—Norborne Berkeley, Baron de Botetourt, the new British governor of Virginia, arrives with much fanfare at Hampton. Governor Botetourt would die in office two years later, mourned by Virginians; he would be the last popular royally appointed governor. The College of William & Mary annually awards the Botetourt Medal, its most prestigious prize for a student.

1775—The hated last British governor of Virginia, John Murray, Lord Dunmore, has his fleet under Captain Matthew Squire destroy rebellious Norfolk, and then, guided by escaped Hampton slave Joseph Harris piloting the *Otter*, cross Hampton Roads and sail into Hampton Creek (now River), announcing that they will burn the town in retaliation for the destruction of the small ship HMS *Liberty* in Back River in September. Squire leads a flotilla of small boats toward King Street wharf, but accurate musket-fire from locals plus vessels deliberately sunk in the creek hampering his progress keep him offshore. A contingent of British troops eventually lands and burns a dwelling on Cooper's plantation (now the Merrimac Shores neighborhood), but the Patriot militia refuses to meet them in open battle, instead firing at them from the cover of woods and structures; at dusk, the marauders reboard their ships.

OCTOBER 27

1775—The attack on Hampton by British Captain Matthew Squire continues. In an early morning driving rain, Squire finally makes his way through the cordon of ships the Patriots had sunk in the Hampton Creek (now River) channel, closes in and begins to use his artillery accurately. The Episcopal church, now called St. John's, is damaged. Patriot reinforcements arrive under Colonel William Woodford at 7:00 a.m. after a wet overnight march from Williamsburg. The Patriot fire from both shores and from King Street wharf effects many British casualties, including one death, forcing the startled British back up the creek in their ships. They retreat ignominiously, with two ships run aground and lost to capture, plus ten men captured. Hampton is battered in the Battle of Hampton, but there are no Patriot fatalities.

1882—Chesapeake and Ohio Railroad work crews are busily working to complete a spur to Hampton from the line's current East Coast terminus in Newport News. Eventually, the C&O would reach Phoebus, the spur being completed in December. In 1885, one could take a train from Cincinnati to Phoebus. After the building of a 2,800-foot trestle across Mill Creek, the line would be extended to Old Point Comfort in 1890. However, the "Great Storm of '33" destroys the railroad trestle, and it can no longer be used. Excursion trains would sometimes be run to Buckroe, using the local trolley tracks, built in heavy-duty fashion for just such an eventuality.

2010—On behalf of the City of Hampton, at a meeting of the city's governing body, Councilman Will Moffatt presents a recognition plaque to Andrew Smith III of the Smith Brothers Funeral Home as the oldest continuous business in the city and one of several Hampton businesses that are more than one hundred years old. The first African American funeral home on the Peninsula is one of the oldest black-owned funeral homes in the Commonwealth, dating to 1862. Smith is the fifth generation of family owners. A part of Hampton's 400th anniversary celebration, other businesses honored for being more than a century old include Goodman Glass Company, Robert F. Snow & Son Bicycles, the R. Hayden Smith Funeral Home, Mugler's (clothing store) and W.T. Patrick & Sons Hardware.

OCTOBER 28

1872—Located in the southern end of Chesapeake Bay just outside the Hampton Roads Channel and easily visible from Buckroe Beach, Thimble Shoal Lighthouse replaces the Bay's last lightship (a permanently anchored vessel) and is first lit on this day. It would be consumed by fire in 1880 but would be rebuilt in fifty-five days. It would be struck and damaged by a steamer in 1891 and a coal barge in 1898 but quickly repaired. Then the *Malcolm Baxter*, in tow, would slam into it on December 27, 1909, causing another destructive blaze and putting the light out of commission. Originally screwpile in construction (where the lighthouse rests on a hexagon of long metal rods fortified with crossbars and piles of stone), in 1914 it would be replaced with a round caisson structure, made of iron on a solid cement base, near the ruins of the first lighthouse. The light will be automated in 1964. It will be sold at auction in 2005, and while it is now a private vacation retreat, it is still an active aid to navigation.

OCTOBER 29

1918—The so-called Spanish influenza epidemic reaches its peak during this time—71 residents of Elizabeth City County and its towns perish, while 30 more persons die from pneumonia. A major worldwide pandemic enduring for three years (January 1918–December 1920), the disease infects about 500 million humans and kills 30–50 million (3 to 5 percent of the human population). Unlike in other epidemics, those who die are primarily young and previously healthy. The spread of the flu is enhanced by the close quarters of World War I combat and by increased world travel. The epidemic probably kills more people in Europe than had the Black Death (1346–53) and may be the world's most lethal epidemic.

OCTOBER 30

1824—The Marquis de Lafayette continues his grand tour of the United States. After recently visiting Fort Monroe and Fort Calhoun (now called Fort Wool) in Hampton, he travels to Richmond, where he is met by an

honor guard, one of whose members is a youthful Edgar Allan Poe. Welcomed by Americans as a hero, Lafayette visits every state and does not leave the United States until September 1825, having journeyed more than six thousand land miles.

OCTOBER 31

1934—Two airplanes based at Langley Field collide over Fox Hill and crash nearby. The impact is not fatal to either pilot, but one plane strikes a two-story house, with its engine and fuselage passing through an upstairs bedroom and hallway and exploding at the rear of the house, leaving a gaping hole. The blast incinerates a wedding gown, postponing a planned 5:00 p.m. wedding that day. One of the pilots, Second Lieutenant William D. Eckert, will rise to the position of lieutenant general in the U.S. Air Force and during 1965–68 will serve as the commissioner of Major League Baseball. The other pilot, Second Lieutenant Harold L. Neely, will eventually become brigadier general in the U.S. Air Force.

November

NOVEMBER 1

1834—The United States Army chief of engineers reports the completion of "all the permanent parts of" Fort Monroe, at a cost of almost $2 million. It covers sixty-three acres, and its walls stretch 1.3 miles around. Tidal water in the moat ranges from three to five feet deep, fed from a gate to Mill Creek. At this time, only the Jeffersonian Point Comfort Lighthouse exists on Old Point Comfort outside the moat.

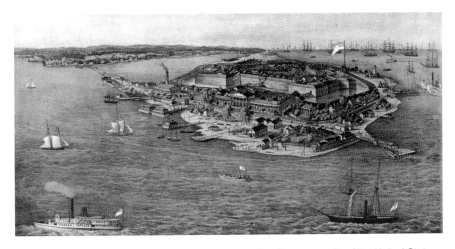

Fort Monroe has witnessed many changes, from imprisoning opponents of the United States to becoming a bastion of defense for Hampton Roads. *Library of Congress.*

1974—Evangelist Billy Graham brings his Christian ministry to Hampton's Coliseum, with an attendance that night of 14,300, and stays to preach for three more days. He draws more than 175,000 people over a ten-day period that includes six days at Norfolk's Scope. Crusade organizers say that more than 5,300 persons made a "commitment to Christ."

2011—Using the Antiquities Act of 1906, designed to protect sites deemed to have natural, historical, or scientific significance, President Barack Obama designates 570 acres on Old Point Comfort—including the entire moated fort, some land surrounding the moat, and significant wetlands on the north end of Old Point Comfort adjoining Buckroe, all with important landscapes and viewsheds—as the Fort Monroe National Monument.

NOVEMBER 2

1937—Charles and Maggie Jones have become the first residents of Aberdeen Gardens, a black-designed and black-built housing community.

NOVEMBER 3

1867—Amid the transition to peacetime following the conclusion of the Civil War, the Artillery School of Practice is reestablished at Fort Monroe and renamed the Artillery School of the U.S. Army. Instruction focuses on training for the use of field, siege, and seacoast guns, mortars, and howitzers, in addition to proper loading and firing procedures, use of fuses, the weights of shell charges, and the velocities and ranges of weapons.

1963—Francis Asbury Elementary School in Fox Hill is severely damaged by fire. Fox Hillians had long desired their own school, as traveling to Hampton or paying for the Syms and Eaton Academies presented cost problems, but their petition was rejected by the Virginia General Assembly in 1818. In 1837, they established Fox Hill Academy. Even though land was acquired for a public school in 1881, Asbury was not built until 1917, at a cost of $18,000, by R.V. Richardson of Hampton. Children who lived too far to walk came to school by horse, wagon, or boat; in 1917, a teacher

earned $800 annually, while a principal took home $1,500. After the 1963 fire, the school would be rebuilt in 1964.

NOVEMBER 4

1861—Two companies of the Ninety-Ninth New York under Colonel Wilson A. Bartlett, formerly stationed at Camp Hamilton (present-day Phoebus) and known as the Naval Brigade, have been moved to Fort Calhoun (now Fort Wool). This hard-luck contingent of former sailors came to Virginia lacking uniforms and weapons, but they were finally provided with arms and flannel shirts, white duck pants, and straw hats, taking their places on the "Rip Raps," as the island fort has become known. The previous June, the men of the Naval Brigade had been instrumental in aiding the Federal assault on entrenched Confederates at Big Bethel by rowing the Union troops across Hampton Creek (now River).

Using bateaus to transport Federal troops, the Naval Brigade proved "of greatest service throughout the night and day" for the assault on Big Bethel. *From* Frank Leslie's Illustrated Newspaper.

NOVEMBER 5

1918—Mobilized in 1917 as the United States entered into World War I; having trained at Camp McClellan, Alabama; and having been assigned to the 111th Field Artillery Regiment of the 29th Division, Battery D, Hampton's National Guard unit, is ordered to front-line wartime duty in France.

NOVEMBER 6

1956—Voters go to the polls in Hampton, Newport News, and Warwick to cast ballots on the issue of consolidation of the three civic units into one city. While Newport News and Warwick vote yes and are consolidated, Hampton turns it down.

NOVEMBER 7

1861—A large expeditionary force, assembled late in October at Annapolis and New York City and then moved to Fort Monroe, captures Hilton Head Island and the harbor of Port Royal in South Carolina. It is supposed to be a combined operation, utilizing naval and army personnel. Storms batter the transit of the forces from Fort Monroe, preventing the use of army troops because of the loss of ammunition and landing vessels, and delaying the initial assault for four days. The attack concentrates on Fort Walker on Hilton Head Island, and by 2:00 p.m., it has driven most of the Confederates out of the fort, which has only three guns still operable and a shortage of powder as well. The Federals claim the abandoned fort but do not pursue the Confederates. Across the harbor, the Rebel garrison at Fort Beauregard hears the cheers of Federal victory at Walker and abandons its position. Commanding, General Robert E. Lee uses the retreating garrisons effectively to prevent Federal capture of the railroad from Charleston to Savannah.

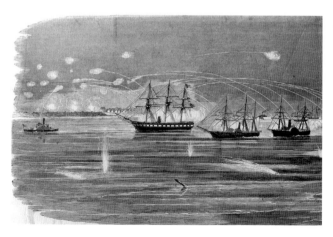

Departing Hampton Roads, the expeditionary force consisted of fourteen warships with 120 guns, twenty-six collier and supply ships, and twenty-five transports carrying 120,000 troops. *Wikimedia Commons.*

NOVEMBER 8

1610—The Virginia Council reports that Forts Henry and Charles near Southampton River (now Hampton River) are completed. Fort Henry encloses the conquered village of Kecoughtan on Strawberry Bank and probably abuts Johns Creek, today the western edge of the National Soldiers' Home grounds. Fort Charles is a "musket shot" away, at the other end of the inhabited area along Hampton Roads, containing much of the cleared land used for agriculture. Both were built to provide protection against an expected retaliatory attack by the Indians who had been driven out of the area by an invasion in July 1609, launched from Jamestown.

1887—The Hampton Town Council's Fire Committee is authorized to purchase one thousand feet of fire hose, two hose carts, and a hook and ladder truck, at a cost of $1,282.50. Also purchased is a large horse-pulled fire engine, which becomes known to the firemen as the "threshing machine." The new equipment replaces the horse-drawn hand-pump machine originally obtained in 1884 after the disastrous downtown fire of that year.

NOVEMBER 9

1879—The Academic Hall—a dormitory, library, and classroom building at Hampton Institute (now Hampton University)—is destroyed by fire. It was the first major structure built at the campus, in 1868. A replacement hall on the same site, planned by the school's faculty and built by its trade school students, would be completed in 1881.

NOVEMBER 10

1937—All of the streets in Aberdeen Gardens except Aberdeen Road are renamed after influential and important African Americans, as the subdivision was designed and built by blacks for blacks, and the residents desire that the names be changed to commemorate their cultural heritage.

NOVEMBER 11

1918—With the signing of an armistice ending World War I in Europe, Battery D of Hampton proves to have only four days of official wartime duty, as it did not arrive at the front until November 7. Along with other Virginia National Guard units, such as the Norfolk Blues and the Richmond Howitzers, they arrive in England in June and cross to France on July 16, engaging in further training before deployment to the front.

NOVEMBER 12

1959—After more than a century and a quarter, the steamboat wharf at Old Point Comfort, long used primarily for passenger traffic but also important for unloading materiel, closes. Rail, air, overland trucking, the automobile, and bus service have combined to render it too costly to maintain. It would be torn down in 1960.

NOVEMBER 13

1935—The colorful era of lighter-than-air airships and balloons in the history of Langley Field comes to an end when the Nineteenth Airship Squadron and the helium-filled 233-foot-long dirigible *TC-13* are transferred to Moffatt Field, California. Useful for reconnaissance and advertising, airships ("blimps") are still in both military and civilian service. A portion of Langley Field is still referred to as the LTA ("lighter-than-air") area.

NOVEMBER 14

1789—The Virginia General Assembly votes to purchase the freedom of Hampton slave Cesar Tarrant for "meritorious service" during the Revolutionary War. Tarrant is a highly skilled boat pilot whose coolness under attack and deft handling of his duties amazed his comrades-in-arms; unlike many enslaved people, he did not flee to claim the freedom offered by

the British but chose to stay in Hampton. In a fierce battle in 1777, Tarrant boldly rammed his vessel, *Patriot*, into the larger *Lord Howe*, preventing its escape, and earned great praise from his superior officers in the ensuing fight. Before his death in 1797, Tarrant would be able to purchase freedom for his wife and a daughter, but his son and another daughter would remain in slavery.

1910—Barely surviving a thirty-seven-foot plunge into the whitecapping crests of Hampton Roads' waves, exhibition pilot Eugene Ely becomes the first to have a heavier-than-air aircraft take off from a ship when his fifty-horsepower Curtiss biplane lifts off via a specially fitted-out eighty-three-foot ramp on the USS *Birmingham* in cold, blustery, foggy, and intermittently rainy weather. The propeller is damaged and his goggles are obscured by salt spray before Ely, who cannot swim, eases the plane out of the waves and slowly climbs over Fort Wool, eventually reaching about five hundred feet over Chesapeake Bay before landing at Willoughby Spit. The daredevil Ely would break his neck and die in a crash at an air show at Macon, Georgia, in October 1911.

1941—James Adams's Floating Theatre burns and sinks as it is being towed to Savannah, Georgia, to be converted into a cargo barge. Starting in 1914, the 132-foot flat-bottomed vessel—two stories high and containing a 500-seat auditorium, a 350-seat balcony for black passengers during the era of segregation, a 19-foot-wide stage with an orchestra pit, eight dressing rooms doubling as bedrooms, a dining room and a kitchen, plus an apartment for Adams and his family and rooms used as offices—tours waterfront towns in Maryland, Virginia (including Hampton), and North Carolina for thirty-seven weeks a year. It offers concerts and a different play each night during a week's sojourn in a port. About twenty workers living on the vessel combine the tasks of boat crew, actors, musicians, ticket-takers, ushers, and stagehands. Edna Ferber memorializes the Floating Theatre in her best-selling 1926 novel *Showboat*, later a smash hit as a musical on Broadway.

NOVEMBER 15

1921—The 410-foot-long airship *Roma* is flown for the first time in the United States by the Army Air Service from Langley Field. With a lifting

capacity of seventeen metric tons, its six 450-horsepower engines can produce a speed in excess of sixty-five miles per hour. Newsreels of the successful test are shot and rushed to the Imperial Theater in Newport News to be shown that evening.

NOVEMBER 16

1954—Hampton no longer has passenger service from the Chesapeake and Ohio Railroad. The last travelers left the station the day before, ending sixty years of chuffing steam engines and the ability of Hamptonians to take day trips to Richmond for shopping without worrying about auto traffic.

1993—The U.S. Navy's submarine USS *Hampton*, named for the four cities called "Hampton" in the United States (including Hampton, Virginia), is commissioned after it is built and launched at the Newport News Shipbuilding and Dry Dock Company. In the charge of Commander Lincoln Reifsteck, the *Hampton* is 360 feet long and has a crew of 13 officers and 116 enlisted submariners. The other Hamptons are in Connecticut, New Hampshire, and South Carolina.

NOVEMBER 17

1718—Lieutenant Robert Maynard, in command of the armed sloops *Jane* and *Ranger* plus fifty-seven British sailors and some civilian crewmen, sails from Hampton under the aegis of Virginia governor Alexander Spotswood on an expedition to capture the pirate Edward Thatch (or Teach), famously known as Blackbeard. Maynard attacks his quarry anchored on the inner side of Ocracoke Island, North Carolina, on November 22, and in a furious and bloody battle, Blackbeard is killed. Maynard sails back to Hampton with the pirate's head hanging from the bowsprit. Thatch had been a pirate since about 1713 and had captured more than thirty ships. He found a haven in North Carolina by sharing his loot with its governor, Charles Eden.

NOVEMBER 18

1619—The Virginia Company of London divides the colony of Virginia into four "corporations" or "cities," one of them being Kecoughtan, whose name is almost immediately changed to Elizabeth City. The "cities" extend across rivers and the Chesapeake Bay; Elizabeth City includes what are today the Eastern Shore, Virginia Beach, Norfolk and Portsmouth. In 1634, King Charles I would eliminate this form of governance, establishing eight shires. The former corporation of Elizabeth City, now Elizabeth City Shire, is limited in size to that portion of the old "city" located on the Peninsula (including a piece that will much later be incorporated into Newport News). The shires will become counties by 1642, while the town of Elizabeth City will eventually be renamed Hampton.

NOVEMBER 19

1865—The illegally captured Confederate raider CSS *Florida*, anchored off Fort Monroe, is rammed and sunk when the steam transport USS *Alliance* comes afoul of its rigging, probably a deliberate action by Admiral David Dixon Porter to prevent the Federals from having to return the ship to Brazil (where its daring nighttime capture by Commander Napoleon Collins of USS *Wachusett* had occurred). Purchased by the Confederate government from a British shipbuilder in 1862, the sloop *Florida* had proven a huge thorn in the side of the U.S. Navy, capturing or disabling at least thirty-seven merchant vessels, all while eluding Federal pursuit. Due to the diplomatic crisis between the United States and the Empire of Brazil stemming from the *Florida*'s illegal seizure, Collins is court-martialed and convicted, but this is set aside by Secretary of the Navy Gideon Welles.

1909—President William Howard Taft visits Fort Monroe at the end of a cruise to Panama, where he inspected dams and locks on what would become the Panama Canal, one of the largest and most difficult engineering projects ever undertaken.

1915—In a reorganization, Hampton's Peninsula Guards national guard unit becomes Battery D. In 1917, it will be assigned to the 111th Field Artillery Regiment.

NOVEMBER 20

1957—The 3.5-mile-long Hampton Roads Bridge-Tunnel has been open for nearly a month, connecting the Phoebus neighborhood in Hampton with Willoughby Spit in Norfolk using lengthy sections of bridge plus an automobile tunnel deep under the entrance to Hampton Roads. It replaces a ferry system and makes it much easier to travel between the Peninsula and the Southside. Originally a toll facility, when sufficient moneys are collected to repay the construction costs, it becomes free; state senator Hunter B. Andrews honors the original promise, refusing to countenance continued collection of duties in order to build other needed roads. The second span and tunnel, opened in 1976, allowing two-lane one-way traffic in each tunnel, would be constructed primarily with federal highway trust funds and be toll-free. By 2018, more than 100,000 vehicles per day pass through during vacation season, and there are frequent backups of traffic.

NOVEMBER 21

1919—The LaSalle Improvement Association begins a project to widen LaSalle Avenue. LaSalle had been extended from Electric Avenue (now Victoria Boulevard) to Chesapeake Avenue in 1905 as a trolley line was laid along it, in order to provide better access for its namesake, the De LaSalle Institute for Boys, a Catholic school brought to Hampton in 1898 and located at the corner of LaSalle and Chesapeake.

2013—The Greenman House near Newmarket Creek and Interstate 64, built in 1901, is being completely razed to allow completion of the city's Newmarket Creek Park and Trail System, a walking path from the Power Plant development over the interstate to Air Power Park on Mercury Boulevard.

NOVEMBER 22

1755—The Virginia governmental council, by one vote, provisionally accepts five boatloads comprising 1,140 French Acadians expelled from

maritime Canada by English authorities. One boatload is sent to Richmond and two more to Norfolk, while the final two remain at Hampton. Persons in Hampton and Norfolk are ordered to provide houses for them, while the legislature grants them weekly portions of meat and flour. There is some discontent because the refugees are Roman Catholic, and in April or May 1756, they would be sent to England at Virginia's expense.

1970—Bobby Allison wins the final of nine NASCAR Grand National stock car races held at Hampton's Langley Speedway. The series would be renamed the Winston Cup and is now called the Sprint Cup. The raceway, on the national circuit of NASCAR, opened in 1950 as a dirt track, received its present name when Henry Klich bought it in 1963, and was asphalted in 1968. From 1982 to 1988, fourteen events in NASCAR's Nationwide Series would be held there. Dale Earnhardt, Richard Petty, David Pearson, Ned Jarrett, LeeRoy Yarborough, and Donnie Allison are among the stars who have raced there. It becomes likely the first NASCAR-sanctioned weekly track with skyboxes and suites accessible via elevator. Closed for 2016 due to difficulties in selling the track, it would reopen in 2017 as the Larry King Law Langley Speedway.

Langley Speedway is a relatively flat track that measures 0.395 miles in length, with only 6 degrees of corner banking and 4 degrees on the straights. *Langley Speedway.*

NOVEMBER 23

1775—Patriotic resistance to British rule is emphasized by the election of a Committee of Safety for Hampton and Elizabeth City County, where there are about one thousand residents. The committee will effectively be the new governing body, as English authority has drastically waned. Its chair is William Roscoe Wilson Curle, and other members include Westwood Armistead, Moseley Armistead, Wilson Miles Cary, John Cary, Edward Cooper, Joseph Cooper, Miles King, Henry King, John King, George Wray, Jacob Wray, John Allen, James Wallace Bailey, George Booker, Simon Hollier, John Jones, William Mallory, Augustine Moore, John Parsons, and John Tabb, with Robert Bright as clerk.

1829—James Barron Hope, to become the poet laureate of Virginia, is born at the Gosport Navy Yard near Portsmouth. He would later reside in Hampton.

1903—Pioneering African American attorney James A. Fields dies of Bright's disease. Born into slavery in August 1844 in Hanover County, Fields was brutally beaten by his owner in 1863 and escaped to Fort Monroe to join his mother and some siblings, who had already escaped. Having worked in the fort's quartermaster department and as a watchman for the Freedmen's Bureau while attending a missionary school, he enrolled in 1869 in the first class to enter Hampton Institute (now University), while also serving in the town's militia and as a justice of the peace. In 1887, he moved his practice to the boomtown of Newport News, where he was elected to a term in the House of Delegates, 1889–91, and served as commonwealth's attorney. He found time to teach grade school and Sunday school. His Late Victorian Italianate residence has become a museum.

NOVEMBER 24

1991—A funeral is held for Dr. Russell V. Buxton, member of a noted Peninsula medical family. His father, Dr. Joseph T. Buxton, chief of surgery at the first Newport News General Hospital in 1903, founded his own hospital and nursing school in what is now Hampton in 1906, at the corner of the Boulevard (now Chesapeake Avenue) and Cypress Street. At first,

the Elizabeth Buxton Hospital had only fifteen beds, but it became a large three-hundred-bed facility in 1930. It was renamed the Mary Immaculate Hospital in 1953 and the Riverside Rehabilitation Center in 1961.

NOVEMBER 25

1918—Construction at Langley Flying Field has been halted due to the signing of the armistice in Europe. It will be resumed in 1919 when a massive hangar for lighter-than-air craft (dirigibles), 125 feet wide by 420 feet long by 116 feet high, is begun east of the Lamington Plantation cottage. This giant structure would dominate the Langley landscape and skyline from the mid-1920s until demolished in 1947.

NOVEMBER 26

1970—The final football game played between defending state champion Hampton High School and Newport News High School in the annual Thanksgiving match-up results in a rare defeat for the Hampton Crabbers, ending a twenty-eight-game winning streak. Hampton plays its home games at J.S. Darling Memorial Stadium, located on property given to the city by Frank Darling in 1928 for athletic purposes. The original Darling Stadium opened in 1929, was renovated with New Deal funding in the mid-'30s, and would be demolished in 1987. A new stadium on the same site will be dedicated in 1989. Hampton has won seventeen state football championships, more than any other high school in Virginia, appearing in ten straight title games in the 1980s and capturing eight of them. Teams coached by Mike Smith have won eleven of these state crowns. The 1996 and 1997 Hampton High squads are recognized as national U.S. high school football champions.

NOVEMBER 27

1902—In a race held on Thanksgiving Day, a horse brought down from Baltimore sets a new course record time of 2:12 at the Hampton Roads

Driving Park, the first horse racing track on the Peninsula. Located in the Wythe area where St. Mary's Church and the Kecoughtan Apartments sit today, just off the main trolley line from Newport News to Hampton, the half-mile oval hosts trotters, pacers, and runners. Stables are adjacent, and the grandstand overlooks Hampton Roads harbor. Races are held in the spring and fall, with major events occurring on July 4, Labor Day, and Thanksgiving, and more than two thousand spectators sometimes attend. Nearby is built the first local baseball diamond, used by teams from Hampton, Newport News, Elizabeth City County (then separate from Hampton), and Warwick County.

1919—African Americans raise $2,500 for a school. Union Street School, opened before 1898 in what is then Elizabeth City County at the corner of Armistead and Union Streets, uses the gift to construct brick classroom additions, completed in 1921. Under the strong leadership of Principal Y.H. Thomas, senior grades are added, and high school graduations occur from 1926 through 1931. Then a thoroughly modern, well-equipped George P. Phenix Training School opens on the Hampton Institute (now Hampton University) campus, and the Union Street facility is left with elementary and junior high school students until it closes in 1966.

NOVEMBER 28

1976—All boat channels into Chesapeake Bay's remote Tangier Island are clogged because of a dispute over where to dump dredging spoil. Fuel barges are unable to bring in the natural gas needed for all cooking and heating. School days are shortened, and the islanders lower their thermostats during the crisis. When supplies had nearly run out, Captain Bill Hunt of Hampton, hearing about the near disaster, makes an emergency run in the tugboat *Connie Hunt* and brings in the needed supplies.

NOVEMBER 29

1919—The Phoebus Men's Club is well into its campaign to collect $200,000 to build a road from Phoebus to Grandview. The road is, however, never built.

NOVEMBER 30

1619—John Woodliffe, bringing thirty-eight settlers to Virginia on the *Margaret*, lands at Kecoughtan (now Hampton) after a voyage of two and a half months from England. The adventurers are bound for Berkeley Hundred Plantation, on the James River.

1907—Among the attractions closing down as the Jamestown Exposition comes to an end in Norfolk is the Miller Bros. 101 Wild West Show, which featured sharpshooter and trick horseback rider Lilian Smith (as "Princess Wenonah"), who had earlier performed with Annie Oakley in "Buffalo Bill" Cody's Wild West Show throughout the United States and Europe. Even with direct daily passenger service by ferry from Hampton, visitorship at the events and displays is highly disappointing, and it has not been a profitable venture. Many of the buildings remain standing, and some of the streets retain their exposition-given names, as the former venue has been incorporated into the Norfolk Naval Base (technically Naval Station Norfolk). Since the base is not open to the public, visitation to the site is difficult.

December

DECEMBER 1

1921—The U.S. Navy flies the nonrigid dirigible *C-7* from Hampton Roads to Washington, D.C. It is the first U.S. flight that uses helium to keep the dirigible aloft. Dozens of airships using hydrogen have burned or exploded, and so helium, an inert gas (chemically inactive), would be the sole lifting agent used after the Langley-based *Roma* disaster in 1922. Since in operative terms the other gas—much rarer and more expensive—is twice as heavy as hydrogen, payloads are usually about half those available with helium.

1969—The Hampton Coliseum (until 1974 called Hampton Roads Coliseum) hosts its first collegiate basketball game, between William & Mary and North Carolina State. The Wolfpack downs the Tribe, 93–84. The official opening of the Coliseum would occur two months later, on January 31, 1970. On February 24, 1989, a snowstorm with fifty-mile-per-hour winds would deposit eight inches of swirling snow, causing the cancelation of performances by Ringling Bros. and Barnum & Bailey Circus.

2003—Rescue workers in Wythe plan to continue providing ambulance service at no cost, despite the decision of Hampton's Fire Division to begin charging a fee for emergency medical transport. The Wythe response unit has always been staffed with well-trained volunteers, while those who

drive ambulances in other parts of the city are professionals. The first ambulance service available locally had been established in 1939 by the Wythe Rescue Squad.

DECEMBER 2

1787—Virginia's naval officer for the port of Hampton in the District of James River, George Wray, is required to post a bond of £5,000, an enormous sum even though it is payable in "Virginia money."

1899—The new West End Academy becomes the first high school that white children from Elizabeth City County, Phoebus, and Hampton could attend without extra cost to their parents. It has eight spacious and well-ventilated classrooms and cost $28,000 to construct. The first graduates would leave in 1904. After a new Hampton High School will be opened in 1922, just up the street at the corner of Kecoughtan Road and Electric Avenue (now Victoria Boulevard), the West End building would be renamed John M. Willis Elementary School, honoring the local pioneer superintendent who served more than thirty years (1886–1919). The name would be changed once again in 1940, to Willis-Syms-Eaton Elementary School, when the Syms-Eaton Academy is closed. The oldest portion, part of West End, would be demolished in the 1950s, while the remainder of the structure would close in 1974 and be demolished in 1977.

1919—Leading men in Hampton meet to promote a change to a city-manager form of government. A typical Progressive era reform, supposedly a professional manager can plan and run a government free from graft, corruption, or the vicissitudes of amateur executive decision-making. The manager will be hired by the city council and will be given broad policy objectives; day-to-day execution of the policies will be up to the manager.

DECEMBER 3

1862—By order of Secretary of War Edwin M. Stanton and pursuant to the agreement permitting the hotel to be built next to an army base, the first

Hygeia Hotel at Old Point Comfort is under demolition because of the large number of civilians who have been crowding into the hotel. Fort Monroe, on Old Point Comfort, which is practically surrounded by Confederate-controlled territory, is nevertheless always held in Union hands, and some of the hotel guests are deemed suspicious.

DECEMBER 4

1916—The U.S. Army and NACA (now NASA) approve the deal to purchase the land that will become Langley Field, offered by Harry H. Holt, Nelson S. Groome, and Hunter R. Booker of Hampton.

DECEMBER 5

2003—One of the most damaging nor'easters on record strikes the East Coast. Later, it would combine with a storm from the arctic so that the northeastern United States suffers a massive blizzard, but only high winds and rain affect Hampton. However, following up on the battering generated by Hurricane Isabel the previous September, these gusts knock down one-third of the brick façade of Hampton's oldest surviving structure, the Herbert House. Built by seaman and shipbuilder John Herbert in 1753 and long known as Ivy Home, the future of the two-story Georgian brick house near Hampton River is in severe doubt, but the building is saved by developers who restore it to be the centerpiece of a new neighborhood.

DECEMBER 6

1884—The first issue of the *Home Bulletin*, a weekly newspaper, is printed for the residents of the National Soldiers' Home (now the Veterans Administration). The publication is still extant as of 1891.

1945—A map of this date, probably drawn by Surveyor E.E. Pyle, shows the two-thousand-foot-long asphalt runway of the Peninsula Airport, an airstrip

between Shell Road and Pembroke Avenue, at the end of Celey Street. A short cross runway is almost never used, and the airport would close in 1949.

DECEMBER 7

1941—Following the Japanese attack on Pearl Harbor, Fort Monroe goes on full alert, and a garrison from the Second Coast Artillery occupies Fort Wool, an island in Hampton Roads to which all food, water, coal, and other supplies must be brought by boat. Fort Wool's makeshift machine gun defenses protected by sandbags are not replaced with two .50-caliber antiaircraft guns until October 1942. Construction for a complete battery of two guns embedded in a massive bunker would be completed on January 31, 1944, but the weapons themselves are never installed. To guard against sabotage, barbed wire is installed around the island's perimeter. Meanwhile, a minefield is laid offshore near the lighthouse at Thimble Shoal, while an antisubmarine net is positioned underwater between Fort Wool and Fort Monroe and an anti-motor torpedo net is strung between Fort Monroe and Willoughby Spit.

Artillery at Fort Monroe. During World War II, Forts Monroe and Wool were used to protect the inland military and civilian resources in Hampton Roads. *Wikimedia Commons.*

DECEMBER 8

1941—In response to the Japanese attack, the Twenty-Second Bombardment Group departs Langley for March Field, California, in forty-four B-26 bombers. After two months of searching for Japanese submarines, the group is transferred to Australia and attacks Japanese targets in New Guinea and New Britain. In February 1944, the group will be equipped with B-24s and begin to attack targets in the Dutch East Indies. In November, the group will be moved to the Philippines, and on August 15, 1945, it will again be moved, this time to the Japanese island of Okinawa, where it will fly missions over Japan to ensure that the terms of the peace treaty are being followed.

DECEMBER 9

1941—Following the attack on Pearl Harbor, and anticipating war with both Germany and Italy, the commander at Langley Field, Brigadier General Eugene Lohman, initiates preparations for defense of the base. A thirty-millimeter antiaircraft battery is sent from Fort Eustis and positioned north of the landing field at the northeast branch of Back River, while sandbag revetments are placed adjacent to taxiways and aprons.

DECEMBER 10

1910—Conrad Wise Chapman, who ran away from home to join the Confederate army, seeing action in Mississippi, Louisiana, Virginia, and South Carolina and suffering a head wound, dies in Hampton, aged sixty-eight, and is buried in St. John's Cemetery. He and his wife, Laura, had lived for a short time in the Simpson cottage Quietude, the oldest home in Wythe, located on Chesapeake Avenue (then the Boulevard) near LaSalle Avenue. Chapman is probably the most eminent Southern painter of Civil War scenes. He was born in New York City and grew up in Europe, where his father, John Gadsby Chapman, worked as a painter. After the Civil War, unreconciled to Southern defeat, he and Laura lived in Mexico and Europe before returning to Virginia. Many of his paintings are in the collections of the Museum of the Confederacy and the Valentine Richmond History Center.

DECEMBER 11

1962—The several schools at Fort Monroe, including the Post Elementary School and the Fort Monroe Post School, previously operated by military authorities, are transferred to the Hampton City School System.

DECEMBER 12

1996—Two masked gunmen invade Robert F. Snow & Son Bicycles, a business established in Phoebus since 1908, and shoot Will Snow Jr. at point-blank range in a robbery attempt, with his small son and daughter watching. Third-generation owner Snow is hospitalized but recovers, and he is soon back to playing mandolin in the band New Dominion Bluegrass. The culprits are never apprehended.

DECEMBER 13

1776—The Virginia General Assembly approves a report noting that John Cary of Elizabeth City County had completed three-quarters of the salt works he was constructing at a site between Fox Hill and Buckroe, known today as the Salt Ponds. He would be paid by the state two shillings per bushel of salt, gained by the ancient method of solar evaporation, and the product would be rationed at the rate of one peck per Virginian per year.

DECEMBER 14

1941—Fort Monroe has been recently named headquarters of the Chesapeake Bay Sector of the Eastern United States Defense Command.

DECEMBER 15

1922—The Esther Burdick Library is dedicated, housed in a room at Syms-Eaton Elementary School. The first public library in Elizabeth City County starts with a donation of forty-five books from Mr. and Mrs. F.L. Burdick. Much of the collection is moved to the Charles H. Taylor Library when it opens in 1926, and the Burdick library would be dismantled in 1938.

DECEMBER 16

1907—Beginning a fourteen-month around-the-world voyage that expresses the sea power of the maturing United States in a forceful way, the Great White Fleet, dispatched by President Theodore Roosevelt, steams from Hampton Roads past Old Point Comfort. The fleet consists of sixteen battleships, two of which are replaced in San Francisco in May 1908 by other battleships. They are manned by fourteen thousand sailors, and the tour covers forty-three thousand nautical miles. Accompanying the battleships are two store ships, a hospital ship, a repair ship, and a tender.

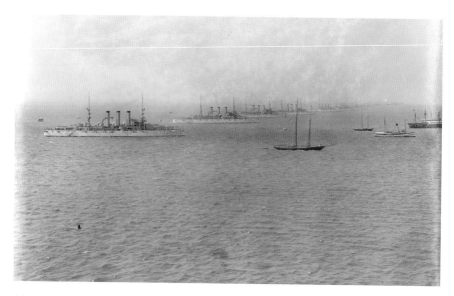

A twenty-one-gun salute greeted President Theodore Roosevelt as he watched the white-hulled naval armada pass in review by the steamboat wharf at Old Point Comfort. *Library of Congress.*

DECEMBER 17

1747—Seventeen-year-old Sally Cary of Celeys—the grand plantation of her father, Colonel William Cary, on the shore of Hampton Roads abutting Salters Creek in what was then Elizabeth City County—marries the wealthy George William Fairfax and moves to his magnificent family home, Belvoir, on the Potomac River. She will soon meet a tall sixteen-year-old neighbor, George Washington, who is severely smitten and falls in love with her, but he must marry elsewhere. Nevertheless, Sally would offer advice to her friend in letters and on some of his many visits.

1909—Kecoughtan Road, a major new roadway from Newport News to Hampton, is opened after a few weeks of construction. It is a continuation of what was then called Third Street in Newport News and runs from Salter's Creek Bridge near Greenlawn Cemetery to the Jackson Street Bridge, now the end of Sunset Creek. Of the cost of $24,500, the Commonwealth of Virginia contributes $12,000, Elizabeth City County pays $5,000, the City of Hampton puts up $500, the Business Association of Hampton contributes $1,000, and private citizens Frank Darling and William C. Armstrong head a committee that raises the remaining $6,000.

DECEMBER 18

1873—Tax-paying residents of Fox Hill petition William R. Willis, the judge of Elizabeth City County, to prevent removal of a gate across the main road. Many local residents keep cattle, which under Virginia's "open range" law are allowed to roam freely. Houses and gardens are fenced instead. To keep the cattle from escaping, a fence had been run from Harris Creek on the west over to Chesapeake Bay on the east. It was punctuated by an iron gate at Beach Road that opened when a horse-drawn cart drove over a trigger mechanism in the road—a second trigger on the far side would shut the barrier again. County officials decide that the obstacle has to be removed. Cattlemen are forced to fence their pastures.

1919—After thirty-three years on the job, John M. Willis resigns as superintendent for the consolidated schools of Hampton, Phoebus, and Elizabeth City County. Coming into office when there was little money to operate public schools, Willis oversaw the opening of several new structures for white children and developed the plan that produced a single white high school and a single black high school for all three political subdivisions together.

DECEMBER 19

1606—Three vessels—*Susan Constant, Godspeed,* and *Discovery*—set sail from Blackwell in London to found an English colony in Virginia under the auspices of the private Virginia Company. After making shore at the Indian village of Kecoughtan (now Hampton) in late April, in May 1607 they will found Jamestown, thirty miles up the James River.

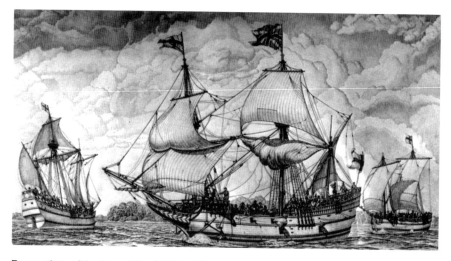

Re-creations of the three ships that brought the first permanent English settlers to Virginia are moored at Jamestown settlement for visitors to explore. *Library of Congress.*

DECEMBER 20

1828—Using the pseudonym E.A. Perry, Edgar Allan Poe of Company H, First Artillery, reports for army duty at Fort Monroe. He soon reveals his true identity and his literary skills to Lieutenant Joshua Howard, his commanding officer. He spends much time attempting to leave military service.

It's believed that Poe's inspiration for the poem "Annabel Lee" came from his Fort Monroe service. He returned later for respite at the Hygeia Hotel. *Library of Congress.*

DECEMBER 21

1926—Bus and streetcar service on the Lower Peninsula has been combined into one corporation, as the Virginia Public Service Commission has acquired the Citizens Rapid Transit Corporation, formed in 1923, and the Newport News Hampton Railway, Gas and Electric Company (which resulted from the 1914 merger of several smaller lines with the Newport News and Old Point Railway and Electric Company). When Virginia Electric and Power Company acquires the Public Service Commission in 1944, its bus and streetcar services would be divested and would become the new Citizens Rapid Transit Company. Ultimately, Citizens Rapid Transit bus service will become a part of the area-wide Hampton Roads Transit, incorporated on October 1, 1999.

DECEMBER 22

1896—The smallest of the three resort hotels on Old Point Comfort, the Sherwood Inn, has its three upper stories destroyed by fire. The structure is quickly rebuilt and would be operated for the next two decades as the New Sherwood Inn. Originally the home of Fort Monroe's chief surgeon, Dr. Robert Archer, over the years it had been enlarged into an inn. It was acquired in 1889 by Hamptonian George Booker, who renamed it after his family's plantation near Back River.

1941—After a difficult and hastily planned winter crossing of an Atlantic Ocean full of German U-boats aboard the British battleship *Duke of York*, British Prime Minister Winston Churchill sails into Hampton Roads and takes a military airplane to Washington, D.C., to engage with President Franklin D. Roosevelt and his military staff in planning for World War II. The *Duke of York* steams up to Maryland soon afterward, bringing Churchill's military entourage. The lengthy set of meetings between the two heads of government, not ended until January 1942, has become known as the First Washington Conference. Churchill and Roosevelt would meet twelve times in 1941–45 concerning the war.

DECEMBER 23

1919—In response to the nationwide strike of coal miners, Hampton Institute (now Hampton University) has instituted a cutback on the use of the fossil fuel. The strategic cold weather strike has got many people scurrying to conserve their coal supplies.

DECEMBER 24

1892—The Newport News Street Railway Company extends its trolley service to Hampton. The company operated the first streetcars on the Peninsula in 1889, and several competitors appeared and laid tracks covering various parts of the Peninsula. A complicated history of mergers would follow over several years. Trolleys eventually find stiff competition from automobiles and buses, and Peninsula service would be discontinued in 1946.

DECEMBER 25

1862—The officers and crew of the Union ironclad USS *Monitor* enjoy their Christmas dinner anchored off Fort Wool, guarding the entrance to Hampton Roads.

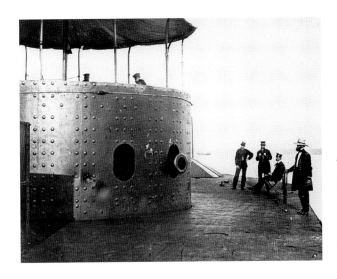

The USS *Monitor*'s crewmembers were all volunteers, totaling forty-nine officers and enlisted men. In this photo, dents from cannon fire are seen in the turret. *Wikimedia Commons.*

DECEMBER 26

1898—James Sands Darling sells the Hampton and Old Point Railway Company, a trolley line. The net profit of $16,000 is given to the employees as Christmas bonuses.

DECEMBER 27

1904—The War Department gives official names to the gun batteries at Fort Wool, honoring noteworthy soldiers in past wars. One rapid-fire battery is named for Robert E. Lee's father, cavalryman Henry "Light-Horse Harry" Lee of the American Revolution, while the other honors Jacob Hindman, a respected artillerist in the War of 1812. A disappearing gun battery is named for Ferdinand L. Claiborne, who fought the Creek Indians during the War of 1812; a second pays tribute to Alexander B. Dyer, army chief of ordnance at the close of the Civil War; and the third is dedicated to Horatio Gates, credited with the pivotal Revolutionary War victory at Saratoga, New York.

2010—The Hampton Downtown Historic District is added to the National Register of Historic Places. Encompassing twenty-five buildings reflecting the Beaux-Arts, Art Deco, and Gothic Revival styles,

among those included are the Old Hampton Post Office (built in 1914), the former Hampton Circuit Courthouse (1876), St. John's Church (1728), Hampton Baptist Church (1883), Hampton City Hall (1939), St. Tammany's Masonic Lodge (1888), First United Methodist Church (1887), and the Sclater Building (1871).

DECEMBER 28

1775—James Barron of Hampton sails *Liberty*, the small sixty-ton flagship of the Virginia Navy (homeported at Hampton), with a complement of twenty sailors, into the Chesapeake Bay at the beginning of the American Revolution. He returns in January with a string of ten English trophy merchant vessels in tow, having campaigned against a surprised foe that outmanned and outgunned him but could not outfight him. The fifty ships in Virginia's fleet make it the largest navy of any state. Perpetually undermanned and poorly armed, they are really neither prepared nor equipped to confront the mighty British navy head-on, but they successfully diminish enemy merchant shipping and disrupt enemy privateers.

DECEMBER 29

1608—Driven ashore by a nor'easter, Captain John Smith and several companions begin a weeklong stay as guests of the Kecoughtan Indians. Amazingly facile with languages and by now conversant with many Indian groups, Smith spends time learning more of the Algonquian dialect spoken by the Powhatans.

DECEMBER 30

1780—During the American Revolution, Hamptonian James Barron, commodore of the Virginia Navy, while aboard his vessel *Liberty*, observes the passage into Hampton Roads of twenty-seven ships of the British fleet under the command of American turncoat Benedict Arnold. Barron sails

to Hampton to send notification to General Thomas Nelson at Yorktown and, eventually, Governor Thomas Jefferson at Richmond. Meanwhile, Arnold lands three hundred men to reconnoiter Newport News and Hampton, preparatory to an assault on Richmond.

1916—The U.S. government buys 1,659 acres of farmland near Back River, which less than a year later would become the nucleus of Langley Field.

1959—The Old Bay Line steamer *City of Richmond* makes the final stop of any steamship company at Old Point Comfort. The wharf is condemned. The Old Bay Line will make its last voyage on the Chesapeake Bay on April 13, 1962, from Baltimore to Norfolk and discontinue all service the following day. The *City of Richmond* will eventually be sold to become a floating restaurant in the Virgin Islands, but while being towed there in 1964, it will sink in a storm off the North Carolina coast. Its companion, the *City of Norfolk*, will sit at dock in Norfolk until 1966, when it is scrapped.

DECEMBER 31

1780—A Hessian contingent of British forces under American turncoat Brigadier General Benedict Arnold occupies the town of Hampton. This third British assault on Hampton during the War for Independence is short in duration. Arnold embarks his forces from the lower Peninsula on January 1, proceeding up the James River.

1959—Ferry service terminates from Hampton to Norfolk, as the Hampton Roads Bridge-Tunnel provides a link that can be used without confining a driver to the ferry's schedule.

About the Authors

Following his graduation from Arkansas State University, EDWARD B. HICKS worked for more than three decades as a newspaper advertising executive. He is coauthor of *Battle of Big Bethel: Crucial Clash in Early Civil War Virginia* and has edited and provided extensive research for several historical publications. For six years, he was assistant to the curator of the Hampton History Museum and has served on the Fort Monroe Casemate Museum Board of Directors.

WYTHE HOLT received a JD and a PhD in American history from the University of Virginia and taught at the University of Alabama School of Law for thirty-nine years, where he is University Research Professor of Law Emeritus. He has published several articles and books, including being the coauthor both of *Battle of Big Bethel: Crucial Clash in Early Civil War Virginia* and of a volume in the Arcadia series *Images of America: Hampton*. He has completed a legal history of the Whiskey Rebellion of 1794.

Visit us at
www.historypress.com